Community Art

What's the point of cities, built
without the people's wisdom?

Bertold Brecht,
Great Times, Wasted

Community Art

An Anthropological Perspective

Kate Crehan

BERG

Oxford · New York

English edition
First published in 2011 by
Berg
Editorial offices:
49-51 Bedford Square, London, WC1B 3DP, UK
175 Fifth Avenue, New York, NY 10010, USA

© Kate Crehan 2011

All rights reserved.
No part of this publication may be reproduced in any form
or by any means without the written permission of Berg.

Berg is the imprint of Bloomsbury Publishing Plc.

Library of Congress Cataloging-in-Publication Data

Crehan, Kate A. F.
Community art : an anthropological perspective / Kate Crehan. — English ed.
p. cm.
Includes bibliographical references.
ISBN 978-1-84788-833-4 (pbk.) — ISBN 978-1-84788-834-1
(cloth) — ISBN 978-0-85785-055-3 (individual e-book)
1. Artists and community—Great Britain. 2. Free Form Arts Trust
(Great Britain) I. Title.
N72.A76C74 2011
700.1'03—dc23
2011022355

British Library Cataloguing-in-Publication Data

ISBN 978 1 84788 834 1 (Cloth)
978 1 84788 833 4 (Paper)
e-ISBN 978 0 85785 316 5 (Institutional)
978 0 85785 055 3 (Individual)

Typeset by Apex CoVantage, LLC, Madison, WI USA.

www.bergpublishers.com

Contents

List of Figures	vii
Acknowledgements	xi
Preface	xiii

I: THE REJECTION

1 Art Inside and Outside the Gallery — 3
 The Art World — 5
 Art with a Capital A — 11
 The Art World and Common Sense — 18
 Charges and Briefs — 22

II: THE SHAPING

2 Moving beyond the Gallery — 29
 Beginnings — 29
 An Art World Brief — 35
 Into the 'Community' — 38
 A Warmly Persuasive Word — 40
 Back to the Art World — 41
 'What's It For, Mister?' — 44
 Freedom and Structure — 47
 Fun Events v. Artism Lifeism — 51

3 From Performance to the Environment — 57
 'I'm Afraid This Whole Horrible Box Takes Priority' — 58
 From Visual Systems to Free Form Arts Trust — 59
 Performance — 61
 Dead Fish and Totem Poles — 72
 The Environmental Turn — 76

4 Community Arts and the Democratization of Expertise — 79
 The Rise and Fall of Community Arts and
 Community Architecture — 80

vi CONTENTS

	Early Environmental Work in Hackney	87
	Providing Access to Expertise	91
5	Responding to Local Needs: Goldsmiths	95
	Football and Mosiacs	98
	Of Distraction and Expression	103
6	Making Art Collaboratively: Provost	111
	Paths and Plantings	111
	The Mural	115
	'Everybody Was Involved in the Mural'	124
	The View from the Arts Council	125
7	Theoretical and Political Locations	129
	Artists and Ethnography	129
	Locating the Free Form Artists	131
	The Coming of the Audit Culture	137

III: INTO THE TWENTY-FIRST CENTURY

8	Free Form in 2004	141
	A Professional Organization	141
	The Norwich Commission	148
	The Catton Grove Brief	152
9	A Carnival and a Standing Stone	157
	The Catton Clear Day Carnival	158
	'It's Personalized the Rubbish Collection a Bit More'	162
	The Fiddlewood Project	165
	Selecting an Artist	165
	The Standing Stone	171
	'It's Much Better Than That *Angel of the North*'	177
	The End of the Journey	180

Conclusion: Of Art and Community	**181**
Artists in the 'Community'	181
New Genre Public Art	186
The Free Artist and the 'Nonexclusive Audience'	189
Community Art and the 'Community'	193

References	**197**
Index	**203**

List of Figures

1	Martin Goodrich, 2009.	4
2	Jim Ives, 2009.	5
3	Barbara Wheeler-Early, 2009.	6
4	Free Form fire show with King Kong, 1970s.	52
5	'Architectonic Paint Rags', Barbara Wheeler-Early, Artism Lifeism, 1971.	53
6	Hackney Marsh Fun Festival, Triceratops inflatable, 1970s.	62
7	Street Participatory Theatre, Fumbelo Fellini, 1970s.	62
8	Alan Rossiter, 2009.	63
9	Hazel Goldman, 2009.	64
10	Diana England, 2009.	65
11	Performance Albany Empire, 1979.	66
12	Mobile Roadshow, 1978/9.	67
13	Constructing Granby mosaic, 1974.	74
14	Free Form poster, 1979.	84
15	Working towards a mural design, 1980.	88
16	Evering Road mural (created in 1982), 2009.	90
17	Goldsmiths Estate before D&TAS project.	96
18	Goldsmiths Estate after D&TAS project.	96
19	Dee Emerick, 2009.	97

viii LIST OF FIGURES

20	Provost Estate showing mural, 2005.	112
21	Provost Estate tenants June Trikilis and her father, Robert Trikilis, 2009.	113
22	Provost mural with two local children, 2005.	117
23	Provost mural, relief panel detail showing Notting Hill Carnival and street market, 2005.	118
24	Provost mural, detail of mosaic work, 1980s.	119
25	Discussing mural design, Provost Estate, 1985.	121
26	Landscaping Hackney Grove Gardens, London, mid 1980s.	132
27	Boy with his drawing, which was used in the design of street light behind him, Barking Town Quay, 1992.	135
28	Working on a mosaic mural, 1979.	137
29	Fishscape mosaic, Tyneside, late 1980s.	142
30	Fish Quay Festival, Tyneside, 1990.	143
31	Covent Garden hoardings with a design incorporating the stencilled names of market porters, official opening, 1985.	146
32	Art Works hoarding, early 1990s.	147
33	Snake play sculpture, Stonebridge Park, London, 1984.	151
34	Chloe Green, participant in Fiddlewood Standing Stone workshops, Fiddlewood Estate, 2009.	153
35	Janet Green, participant in Fiddlewood Standing Stone workshops, Fiddlewood Estate, 2009.	154
36	Collecting discarded TVs, Catton Clear Day Carnival, 2004.	160
37	Carole Reich, 2009.	168
38	Charlotte Howarth, 2009.	169

39 Fiddlewood Standing Stone poem, final
design for Standing Stone, and one of the workshop
prints included in the design. 174

40 Unveiling of the Fiddlewood Standing Stone, 2005. 176

Acknowledgements

Two chapters contain material that was previously published. Chapter 3 draws on my chapter, 'Hunting the Unicorn: Art and Community in East London', in Gerald Creed (ed.), *The Seductions of Community: Emancipations, Oppressions, Quandaries* (SAR, 2006); and Chapter 6 on, 'Sinking Roots: Using Gramsci in Contemporary Britain', in Joseph Francese (ed.), *Perspectives on Gramsci: Politics, Culture and Social Theory* (Routledge, 2009). I would like to thank SAR, Routledge and the editors for permission to reprint this material. I am also grateful to the Arts Council of Great Britain for granting permission to quote from their files. The staff at the V&A's Archive of Art and Design were extremely helpful; special thanks to Alexia Kirk, the V&A archivist who helped me find my way through the ACGB files.

The earliest research for this study was funded by an Arts Council grant. I would like to thank Ben Heywood, the Arts Council officer responsible, for his support and belief that Free Form's work should be recorded. Several grants from CUNY-PSC provided support for both research and writing. I also benefited from my participation in 2005/6 in the Andrew W. Mellon Seminar in the Humanities, 'Politics and Aesthetics', at the Center for the Humanities, at the City University of New York's Graduate Center. Numerous colleagues read the manuscript, or parts of it, at various stages during the writing of the book, and I received enormously helpful feedback. I would like to thank, in particular, Talal Asad, Gerald Creed, Peter Geschiere, Aisha Khan, Shirley Lindenbaum, Charity Scribner and Barbara Wolbert.

This book would not have been possible without the unlimited access granted me by Free Form Arts Trust and its artists, all of whom were unstintingly generous with their time. I owe a special debt to Martin Goodrich, Jim Ives, Barbara Wheeler-Early, Hazel Goldman, Alan Rossiter, Diana England, Shahed Ahmed, and Andy Newman. Carole Reich and Charlotte Howarth of Making Marks were wonderfully welcoming and supportive of my project. I am also grateful to Dee Emerick and to the residents of the Provost Estate for sharing their memories of Free Form, and to the people of Fiddlewood (and the community development officer, Emma Bacon) for allowing me to participate in the Catton Grove project and for their openness in talking with me about it.

xii ACKNOWLEDGEMENTS

I am also grateful to Free Form for allowing me to use images from their archive and to Stan Gamester for permission to use his photo of Fumbelo Fellini. Many thanks also to Kate Goodrich, who took many of the photographs and helped prepare all the illustrations for publication. Finally, I would like to thank Anna Wright at Berg, an exemplary editor with whom it has been a joy to work.

Preface

This book tells the story of a British arts organization, Free Form Arts Trust. The founders of Free Form were part of a larger movement of artists, beginning in the 1960s, determined to make 'art' that would reach beyond the usual art world audiences. These artists wanted to make art not only for but *with* those they saw as excluded from the elite world of high art. They called this new form of art 'community art' (or, since it included many different arts, 'community arts') and themselves 'community artists'. As one policy document we shall meet again in Chapter 4 explained, community arts 'defines an approach to creative activity . . . [that] enjoins both artists and local people within their various communities to use appropriate art forms as a means of communication and expression, in a way that critically uses and develops traditional art forms, adapting them to present day needs and developing new forms' (quoted in Kelly 1984: 1). Community artists, the document continues, 'operate in areas of deprivation, using the term "deprivation" to include financial, cultural, environmental or educational deprivation.' For many in the community arts movement, including the authors of this document, theirs was an inherently political movement: 'Community arts proposes the use of art to effect social change and affect social policies and encompasses the expression of political action' (Kelly 1984: 2). In the case of Free Form, their work came to centre on finding collaborative ways of working with those living in impoverished 'communities'—often bleak social housing—on projects to improve their built environment.

The community art movement was not only a British phenomenon. Artists in other European countries, the US and elsewhere were working along similar lines, and there was a good deal of interaction and mutual influence among these artists. My aim in this study, however, is not to provide a history of community art. Rather, I use the history of Free Form to explore some key questions raised by community art's attempt to use visual expertise in more 'democratic' ways. My vantage point is that of an anthropologist, but let me stress at the outset that what I have provided is simply *an* anthropological perspective; in no way is this book a survey of the community art movement as a whole. Rather, I trace the forty-year journey of one organization as it sought to make 'art' not for galleries but for, and with, 'deprived communities'.

One way of seeing the Free Form journey is as a search by artists trained in the fine arts but determined to find ways of using visual expertise different from those laid down in their art school training. The wide range of issues they faced and the techniques they developed in response to specific problems give this reimagining of expertise a relevance that extends beyond both its British setting and its specific concern with the visual. Following the twists and turns of this single organization's attempt to steer a course through shifting artistic and political waters allows us to think through the possibilities and limitations of community art more generally.

A key issue here is that of expertise. Experts and expertise are central to all contemporary industrial societies. Take the built environment, for example. The relevant experts here would include city planners, developers, architects, designers and landscapers, as well as the all-important accountants and other money men. Expertise, however, is not defined simply by the objective possession of particular skills; experts need to be recognized as possessing specific skills. As the Marxist theorist and activist Antonio Gramsci long ago stressed, it is their acknowledgement by the relevant social institutions that gives experts their status *as* experts; experts need to be accredited.[1] Should those claiming any form of expertise begin to distance themselves from the accrediting bodies in their field, they risk losing their standing as experts. This reality, as we shall see, created a dilemma for the community art enterprise, with its rejection of the established art world and its determination to find new ways of including those without recognized visual expertise in the making of artworks.

The authority of the expert in the contemporary world is so pervasive and so taken for granted that it can be difficult to recognize how hard it would be to include nonexperts in any substantive way. To bring this challenge into focus, I want to leave London briefly and travel to a place where individuals had a very different relationship with their built environment.

Many years ago, I did fieldwork in rural Zambia.[2] Those living in what was a rather remote region were, by any standard criteria, incomparably poorer than even the most impoverished Londoner; hunger was a periodic reality for many and for some a daily one. They lived in houses that lacked the basic services—water, electricity, sewage—taken for granted by all Londoners. Nonetheless, as individuals, these rural Zambians controlled their built environment to an extent quite unimaginable in any contemporary British city. Land in this sparsely populated region was considered to belong to the local people as a whole; in theory, and to a great extent in practice, anyone was free to clear a patch of

1. See, for instance, Gramsci 1971: 8–9.
2. See Crehan 1997.

bush and construct a house. As long as an individual could legitimately claim—normally on the basis of kinship—membership in the local group accepted as the owners of the area, the simple clearing of unused bush established the right to build on it. Most houses were simple wattle and daub structures with thatched roofs. The materials needed to construct them—the timber for the framework, the fibres to bind it together, the mud to plaster the walls and floor, the grass for the thatch—all came from the surrounding bush, their cost no more than the time and labour spent collecting them. The building of the timber framework and the thatching of the roof were done by men, who had searched out suitable trees, felled them and prepared the wood, while the collection of grass for the thatching and mud for plastering and, often, the plastering itself were done by women. Some men were known as particularly skilful builders or thatchers, and others might pay these known 'experts' to help them construct their houses, but in general it was assumed that all adults had mastered the basic skills appropriate to their gender. These including knowing which varieties of trees would best withstand the ravages of the termites that ultimately destroyed even the best-built house; being able to spot the individual trees that would furnish strong, straight timbers; knowing the appropriate mix of coarse, robust grasses and fine finishing ones to assemble for the thatch; and being familiar with local sources of mud suitable for plastering. Similarly, the principles of how houses and homesteads should be sited were known to all, as was the proper arrangement of the various buildings within a homestead. The degree of control these rural Zambians exercised over their built environment, as *individuals,* therefore, was of a quite different order from that possible for individuals in any urban society in the global North.

Now, it is clearly quite impossible to go back to anything like this, and I would certainly not want to hold it up as an ideal. We should not romanticize rural poverty. This remote corner of Zambia was not an Eden; it had its own forms of exclusion and its own inequalities. Virtually everyone by the standards of the global North may have been poor, but some people were very definitely poorer than others; women in particular were often only too happy to escape a life of back-breaking labour and move to town, even if this meant surrendering a degree of control over access to certain resources and little more than the exchange of rural for urban poverty. Nonetheless, sharing the lives of these rural Zambians, I was repeatedly struck by the contrast between their extreme poverty and their very real control over their built environment, and by how distant contemporary industrial societies have become from this degree of individual control. The reality is that, as societies become ever more skilled at transforming nature, their collective skill is embodied in an ever-increasing division of labour that inevitably robs individuals within those societies of their everyday basket of knowledge about their environment and the associated practical skills. At the same time, individuals' rights to determine

the shape of their built environment tend to shrink and those of states and governments to expand. We cannot go back; for good or ill, the division of labour in contemporary industrial societies will continue to proliferate. But does this mean that the ordinary 'nonexpert' inhabitants of a city like London, especially those living in its more deprived neighbourhoods, are doomed to be ever more excluded from the shaping of their built environment? Is it possible to imagine mechanisms through which such 'nonexperts' might perhaps be included in genuine, even if small, ways? Are there forms of collaboration, specific techniques perhaps, which could bring experts together with those who may 'know' a lot about where they live but lack formally accredited knowledge? What might such collaborative relationships between 'experts' and 'nonexperts' look like? These are some of the questions I explore through the history of one small arts organization.

The arts organization I focus on provides a particularly interesting context within which to explore these questions, in part because of the very nature of expertise in the domain of 'art'. On the one hand, the evaluation of art is notoriously subjective; one person's masterpiece is another's childish daub. On the other hand, there is an art world whose experts have the power to determine what is and what is not 'good' art—judgements on which the multi-million-dollar art market is based. Such judgements, however, tend to have less sway outside that art world. While it would be wrong to generalize about the aesthetic taste of those living in working-class neighbourhoods, a certain scepticism as to the value of cutting-edge contemporary art seems fairly prevalent. Free Form's forty-year history is a story of artists navigating between different aesthetic worlds. Tracing the intricate windings of this journey, in an ever-shifting political and economic climate, gives us an interesting vantage point from which to observe the hegemonies of the art world and to reflect not only on the nature of visual 'expertise' but on the very category 'art' itself. What kind of 'art', for instance, did the Free Form artists end up producing? How should we see this art as located with the art world? And, viewed from a vantage point outside the art world, what does the story of Free Form tell us about the potential value of expertise in the visual arts for those living in grim, poorly maintained public housing in impoverished neighbourhoods beset by unemployment and all the associated social problems?

In common with other artists who shared their vision, the Free Form artists would come to describe their work in working-class communities as community art. But who or what is the 'community' here? As long as the term 'community' is used merely rhetorically, as it is in the pronouncements of so many politicians and planners, it is not necessary to worry about this, but, for those, like the Free Form artists, trying to carry out projects with real people, this issue is inescapable. A crucial part of the task they had set themselves was establishing the relationships of trust essential if there was to be genuine collaboration between artists and local people. Their experience of working

in poor neighbourhoods meant that the artists could not but recognize that 'communities' are not simple, already-existing entities sitting there waiting to be engaged by those seeking 'community participation'. Tracing the history of the Free Form artists' attempts to devise collaborative aesthetic practices throws an interesting light on the concept of 'community'.

My interest in Free Form goes back a long way. I first came to know of Free Form many years before I began this study. Two of the three founders, Martin Goodrich and Barbara Wheeler-Early, were and are good friends whom I have known for more than forty years. This friendship has its roots in a common intellectual formation at a particular historical moment. Before turning to anthropology, I obtained a degree in fine art. I first met Barbara Wheeler-Early, a fellow student, during my three years at what was then the Manchester College of Art and Design (now part of Manchester Metropolitan University). Although I subsequently found a more permanent home in anthropology, I have always been grateful that I was originally trained to approach the world visually, and at a time, the late 1960s, when arts schools in Britain were extraordinarily exciting places to be. Finally, it seemed, the drab and conformist Britain of the 1950s was cracking open to reveal all manner of new possibilities. Over the years, I kept in touch with Wheeler-Early, by now married to Goodrich, and followed Free Form's development at a distance, while coming to know a number of the other artists working with them. From the beginning, I was intrigued by the organization and its aspirations, but my contact was sporadic, and I had only a vague sense of what they were doing. It was in the 1990s that I came to know the organization better. I was by this time teaching in the States, and, when I went back to London, as I do once or twice a year, I would often stay with Wheeler-Early and Goodrich. Inevitably, I became more familiar with the work they were doing. The more I learned, the more I felt that this was an organization that deserved study.

Once I had begun my study, what effects did those friendships have both on the collection of data and on its writing up? To some extent, having these strong friendships made it easier to negotiate the terms of the study. There had never been a serious study of Free Form, and its founders were very supportive of the idea of their work being recorded. It was always clear, however, that the book I would eventually write would represent *my* understanding of Free Form and that this might be different from their understanding. At the same time, it was possible to give them drafts of what I was writing and to get informed feedback. The primary advantage of studying an organization I knew well and people who were already friends was that it allowed me to achieve a far more profound knowledge of the organization in the course of my study. Inevitably, this kind of closeness to an object of study has dangers, in particular that of overidentification with those being studied, seeing the world too much from their perspective. Achieving the necessary distance was helped, as it so often is in anthropology, by my moving back from London to New York and by my reimmersion into the intellectual world of my fellow anthropologists and other academics.

The book is based on both oral history and participant observation. I began my research in the summer of 2001. Funded by a small Arts Council grant awarded to Free Form to document its history,[3] I spent the summer interviewing people associated with Free Form about its history and its current practice. I followed this up with more interviews during summer trips to London in 2002 and 2003. The major participant-observation element of the study took place from July 2004 to July 2005 during a sabbatical year spent in London. During this time, I selected certain specific projects, which I followed on a day-to-day basis while continuing my interviews. In total, I interviewed sixty-eight individuals, some of whom I interviewed several times. The majority (fifty-three) were artists associated with Free Form (forty-five) or employees not from an arts background (eight), but I also interviewed a number of those who had worked with the organization as members of the 'community' (eight). The remaining seven interviewees included two property developers, two regional arts officers, one community development worker and two people who were active in the early years of community arts. Most of the interviews lasted between one and two hours, although some were considerably longer. Although I had a list of topics I tried to cover, I encouraged my interviewees to talk about anything they thought relevant. During my time in London, I also spent a month working in the Arts Council archives researching the history of community arts in Britain.

The book itself is organized chronologically. The first chapter examines what the Free Form founders were rejecting when they turned away from the gallery world and why they felt it was impossible for them to be the kind of artists they wanted to be within that world. Chapters 2–7 trace out how their initial, rather general, aspiration to use their expertise to reach those normally excluded by the art world was transformed into specific aesthetic practices and artist/community relationships and how this transformation was the result of their practical experience of attempting to make art in working-class neighbourhoods. Chapters 8 and 9 look at what happened to these aesthetic practices and relationships in the face of the new economic and political realities of the post-Thatcher Britain of the early twenty-first century. Drawing on the Free Form story, a concluding chapter comes back to the questions raised in this Preface and reflects on the relationship of community art both to 'art' and to the 'community'.

3. This grant was thanks to Ben Heywood, then the Arts Council officer with responsibility for Free Form, which was still receiving some Arts Council funding at this time. Although, as we shall see, the relationship between the Arts Council and Free Form was strained at times, there were always some individuals within the Arts Council, of whom Heywood was one, who supported Free Form's work.

I: THE REJECTION

–1–

Art Inside and Outside the Gallery

> Students from working-class backgrounds are . . . often saddled with what is known as 'impostor syndrome'. This is a deep-seated sense that the world of culture, particularly so-called 'high-culture', is not for the likes of them, a feeling that at any moment they will be tapped on the shoulder and asked to leave.
>
> —Grayson Perry, artist and Turner Prize winner, quoted in Asthana and Thorpe 2007

The late 1960s were a time of political, social and artistic upheaval in Europe, the United States and beyond. Responding to the general feeling that old ways needed to change, many artists were becoming increasingly uncomfortable with the elitism of the traditional art world and its focus on the creation of gallery art for a privileged few.[1] Among them were three British artists completing their fine-art training: Martin Goodrich, Jim Ives and Barbara Wheeler-Early (see Figs 1–3). All three saw their art school years as profoundly transformative; they were convinced that art has the power to change lives. They were equally convinced that their training had equipped them with particular forms of visual expertise. At the same time, they rejected the conventional model of the gallery artist they were being offered. What they were looking for were different ways of using their expertise: ways of creating art that would bring art's transformative power into the lives of working-class people. The question was how to put this into practice?

One problem was the gulf that seemed to separate the world they inhabited as art students and the world of the working-class people they wanted to reach. On one side stood the creators of gallery art, inhabitants of an art world that seemed to have little interest in reaching out beyond its privileged confines; on the other, working-class people who by and large seemed to regard contemporary art as irrelevant to them and their lives. Goodrich, Ives and Wheeler-Early's search for a bridge across this cultural divide would take

1. Pamela Lee provides an interesting account of New York artists' creation of alternative art spaces in the late 1960s in her study of Gordon Matta-Clark (2001). Grant Kester's study of art created outside conventional galleries and museums (2004) discusses the discomfort with the gallery world felt by many artists in Europe and the United States.

Figure 1 Martin Goodrich, 2009 (photograph and copyright: Kate Goodrich)

them on a forty-year journey which would radically reshape both their artistic practice and their location as artists. This book tells the history of that transformation, focussing particularly on the artists' struggles to find ways of using their visual expertise that would help those living in impoverished neighbourhoods improve their built environment. The name they gave the organization they founded, once it was set up formally as a charity (equivalent to the US nonprofit), was Free Form Arts Trust, and I have termed their aspiration to make art relevant to working-class people the Free Form Project. Uncapitalized, 'Free Form project' or 'projects' refers to the individual pieces of work, commissions and the like that they undertook.

The Free Form Project began as rejection. But what exactly were these artists rejecting? Above all, perhaps, they wanted to escape the gallery world for which their training had prepared them but which to them embodied the very elitism that excluded those they wanted to reach. To understand the nature of their Project and how it developed over time, it is necessary to begin by

Figure 2 Jim Ives, 2009 (photograph and copyright: Kate Goodrich)

looking in some detail at the gallery world they were rejecting, since it was against this world that the Free Form Project took shape.

THE ART WORLD

Both the making of art and its consumption are threaded through with power relations—power relations that make 'art' more accessible to some and less accessible to others. The writings of the art philosopher Arthur Danto, particularly those in which he elaborates the concept of the art world, can help us begin to untangle these threads. Danto's article 'The Artworld',[2] originally published in 1964, is routinely cited by almost anyone writing about the nature of

2. In the original article, 'artworld' is written as one word, but, in later references to it, including those by Danto himself, it has become two words.

6 COMMUNITY ART

Figure 3 Barbara Wheeler-Early, 2009 (photograph and copyright: Kate Goodrich)

'art' as a category. And were we to take the frequency of these citations as our criterion, we might assume that 'art world' is a term that scarcely needs defining. Yet, what Danto himself had in mind has sometimes got a bit lost. It is worth, therefore, spending a little time teasing out his argument.

Danto's original article was prompted by his visit to an early Andy Warhol exhibition featuring Warhol's piece *Brillo Box,* which consists of simple replicas, on a larger scale, of Brillo pad cartons. Confronted with this 'sculpture', Danto asked a philosophical question: what makes something 'art'? His answer is that this is not something inherent in the art object, performance or other product of artistic endeavour itself; whether or not something is defined as 'art' depends rather on how it is seen. 'To see something as art requires something the eye cannot descry—an atmosphere of artistic theory, a knowledge of the history of art: an artworld' (Danto 1964: 580). The fact is that '[W]e cannot readily separate [Warhol's] Brillo cartons from the gallery they are in . . . Outside the gallery, they are pasteboard cartons' (1964: 581).

Danto's argument was taken up by George Dickie, who developed what he called the Institutional Theory of Art. Danto himself, however, has repeatedly expressed his ambivalence towards this development (see, for instance, Danto 1992: 6) and by the mid 1990s felt it necessary to clarify what he had meant by 'the art world':

> I now think that what I wanted to say was this: a knowledge of what other works the given work fits with, a knowledge of what other works makes a given work possible . . . my thought in 'The Art World' was that no one unfamiliar with history or with artistic theory could see these [i.e. Warhol's *Brillo Box*] as art, and hence it was the history and the theory of the object, more than anything palpably visible, that had to be appealed to in order to see them as art. (Danto 1997: 165)

According to Dickie's Institutional Theory of Art, 'works of art are art because of the position they occupy within an institutional context' (Dickie 2001: 52); what makes Warhol's replicas of ordinary Brillo boxes 'art' is the declaration by the art world that they *are* art. Danto's problem with this is that the art world cannot declare just anything to be art. There have to be a set of reasons why Warhol's replica Brillo cartons, Duchamp's urinal and Cage's *4'33"* (four minutes, thirty-three seconds of silence) can be said to qualify as works of 'art', and ultimately it is this linked set of reasons that underpins the concept of the art world. For Danto, 'What is overlooked [in the Institutional Theory of Art] is that the discourse of reasons is what confers the status of art on what would otherwise be mere things, and that the discourse of reasons is the art world construed institutionally' (1992: 40). Given the centrality of this argument to my story of Free Form, I want to turn for a moment from Danto to the curator and art critic Nicolas Bourriaud and his advocacy of what he calls, in his widely cited *Relational Aesthetics,* 'relational art'. Teasing out some of Bourriaud's claims helps clarify Danto's argument and some of its implications.

Relational Aesthetics is concerned with mapping out 'the possibility of a *relational* art', defined as 'an art taking as its theoretical horizon the realm of human interactions and its social context, rather than the assertion of an independent and *private* symbolic space' (Bourriaud 2002: 14, Bourriaud's emphasis). Bourriaud sees this relational art as, above all, based on 'interactive, *user-friendly* and relational concepts' (2002: 8, my emphasis). Relational art for Bourriaud represents the end point of a broad historical trajectory that began with art 'aimed at introducing ways of communicating with the deity', art that 'acted as an interface between human society and the invisible forces governing its movements'. Beginning in the Renaissance, however, 'Art gradually abandoned this goal, and explored the relations existing between Man and the world' (2002: 27). Art has now taken yet another turn, beginning

8 COMMUNITY ART

in the early 1990s; 'artistic practice is now focused on the sphere of inter-human relations . . . the artist sets his sights more and more clearly on the relations that his work will create among his public, and on the invention of models of sociability' (2002: 28). For Bourriaud, 'there is a question we are entitled to ask in front of any aesthetic production: "Does this work permit me to enter into dialogue? Could I exist, and how, in the space it defines?" A form is more or less democratic' (2002: 109). He sees twentieth-century avant-garde art in general as part of an overarching project of modernity, concerned with 'changing culture, attitudes and mentalities, and individual and social living conditions'; the new relational art 'is carrying on this fight, by coming up with perceptive, experimental, critical and *participatory* models' (2002: 12, my emphasis). For Bourriaud, therefore, relational art is potentially more democratic.

He gives us a number of examples of this new relational art, including these:

> Rirkrit Tiravanja organises a dinner in a collector's home, and leaves him all the ingredients required to make a Thaï soup. Philippe Parreno invites a few people to pursue their favourite hobbies on May Day, on a factory assembly line. Vanessa Beecroft dresses some twenty women in the same way, complete with red wig, and the visitor merely gets a glimpse of them through a doorway. Maurizio Cattelan feeds rats on 'Bel Paese' cheese and sells them as multiples, or exhibits recently robbed safes. (2002: 7–8)

My question is: who exactly are the users for whom this work is, as Bourriaud claims, 'user-friendly', who are able to 'participate' in its new 'models of sociability'? It seems to me that in order to appreciate and participate in these works of art—and Bourriaud is clear that they are works of 'art'—it is necessary to have a certain literacy in what defines art nowadays in the global North. Just as with Warhol's Brillo cartons, 'no one unfamiliar with history or with artistic theory could see these as art'. It should be stressed that this says nothing about their quality as art or their user-friendliness among those literate in art world discourse. My point is simply that appreciating them or participating in their models of sociability requires a recognition of them as art, and that requires a certain familiarity with a specific 'discourse of reasons'. We need, as it were, to know the rules of the game.

For Bourriaud, this turn to relational art is profoundly democratic: 'What strikes us in the work of this generation of artists is, first and foremost, the *democratic* concern that informs it' (2002: 57, Bourriaud's emphasis). I am happy to accept that the intent here may be democratic; what I question is: does it in practice translate into new forms of democracy? What form of

literacy is needed to participate in this democracy? It is this second question that Danto clarifies with his concept of the art world as 'a discourse of reasons'. As with Warhol's *Brillo Box,* unless one has some familiarity with this discourse, neither Rirkrit Tiravanja's Thaï soup ingredients nor Maurizio Cattelan's Bel Paese–fed rats are recognizable as art. In subsequent chapters, I shall come back to the question of artistic practice and 'democracy', but for the moment let us return to Danto and his concerns.

Danto has stressed that he is an essentialist, writing, for instance: 'As an essentialist in philosophy, I am committed to the view that art is eternally the same—that there are conditions necessary and sufficient for something to be an artwork, regardless of time and place.' He is also, however, very much a historicist, continuing, '[A]s an historicist I am also committed to the view that what is a work of art at one time cannot be one at another' (1997: 95). The tension between these two convictions can be seen as at the heart of much of Danto's work. It explains, I think, what Denis Dutton has described, rather imperceptively in my view, as 'Arthur Danto's near-obsessional theorizing about indiscernible art/non-art objects, such as Warhol and supermarket Brillo boxes' (Dutton 2000: 232). In the context of this study, what interests me is not so much whether there is some eternal category 'art' beyond the specific names and specific definitions of particular times and places but the much narrower question of how, and by whom, the category 'art' is defined in contemporary Britain and the consequences of such definitions. Putting this in Danto's terms, my basic question might be phrased like this: how does the art world—understood here as a discourse of reasons embodied in a set of institutions and practices—define the space of art at this historical moment, and what power does that definition have?

Danto's approach insists that the question of what art 'is' is not a simple one, refusing, for instance, the easy common sense of theorists like Dutton, for whom,

> From a cross-cultural, transhistorical perspective, art is a vast assemblage of related practices . . . which can be connected in terms of analogies and homologies between all known human societies. The similarities and analogies are not difficult to see in comparing one culture with another, and in fact the anthropological literature leaves no doubt that all cultures have some form of art in a perfectly intelligible Western sense of the term. (2000: 229)

The problem with this insistence on the obviousness of 'art' is that it assumes that the Western sense of the term does indeed describe a universal category, an assumption that, as Danto observes, has more than a whiff of imperialism about it. Danto's reflections on the meaning of the apparent

opening up of the category of art in modern times are directly relevant to certain tensions inherent in the Free Form Project and are worth quoting in full:

> Clement Greenberg has pointed out that 'there has been a broadening of taste in our time in the West, and it is owed in a certain part to the effect of modernist art'. What he neglects to notice is that the broadening has been achieved by treating all art *as if* modernist, so that while it is true that 'we appreciate all sorts of art that we didn't a hundred years ago', that has happened by obliterating as unessential whatever distinguishes exotic from modernist art. Greenberg's assumption is that all art is unchangingly the same—'art remains unchangeable', he stated in another interview. It will 'never be able to take effect *as art* except through quality'. But that means it will work as art to the degree it strikes the eye as visually interesting or excellent in whatever way modernist art does so. This, then, entails a kind of aesthetic imperialism, an expression which may be taken in either or both of two ways: as the imposition of Western aesthetics on world art or, more damaging, as imposing aesthetics itself on art in connection with which quite different values may apply than those which belong to aesthetics as such. So even if aesthetics were as universal as Greenberg believes—and Kant hoped—art may have other aims than aesthetic ones. And hence have criteria of quality other than those defined by aesthetic quality. (1994: 343, Danto's emphasis)

Understanding the kind of challenge something like the Free Form Project represents to the art world requires us not to foreclose analysis by assuming that what art 'is' is obvious and apparent to all and that its value is necessarily synonymous with aesthetic value as defined on the basis of art world criteria laid down by the 'experts', such as Greenberg, who police that world.

The Free Form founders, by virtue of their art school training, could also be considered experts. What was different about them was their commitment to using their expertise in ways that included rather than excluded—as they believed the art world did—working-class people and, moreover, their insistence that this inclusion should be actual and concrete, not merely theoretical. The 'models of sociability' in which they were interested were ones that people living in neglected, problem-ridden social housing would recognize as speaking to them about their problems. Running through the Free Form Project, however, was an inherent aesthetic tension. On the one hand, there are the aesthetic criteria of the world of high art, which the artists had internalized in the course of their traditional fine-art training. From this aesthetic standpoint, the commoditized, mass-produced visual languages of popular culture and working-class life tend to appear sentimental and banal—two of the greatest sins in the eyes of the cultural elite. To be acceptable, such languages must be used ironically. On the other hand, to the working-class people the Free Form artists wanted to reach, the aesthetic language of the art world is often

not only unintelligible but oppressive. Indeed, contemporary visual art seems to have a peculiarly powerful ability to enrage, especially perhaps in Britain. The response to a devastating fire in 2004 at a London warehouse rented by Momart, a major art storage company, reveals a lot about popular attitudes to contemporary art in Britain.

The fire destroyed hundreds of works by leading British artists of the past fifty years with an estimated monetary value of £50m to £60m. An article by James Meek (2004) in the upmarket *Guardian* newspaper four months later describes the different media responses. For Meek, the fire was a tragedy, and what was lost 'was a store of 20th-century British art, the size, breadth and richness of which no private collector has rivalled'.[3] Many in the media, however, actually seemed to celebrate the loss. The destruction of a number of works by members of the Young British Artists (YBA) group owned by the collector Charles Saatchi was greeted with particular glee. In 2004, the YBA, who include the artists Tracey Emin, Damien Hirst and the Chapman brothers, were often seen, particularly in the popular press, as embodying contemporary British art. After the fire, in Meek's words, 'A virtual mob of journalists, pundits, radio phone-in callers, letter-writers and vox poppers declared in one way or another that the Momart loss was Britain's gain. Whoever set the building alight, they implied, was an artist at least on a par with any of the creators in the Saatchi collection.' Emin's 'Everyone I Have Ever Slept With 1963–1995', a tent embroidered with the names that gave the work its title, seemed to be a particular focus for ridicule. The tabloids, more likely to be read by those the Free Form artists wanted to reach than broadsheets like the *Guardian,* could scarcely contain themselves. Meek quotes a *Daily Mirror* columnist who wrote, 'Can a fire ever be funny? Only if all the overpriced, over-discussed trash that we have had rammed down our throats in recent years by these ageing enfant terribles is consumed by the fire. Then the fire is not merely funny . . . it is bloody hilarious.' In the *Daily Mail,* another tabloid but slightly upmarket of the *Daily Mirror,* one Godfrey Barker asked rhetorically: 'Didn't millions cheer as this "rubbish" went up in flames?' The reaction to the Momart fire seems to me to capture in a very vivid way the baffled outrage that is such a common response to much contemporary art. But why this visceral hatred? To begin to understand this, we need to look a little more closely at that apparently simple term 'art'.

ART WITH A CAPITAL A

The meaning of the term 'art' is often taken to be so self-evident that no one but a tedious pedant would worry about it. In a book that sets out to answer

3. This and subsequent quotes are from Meek 2004.

the question 'what is art?', for instance, the philosopher Nigel Warburton writes: 'Answering the question about why some people have used the word "art" in certain ways, applying it to some cases but not others, is probably of most interest to anthropologists' (2003: 126). As an anthropologist, I do indeed find this question interesting, particularly in the context of a study of artists who turned their backs on the world of gallery art. Anthropology as a discipline may have arisen out of the colonizing global North's concern to understand the unfamiliar worlds with which it was coming into contact—all too often with a view to their domination—but at least it has taken those other worlds seriously and genuinely tried to understand how things might look from perspectives other than those of the hegemonic North. And, from such a vantage point, certain categories, such as art, which in the North are taken as timeless and universal, begin to look rather parochial and limiting. The anthropologists George Marcus and Fred Myers, for instance, stress that 'the commonsense category of "art"—transcendent, referring to a sphere of "beauty" external to utilitarian interests, and signifying principally painting, sculpture, and music—would not be universally applicable to human aesthetic activity' (Marcus and Myers 1995: 6). As Alfred Gell, who explored the ethnocentrism of Northern definitions of art and its significance for the anthropology of art in particularly interesting ways,[4] nicely puts it, 'the attitude of the art-loving public towards the contents of the National Gallery, the Museum of Mankind, and so on (aesthetic awe bordering on the religious) is an unredeemably ethnocentric attitude, however laudable in all other respects' (Gell 1992: 40).

Anthropology's origins in a concern to understand cultural worlds other than those of the West (or, in the currently favoured terminology, the global North) and its formation around the study of the 'primitive' have shaped its approach to the study of 'art'. In general, anthropologists have focussed on the indigenous art of the global South, and, while many anthropologists have looked at how such art has entered the commodity circuits of global art markets, few have turned their attention to the art of the global North.[5] It is telling that a 2006 reader, *The Anthropology of Art,* which claims on its back cover to provide 'a single-volume overview of the essential theoretical debates in the anthropology of art' (Morphy and Perkins), contains no readings on Northern art. In their 1995 volume *The Traffic in Culture: Refiguring Art and Anthropology* Marcus and Myers are concerned to address this absence, calling in their

4. See, for instance, Gell 1992, 1995 and 1998.

5. Three significant contributions to the literature on indigenous art and the global art market are Myers 2003, Steiner 1994 and Phillips and Steiner 1999. Plattner 1998 and Savšek 2007 are two of the very few anthropological monographs to focus on art of the global North.

Introduction for 'critical ethnographic studies of contemporary art worlds' (1995: 27).

To some extent, my study of one small arts organization could be seen as such a study. Adopting a critical ethnographic approach, I trace out the alternative aesthetic practices of a group of artists who explicitly rejected the powerful gallery-based art world. Their struggle to create alternative aesthetic practices and relations with their 'public' turns out to be a revealing vantage point from which to observe some of the fundamental power relations underpinning the hegemonic art world of the global North; a view from the shadows can sometimes reveal more than one from the heights of power. The general lack of anthropological studies of contemporary art worlds has meant, however, that, with a few notable exceptions such as Gell, there was little in the way of an anthropological literature for me to draw on in telling the Free Form story. In general, outside the discipline of anthropology, the various literatures on 'art', whether that of aesthetics, art history or sociology, tend to take it for granted that 'art' has existed throughout human history and is to be found, in one form or another, in all human societies. Some historians of art and aesthetics, however, have argued against this, and it is these historians particularly Paul Kristeller and Martha Woodmansee, whom I have found most useful in my attempts to map the Free Form journey.

It is now more than half a century since Kristeller wrote his much-cited article 'The Modern System of the Arts', in which he argues that the modern commonsense understanding of art did not exist before the eighteenth century: 'the term "Art", with a capital A and in its modern sense, and the related term "Fine Arts" (Beaux Arts) originated in all probability in the eighteenth century' (Kristeller 1990a: 164). Kristeller sums up the main characteristics of this commonsense notion of 'the arts' as follows:

> The basic notion that the five 'major arts' [painting, sculpture, architecture, music and poetry] constitute an area all by themselves, clearly separated by common characteristics from the crafts, the sciences and other human activities, has been taken for granted by most writers on aesthetics from Kant to the present day . . . and it is accepted as a matter of course by the general public of amateurs who assign to 'Art' with a capital A that ever narrowing area of modern life which is not occupied by science, religion, or practical pursuits. (1990a: 165)

This Euro-American understanding of 'Art' did not, of course, emerge suddenly and fully formed; as Kristeller goes on to note, 'it has many ingredients that go back to classical, medieval and Renaissance thought.' The story of the rise in prestige of painting and the other visual arts, beginning in Italy with Cimabue and Giotto, for instance, is well known. And an important part of that story is a new distinction that emerges in the sixteenth century between the

three visual arts, painting, sculpture and architecture, and the crafts. The formulation of this distinction owes much to Giorgio Vasari, who used this clustering of the arts of painting, sculpture and architecture (for which he coined the term *Arti del designo*) to structure his celebrated *Lives of the Artists*. *Arti del designo* is identified by Kristeller as the probable origin of the term 'Fine Arts'. Vasari was also the guiding influence behind an important institutional expression of this new separation, the creation, in 1563, of an Academy of Art (*Accademia del Designo*) by Florence's painters, sculptors and architects that explicitly severed their long-standing connections with the craftsmen's guilds. Nonetheless, Kristeller argues, it is only in the eighteenth century that the various ingredients finally come together in the fully coherent form of a particular set of the arts, related in specific ways and occupying a particular place 'in the general framework of Western culture' (1990a: 165).

Judging from the regularity with which it is cited and its many reprintings, we might assume that Kristeller's thesis is now generally accepted. Interestingly, however, this acceptance seems to have left undisturbed the basic assumption that 'art' *is* universal. As the aesthetic historian Martha Woodmansee puts it in her study of the links between the emergence of a market for literary works in Germany and the modern notion of art, philosophers of art 'are given to citing or alluding to Kristeller's article approvingly and then proceeding to operate as if "art" were timeless and universal' (1994: 3–4). There is, it would seem, a largely implicit, commonsense understanding of art which—in part because it is implicit—is extraordinarily hard to dislodge.

One of the central assumptions of this commonsense understanding of art or, rather, Art with a capital A is, first, that the greatest Art is the product of *individual* geniuses and, second, that true geniuses follow no dictates other than those of their own genius; Art produced to order is immediately suspect. In a 1945 broadcast, John Maynard Keynes, at the time the chair of the newly established Council for the Encouragement of Music and the Arts (CEMA, the forerunner of Britain's Arts Council),[6] summed up the conventional view of the genuine, free-spirited, artist:

> [E]veryone, I fancy, recognises that the work of the artist in all its aspects is, of its nature, individual and free, undisciplined, unregimented, uncontrolled. The artist walks where the breath of the spirit blows him. He cannot be told his direction; he does not know it himself. But he leads the rest of us into fresh pastures and teaches us to love and to enjoy what we often begin by rejecting, enlarging our sensitivity and purifying our instincts. (quoted in Skidelsky 2001: 294)

6. Over time, the organization has undergone other names changes. Currently (2010), it is Arts Council England. In general, I refer to it throughout as the Arts Council.

Keynes's stress on the artist as individual genius was echoed more recently by the artist Christo, who, together with his wife, Jeanne-Claude, has created huge public artworks that, as the artist and art theorist Suzi Gablik has noted, 'require the participation and cooperation of thousands of people' (1995: 78). Christo himself, however, insists on the individual origin of his artworks:

> The work of art is irrational and perhaps irresponsible. Nobody needs it. The work is a huge individualistic gesture that is entirely decided by me . . . One of the greatest contributions of modern art is the notion of individualism . . . I think the artist can do anything he wants to. That is why I would never accept a commission . . . The work of art is a scream of freedom. (Quoted in Gablik 1995: 78)

Many years later, Christopher Cornford, at the time Rector of the Royal College of Art, would also stress the centrality of the *individual* creator, as Michael Hecht, a former academic who worked with Free Form for a number of years, recalled when I interviewed him. Cornford explained to Hecht why he could not take Free Form's work seriously as Art: 'When I stand in front of a Rembrandt, I have an absolute guarantee that this is the work of one mind, one man, one artist, but yours is all sorts of people.'

The figure of the lone artist with sole responsibility for his individual creations—only relatively recently, particularly in the visual arts, has it begun to be noticed that there have been some female artists—is very much a product of Romantic thinking, Romanticism and the modern concept of Art with a capital A having arrived at much the same historical moment. This stress on the individual is linked in complex ways to the increasing importance of the market and to the needs of those producing Art within the context of a market, rather than within a system structured by patronage.[7] One of the effects of this shift is the claim—in part in reaction to an economic system organized around the production of commodities—that art inhabits a distinct domain free from the crassness of the marketplace; according to this view, Art is, or should be, concerned with higher things than mere utility. This idea has become firmly entrenched in commonsense understandings of Art.

Kristeller describes the changes in the social location of the artist underpinning the elevation of art to Art, as he, and occasionally she, came increasingly to depend on an art market, rather than an individual patron:

> The social position of the artist underwent a profound change after the middle of the eighteenth century. He gradually lost the patronage of the Church and the state, of the aristocracy and patriciate that had sustained him for centuries, and

7. Woodmansee's *The Author, Art, and the Market* (1994) explores this in the context of literature.

found himself confronted with an anonymous, amorphous, and frequently uneducated public which he often despised and which he would either flatter with a bad conscience or openly defy, claiming that it was the public's duty to approve and support the artist even when it could not understand or appreciate the products of the artist's unbridled self-expression. (1990b: 250–1)

Interestingly, according to Kristeller, examples of that powerful contemporary marker of true genius, being unrecognized in one's own time, were 'something rarely heard of before the nineteenth century'.[8] It is in the context of the shift from a patronage to a market system that the Romantic notion of the 'genius' emerges. The true artist, according to this notion, does not produce to order. Rejecting the judgement of the ignorant multitude who scorn him, he listens only to his muse. The Art he produces is most definitely not a commodity (a good or service produced to be sold, its value inextricably linked to its price in the marketplace).[9] Art here is seen, as it were, as the negative of the commodity, imagined (like the affections of the human heart) as inhabiting its own noncommoditized realm beyond the heartless marketplace where money rules. Works of Art come to be seen as transcendent goods that ideally should not be bought and sold. If they do enter the marketplace—since, regrettably, we live in a world in which Art *is* bought and sold—their *real* value continues to be imagined as that which cannot be expressed in crude money terms.

The problem here is that human activities almost always require material resources in some form or another. The production and consumption of art, with or without a capital A, simply cannot be isolated from the rest of the economic system.[10] Its producers need to make a living in some way or other, and this requires that they have access to some part of the social product. However transcendent works of art may be, their making does not happen outside economic relations. The consumption of art, too, demands resources. There need to be museums, galleries, cinemas and theatres for the consumers of art objects, films and plays. Even the increasingly privatized contemporary world of consumption in the home, and now via the even more individualized iPod, requires its own technology and certain conditions for its consumption. Significantly, access to most recognized forms of high art involves both money and time. Ignoring the reality that people's encounters with art are always deeply embedded in the specificities of particular forms of consumption in given times and places leaves us with what Pierre Bourdieu described as 'the

8. Woodmansee 1994 provides a persuasive elaboration of this argument.
9. See Marx's classic discussion of the character of the commodity in *Capital*, vol. 1 (Marx 1976: 125–77)
10. Sarah Thornton's *Seven Days in the Art World* (2008) is a journalist's vivid account of the contemporary art market and its inescapability for artists.

miracle of unequal class distribution of the capacity for inspired encounters with works of art and high culture in general' (Bourdieu 1984: 29). How is it that the more privileged members of society seem to seek out and respond to high culture in such greater numbers than the less privileged? Understanding this 'miracle', as Bourdieu's own tour de force, *Distinction,* maps out, demands that we pay careful attention to the material reality of consumption and to the particular social nexus in which it takes place.

It is not that a working-class teenage boy who has never been to a live theatre production and who finds himself at a Shakespeare play at the National Theatre cannot have an 'inspired encounter'; indeed, the memoirs of high achievers from poor backgrounds are full of such stories. Neither would I want to claim that people's responses to different forms of culture are determined by their economic, social or ethnic location. Nonetheless, a working-class teenager's experience is likely to be different from that of a middle-class professional, a regular visitor to the National Theatre, Covent Garden and other temples of high culture, who has seen many productions of many Shakespeare plays. And this is in part because the basic relationship of these two individuals to such cultural institutions is different. The middle-class professional is likely to feel completely at home in them, while the working-class teenager may well feel, as Grayson Perry put it, 'that at any moment they will be tapped on the shoulder and asked to leave' (quoted in Asthana and Thorpe 2007). And if the middle-class professional has been socialized into approaching Shakespeare with an 'aesthetic awe bordering on the religious' that sees him as representing one of the most profound expressions of the human condition, to the working-class teenager this whole world of classical theatre, which involves so much more than simply Shakespeare's text, may seem not only alien but actually oppressive, embodying the power of a cultural elite.

It is not that there is something irredeemably alien about Shakespeare for that working-class teenager but rather that 'inspired encounters with works of art' usually depend on a certain familiarity with the art in question and a knowledge of its conventions—a knowledge that the more privileged are likely to have internalized, just as they have the basic grammatical rules of their mother tongue. In other words, they are no longer even conscious of the rules they are applying. Those denied the opportunity to acquire literacy in high culture at an early age—when learning any language is so much easier—are certainly able to acquire it later, but it is likely to be more of a struggle and to require more conscious effort. Gramsci's comment on the advantages that certain children have when they enter school is relevant here:

> In a whole series of families, especially in the intellectual strata, the children find in their family life a preparation, a prolongation and a completion of school life;

they 'breathe in', as the expression goes, a whole quantity of notions and attitudes which facilitate the educational process properly speaking. (1971: 31)

The reality that enjoying and 'owning' an art experience depends on having 'breathed in' or otherwise become familiar with its rules and conventions can be extended to many other fields. In the case of sport, for example, the response of a middle-class, middle-aged professional woman and a working-class teenage boy to what has been called 'the beautiful game', football (soccer in the USA), might well be exactly the reverse of their experience of the Shakespeare play. The unathletic female professional who grew up at a time when football in Britain was most definitely a male activity and who has never been able to grasp the off-side rule might well feel bored and even uncomfortable at a football match, while, for the teenage boy, who himself plays football at school or with his friends and knows all the players and their histories on and off the field, this is *his* team and *his* game. And, whether it is Shakespeare or football, both the thing itself and the informed discussions of aficionados with their arcane details can seem dryly pedantic and alienating to those who do not share their enthusiasm and have not acquired a basic literacy in that particular language. There is an important difference here, however, in that Shakespeare lovers have the weight of cultural authority on their side. There are reasons why no one ever seems to suggest that there should be special programs to introduce professional women to the cultural richness of football. And those reasons have to do with what we might, drawing on Gramsci and his concept of hegemony, term the hegemony of the world of high culture and its aesthetic criteria. It is these criteria that structure the art world as, in Danto's term, a discourse of reasons.

THE ART WORLD AND COMMON SENSE

The art world has enormous power; it defines what counts as art, what does not and what makes some art good and some bad. Danto has coined the nice term 'the curatoriat' to refer to those in the art world whose pronouncements on art matters are considered authoritative (Danto 1997: 181). Not that this world is in any sense monolithic, with a single definition of what counts as art or what makes art good. The art world can accommodate many different and indeed conflicting and contradictory accounts of what constitutes art, as well as many different criteria by which to distinguish good from bad artworks. These narratives also change over time, with certain historical moments marking profound shifts, as when modernism supplants the art of the academies. Nonetheless, at any given time, it is possible to identify certain hegemonic or dominant assumptions that underpin the art world's definitions of 'good' art. Equally, however, and this is a crucial point in the context of the Free Form

story, the dominant narratives expounded by the curatoriat are not the only ones out there. Entangled with them, often in very complex ways, are other understandings of art and what makes it 'good'—understandings embedded in the world of popular culture and common sense. Gramsci's notion of common sense can help us tease out the character of these alternative understandings of art and some of their implications.[11]

For Gramsci, common sense (which does not have the same connotations of down-to-earth, practical good sense in Italian as it does in English) is that hodgepodge of accepted ideas to be found in any given milieu which those who grow up in that milieu absorb unthinkingly through a kind of osmosis so that they appear simply to reflect the way the world is. The power of common sense is that it is 'knowledge' we inhabit; the common sense of our particular time and place is so deeply embedded in who we are that it is almost impossible for us to disinter its assumptions about the world and see them as indeed assumptions rather than facts. Commonsense assumptions do not have to be proved; rather, they are what we appeal to as evidence for our arguments. It is this kind of argument that Dutton is making, for example, when he claims, in the passage quoted earlier, that 'in fact the anthropological literature leaves no doubt that all cultures have some form of art in a perfectly intelligible Western sense of the term'.

A key point is that common sense represents not a systematic or internally coherent understanding of 'how things are' but rather assemblages of disparate bits and pieces that have accumulated over time. There are undoubtedly reasons why particular notions persist over time, but there is also a randomness to what finds a home within this jumble. The process is something like the way history deposits strata of material debris on sites of human habitation. In the following passage, Gramsci describes the relationship between common sense and philosophy. Substituting art theory here for philosophy and science gives us a useful starting point for thinking about the relationship between elite and popular understandings of 'art':

> Every philosophical current leaves behind a sedimentation of 'common sense': this is the document of its historical effectiveness. Common sense is not something rigid and immobile, but is continually transforming itself, enriching itself with scientific ideas and with philosophical opinions which have entered ordinary life. 'Common sense' is the folklore of philosophy, and is always half-way between folklore properly speaking and the philosophy, science, and economics of the

11. 'Common sense' is one of Gramsci's key concepts, and he uses it in many of the Notes in the prison notebooks. See, for instance, Gramsci 1971: 323–3 and 419–25.

specialists. Common sense creates the folklore of the future, that is as a relatively rigid phase of popular knowledge at a given place and time. (1971: 326)

It is important to recognize the links between high art theories and commonsense (in Gramscian terms) understandings of art and to remember that both are part of the art world. However exclusive and elitist the museum and gallery world may be, it is not in reality separate and cut off from the world of popular art. When someone is thinking of buying a picture at the local shopping mall to decorate a living room, that person will evaluate it according to his or her assumptions (whether explicit or implicit) about what makes paintings 'good'. And these assumptions are likely to draw on elements of art theories that 'have entered ordinary life'. In contemporary Britain, virtually everyone has had some exposure to the art world, whether through a school trip to an art gallery, Sister Wendy or some other pundit explaining the old masters on television, or images used in advertisements. Most people, for instance, probably know the name *Mona Lisa* and have at least a vague awareness that this is supposed to be one of the great—perhaps the greatest—painting ever painted.[12] In reality, the heterogeneous bundle of rules and beliefs about art that have entrenched themselves at the level of common sense and that for the curatoriat demonstrate the problem with popular taste—as exemplified, for instance, by the schadenfreude that greeted the Momart fire—reflects in some form or other criteria laid down by earlier generations of art theorists. It is worth noting that Bourriaud's stress on the 'user-friendliness' of the new relational art (quoted earlier) ignores the reality that such art tends to challenge deeply held commonsense beliefs as to what constitutes 'art'.

However far apart in their taste, the shopper in the mall and the mandarins who pronounce so authoritatively on high art both tend to take it for granted that there is a category Art with a capital A, which is, as Kristeller puts it in one of the passages quoted above, 'clearly separated by common characteristics from the crafts, the sciences and other human activities'. Where the curatoriat and the popular world of common sense part company is in their understanding of what makes a work 'good' or 'bad'. On the one hand, we have Kenneth Clark, who defined 'civilization' for a generation with his late-1960s television series of that name, writing: 'Popular taste is bad taste, as any honest man with experience will agree' (1977: 178); on the other hand, common sense pronounces its well-known judgement on being confronted with a Picasso: 'My child could do that.' We can see this commonsense attitude in the responses to the Momart fire, as for instance, when the *Daily Mail* claimed,

12. See Donald Sassoon, *Becoming Mona Lisa: The Making of a Global Icon*, for an account of how the *Mona Lisa* became the global icon it is today.

'In the space of an afternoon, using techniques gleaned from the Blue Peter[13] school of art, we knocked up a replica of the love tent [i.e. Emin's destroyed piece] and the names it contained. The result was a work, you may think, which is indistinguishable from the real thing' (Meek 2004). It is worth noting that the judgement of the curatoriat and that of common sense share the assumption that, whether for the consumer or the producer of art, 'good' art is difficult. For the expert, 'good' art should be challenging; art that is too easy to like is immediately suspect. The nonexpert, in contrast, wants to see clear evidence of skill on the part of the artist: 'This is something my child most definitely could *not* do.'

Where hegemony comes in is in the very different weight these judgements have. If the art world is, as Danto claims, a particular 'discourse of reasons institutionalized', those who produce this discourse are the experts entrusted by society with the task of classifying and explaining art: the art critics and theorists, those who teach in arts schools, and the artists themselves, who through their practice define art. Crucially, the judgements of the curatoriat to a large extent determine value in the art market. It is their undeniable power to confer value, coupled with their palpable disdain for the judgement of 'the common man', it seems to me, that helps to explain the visceral anger of the tabloids' 'commonsense' response to the Momart fire. Gramsci writes about those who occupy the lower slopes of the social pyramid, those who are oppressed rather than oppressors, always being 'subject to the initiatives of the dominant classes, even when they rebel; they are in a state of anxious defense' (1996: 21). And anxious defensiveness, I think, captures a particular kind of hostility to high art that runs through many commonsense attitudes to 'art'. It is not that common sense has its own, coherent, counterhegemonic account of art. What it does have is a cluster of assumptions about what makes art 'good', coupled with a stubborn resistance to the dictates of the art world hegemony and its ability to confer value.

It is not, therefore, that the art world represents some separate, bounded space. We could say that no one who lives in the global North is outside the art world; rather, people inhabit it in different ways and occupy different power positions within it. Even the well-known cliché 'I don't know anything about art but I know what I like', for instance, combines the assertion of the right to judge with an acknowledgement of a lack of expert knowledge. Although we should not take the metaphor too far, the art world can be seen as constituting something like a playing field on which a particular game can be played: those who refuse to play by the agreed rules of that game are not

13. *Blue Peter* is a long-running children's show on British television that for many conjures up images of presenters making crude craft objects out of everyday household objects, such as egg cartons and cardboard tubes.

only guaranteed to lose but are liable to be sent off the pitch. They may be free to continue the game elsewhere but are not likely to be provided with the carefully prepared grounds and the well-appointed stadiums available to recognized players. And neither are they likely to attract the same number of paying spectators. This, as we shall see, was a recurrent dilemma for the Free Form artists.

I began my discussion of the term 'art' by drawing attention to the specificity of the Northern category 'art'. It is not that I wish to question or deny the importance and value of Art with a capital A. I simply want to draw attention to the possibility that there are other forms of human creativity and expressiveness, which risk being dismissed, by both art world experts and the lay public alike, as bad or failed art because they do not conform to the model of Art with a capital A. Anthropologists and others have long complained of the inadequacy of Northern aesthetic categories when confronted with apparent 'art' objects produced outside the North, but, as Gell notes, these categories are problematic even within the North: 'Western categories of (generic) "art works" are inadequate to the task of identifying aesthetic practices even in western societies—including, as they do, the products of every obsolete Sunday painter, but excluding those of the imaginative gardener, home decorator, or budgerigar-breeder' (1995: 21). I shall come back to this point in subsequent chapters.

CHARGES AND BRIEFS

What I am calling the Free Form Project: the determination of the Free Form founders to make art relevant to working-class people, forced Goodrich, Ives and Wheeler-Early to challenge the aesthetic categories and associated aesthetic practices on which their art school education had been based. It was through their experience of trying to make art with working-class people in working-class neighbourhoods that their initial aspiration began to assume a concrete form; gradually, faced with the realities of those neighbourhoods, they developed new collaborative ways of working—ways of working grounded in relationships between artist and 'public' very different from those of traditional fine artists. The next six chapters trace out the development of this different way of making art and the character of its aesthetic practices. To help in this mapping, I am using two concepts, 'Charge' and 'Brief', taken from the art historian Michael Baxandall's *Patterns of Intention: On the Historical Explanation of Pictures* (1985). *Patterns of Intention* approaches individual paintings as solutions to problems. Adopting this approach, we can see the Free Form Project as a problem Goodrich, Ives and Wheeler-Early had set themselves.

'Charge' and 'Brief' are Baxandall's terms for the essential elements that define the problem a particular painting represents for its painter. The Charge is the broad task that the artist is set (whether artists set this themselves or are commissioned); the Brief is the specifics into which the Charge translates in a given context. Baxandall clarifies this with an example of something that most people would not think of as a work of art, that classic monument of Victorian engineering, the Forth Bridge, which spans the Firth of Forth. On being asked to design the bridge, Baker, the bridge's architect, was, in Baxandall's words, 'given a very general charge within which to act: "Bridge!"' (1985: 29). Contained within this general Charge, Baxandall notes, is 'a more specific *brief* for Queensferry [the chosen crossing point]'. He then clarifies what exactly constitutes the Brief: 'The Charge of "Bridge!" embodies parts like "span" and "provide a way" and "stand without falling". What I shall call the Brief consists of local conditions in the special case' (1985: 30; here and in the following quotation, the emphasis is Baxandall's). The specific conditions here were such factors as the silted and deep nature of the Firth of Forth, the need for the bridge to withstand the powerful local side winds and the importance of the bridge not hampering shipping traffic in a busy waterway. What was actually produced, the Forth Bridge itself, can be seen as a solution to a specific problem: how, using available technology, to construct a bridge over this particular estuary. 'Together Charge and Brief seemed to constitute a *problem* to which we might see the bridge as a solution' (1985: 35).

Baxandall goes on to use the concepts of Charge and Brief to discuss three paintings, a Picasso, a Chardin and a Piero della Francesca. His approach is particularly valuable in that it explores how these three paintings are linked to the circumstances of their making while avoiding a facile determinism. Taking the case of Picasso's *Portrait of Kahnweiler,* Baxandall asks:

> who set Picasso's Charge—he had no Forth Bridge Company—and Brief for the Portrait of Kahnweiler? A preliminary half-answer would be that Picasso at least formulated his own. The painter registers his individuality very much by his particular perception of the circumstances he must address. Indeed if one is to think of a painter 'expressing himself', it is most of all here, in the analysis of his environment . . . that one can most securely locate an individuality. (1985: 46–7)

John Richardson's biography of Picasso documents exhaustively how the painter saw himself as continually engaged in struggle with the painters of the past. Late in his life, when Picasso had long ascended into the pantheon of acknowledged geniuses, he still saw himself as engaged in this struggle, remarking: 'I have a feeling that Delacroix, Giotto, Tintoretto, El Greco and the rest, as well as all the modern painters, the good and the bad, the abstract

and the non-abstract are all standing behind me watching me at work' (quoted in Campbell 2009: 36). We can see Picasso's general Charge as the challenge all these other painters, living and dead, presented him. The specific Brief Picasso gave himself in the case of the *Portrait of Kahnweiler* was a particular set of problems he had selected from the general challenge of how to represent an ever-moving, three-dimensional world in a static, two-dimensional form—problems he was interested in at that moment in his development as a painter. Key to understanding any painting, Baxandall suggests, is the relationship between the painter and the context within which the painting was created. However innovative and self-directed Picasso may have been, he constructed his Brief 'as a social being in cultural circumstances' (1985: 47) The Free Form Project may have involved a very different Charge to that of a quintessential art world insider such as Picasso, but Baxandall's concepts of Charge and Brief can still help us make sense of the Free Form artists' journey. We could see the initial Charge these artists gave themselves as: 'Make art that speaks to working-class people!' And, as we shall see, their attempts to fulfil this Charge in the context of specific Briefs[14] would lead them ever further from the world of gallery art and the aesthetic practices of traditional fine artists. Baxandall's approach is particularly useful in its insistence that artists, whatever form their creativity takes, are always in dialogue with their societies, and it is out of this dialogue that their artworks are born.

Understanding the precise nature of that dialogue, as the analyses in *Patterns of Intention* demonstrate, demands that we engage in careful, empirical analysis. The next six chapters trace out how the Free Form Project gradually took shape as a set of concrete aesthetic practices and social relationships as the artists grappled with a series of specific Briefs. While not all the 'experts' who feature in the Free Form story were trained as fine artists, the aesthetic heart of the Free Form Project remained rooted in the visual arts, and, partly for the sake of simplicity, I use the general term 'artist' to refer to all the Free Form workers. I do, however, note the specific training of different individuals when these individuals are introduced. Clearly, the remembrances of these Free Form artists cannot be taken as completely objective or totally accurate. I was able to do a certain amount of cross-checking, since I heard a number of different accounts of the same events and also had access to Free Form's own archival documents. Another valuable source was the Arts Council archives, which have a number of files on Free Form. Finally, even though I was not closely involved, there are my own memories of Free Form's early days.

14. I capitalize Brief whenever I am using it in Baxandall's sense and use lowercase when 'brief' simply refers to the formal specifications of a particular commission.

It remains true, however, that my main source for the early years is interviews, conducted early in the twenty-first century, with people about events that happened many years ago. In essence, the story I tell is the coming into being and consolidation of the Free Form Project as this has coalesced into a particular narrative, or series of narratives, in the memories of its pioneers. What I think these narratives do reflect reasonably accurately is the general aspiration behind the Project and the broad outline of how this assumed a concrete form. And it is this that particularly interests me. This is also why I have relied so heavily on the accounts of Free Form's three founders, Goodrich, Ives and Wheeler-Early. In general I have attempted to let the artists tell the story of this process in their own words, while providing my own gloss and commentary. My hope is that this somewhat dialogic account will make it easier for the reader to become a participant in this conversation.

II: THE SHAPING

–2–

Moving beyond the Gallery

[T]he historical personality of an individual philosopher is also given by the active relationship which exists between him and the cultural environment he is proposing to modify. The environment reacts back on the philosopher and imposes on him a continual process of self-criticism. It is his 'teacher'.

—Antonio Gramsci 1971: 350

BEGINNINGS

Goodrich, Ives and Wheeler-Early met as students at Walthamstow College of Art in the 1960s. From Walthamstow, Goodrich went on to the Royal College of Art (RCA), graduating in 1968; Ives to the Royal Academy Schools, receiving his degree in 1970; and Wheeler-Early to Manchester College of Art (now part of Manchester Metropolitan University) and then Goldsmiths College, from which she graduated in 1973. Art schools in 1960s Britain were exciting places to be. They seemed—particularly to their students—to be at the very heart of the cultural revolution that was transforming so much of the old staid and conformist postwar Britain.

For their part, Goodrich, Ives and Wheeler-Early all felt that their fine-art training had opened up not only new ways of seeing the world but new ways of being in the world, and they embraced the idea of art as emancipatory. At the same time they were profoundly uncomfortable with what they saw as the art world's inherent elitism. While they were passionately committed to being artists and convinced that their training had given them valuable visual expertise, they did not want to be conventional fine artists: they were in search of new ways of using their skills. But how to be an artist outside the gallery; how could they use their artistic expertise in a way that would earn them a living outside the gallery system? The reality is that 'expertise' does not simply mean a given bundle of skills and knowledge: those skills and knowledge have to be socially recognized. In the case of visual artists, the necessary social recognition is provided by the curatoriat and the art world institutions that the curatoriat represents. Art-school training is the first step, but continuing validation by the curatoriat is also necessary. The creation of experts is in fact best thought of not as a single event but as a process, embedded in

social relationships, that produces and locates experts according to certain formal and informal rules. If an artist wants to be accepted as a bona fide, serious artist, it is dangerous to stray too far from the dominant institutions of the art world.

Baxandall's approach, with its concepts of Charge and Brief, is helpful in that it directs our attention to the relationships in which artistic expertise is embedded, reminding us that both the problems artists define for themselves, and the solutions they devise, emerge in particular social contexts. And that those social contexts are populated by people who are the product of their time and place. No one commissioned Goodrich, Ives and Wheeler-Early to make art outside the gallery. They themselves, as social beings at a particular historical moment, defined gallery art with its privileged consumers, as a problem they had to address if they were to be the kind of artists they aspired to be. They were certainly not alone in seeing the gallery as a problem; many artists in both Europe and the United States were seeking to move beyond the gallery. What was unusual about the Free Form founders, though certainly not unique, was the priority they gave to making art with and for working-class people, and their willingness ultimately to sacrifice legitimacy within the gallery world if that was what fulfilling their Charge required.

But what kind of art did the Free Form founders' rejection of the traditional gallery path lead to? Let me begin with what it was not. It was not what the philosopher Jacques Rancière terms 'critical art', that is, 'a type of art that sets out to build awareness of the mechanisms of domination to turn the spectator into a conscious agent of world transformation' (Rancière 2009: 45). The implicit Charge the Free Form founders gave themselves—'Make art that speaks to working-class people!'—certainly reflected a rejection of the gallery world and a determination to reach beyond it, but it was not about 'world transformation' or even 'awareness of the mechanisms of domination'. Their Project was far more modest: it was about finding ways of using the skills of the artist that were relevant to working-class lives. At the same time, the Project had its own radicalism in that it challenged the basic artist/spectator relationship. The artists wanted to make art *with,* not just for, working-class people. It would take a number of years, however, for this aspiration to develop into specific aesthetic practices and relationships. Significantly, what shaped these practices and relationships was not a predetermined theoretical stance, but the experience of attempting to make art in working-class neighbourhoods with working-class people in the context of a refusal to conform to the demands of the established art world.

There were, however, always limits to the artists' rejection of the art world. Free Form as an organization, for instance, would have a long, if at times fractious, relationship with the major source of arts funding in Britain, the Arts

Council. For twenty five years, it received a revenue grant from the Arts Council, and, while the economic significance of this grant became less important over the years, it always represented an important symbolic recognition on the part of the curatoriat. The artists may have turned their backs on the institutions of the gallery world that organize the production and distribution of art, but their relationship to the art world's aesthetic criteria was more complex. Over time, as we shall see, their determination to locate themselves and their work outside the gallery world would call into question some of those criteria; nonetheless, their aesthetic language remained in many respects rooted in the art world.

The art world, as Danto stresses, consists of not only its institutions but also the ideas and beliefs embedded in those institutions, which together constitute a whole discourse on the nature of art, its history, its role in society and so on. This conversation, it should be noted, includes much that is nonverbal; art objects, for instance, speak to each other and to artists and audiences in ways that cannot be reduced to verbal language. The voices and objects in this conversation sometimes disagree fiercely, and they often speak from very different positions of power, but those who create works they wish to be seen as art (with or without a capital A) cannot simply opt out of that conversation. Just as the art world is a shaping presence even for those who never set foot in a gallery, so, too, the artworks produced by artists who turn their back on the established art world remain in a certain sense within that art world conversation. The limit case of outsider artists—an interesting term in itself—is instructive here. While they may be autodidacts, most so-called outsider artists do nonetheless have some links with the general art discourse; the very fact that they themselves often call what they produce 'art' suggests as much. And, of course, as with 'primitive art' (see Danto's discussion in the previous chapter), the appreciation of outsider art—and, not insignificantly, the market for it—depends upon incorporating it within the art world's dominant understandings of art.

In one sense, the Free Form founders came out of their art schools very much as art world insiders. They wanted, as Goodrich explained to me, to bring art to 'the great [public] housing estates in England where art meant nothing'. But in what sense did 'art mean nothing'? Interestingly, Goodrich here excludes both the cheap, often mass-produced popular art so disdained by the curatoriat and the kind of 'aesthetic practices' Gell identifies, 'the imaginative gardener, home decorator, or budgerigar-breeder' (Gell 1995: 21, quoted in the previous chapter). It is safe to assume that a whole range of cheap, mass-produced popular art, as well as many of Gell's unrecognized 'aesthetic practices', could be found in profusion on England's housing estates. Goodrich, Ives and Wheeler-Early may have wanted to move

beyond the gallery, but, initially at least, the 'art' they imagined creating remained aesthetically the gallery art of the 1960s. Where they parted company with the art world was in the emphasis they placed on art produced by artists who worked anonymously and on art that remained embedded in everyday life. Wheeler-Early, for instance, explained her influences to me like this:

> In my [final year] thesis, which was called 'Art in Transition' . . . I looked at William Morris and cave painting and the sculptors of the cathedrals who were anonymous and their work was part of a building, and found that there was this great tradition of art in public. Which is an obvious thing to say because, of course, it was all around you. But in Britain it wasn't exactly, because, as Hugh Casson[1] said, the British are philistine really, in terms of visual arts. But looking at it as moving through centuries and really thinking that canvas painting had been quite a recent thing in the history of mankind or womankind. And I looked at the Russian constructivists, who were decorating buses and making factory uniforms and cups and saucers and all sorts of things. I was very drawn to surrealism because of its comment on the world I think, and how it had an influence even in the 60s, sort of making jokes about life, modern life. And then the New Deal in America [i.e. the WPA artists], I came across that.[2]

Some of the texts Wheeler-Early mentioned as shaping her thinking were Ernst Fisher's *The Necessity of Art,* John Berger's *Ways of Seeing,* and the writings of the literary and art critic Herbert Read. She also read and was influenced by the writings of the 1960s countercultural icons Paulo Freire and Ivan Illich.

For Goodrich, one text in particular was hugely influential: the Spanish philosopher José Ortega y Gasset's 1925 essay, 'The Dehumanization of Art'. He discovered this essay while a student at RCA and still has his heavily marked-up copy. Ortega (1883–1955) might seem a somewhat unlikely patron saint for a project set on bringing art to the masses, given his general elitism and profound distrust of 'mass society'. This, after all, is the man who wrote, in *The Revolt of the Masses,* first published in 1930 and much read in its day: 'Is it not a sign of immense progress that the masses should have "ideas," that is to say, should be cultured? By no means. The "ideas" of the average man are not genuine ideas, nor is their possession culture' (1957: 71). In 'The Dehumanization of Art' itself, Ortega's profound distrust

1. An architect and prominent member of the British curatoriat from his appointment at age 38 as Director of Architecture for the 1951 Festival of Britain until his death, in 1999.

2. This and all quotations from the Free Form artists, unless noted otherwise, come from interviews I conducted for this study.

MOVING BEYOND THE GALLERY 33

of contemporary democracies is reflected in the following passage—one *not* underlined in Goodrich's copy of the essay:

> A time must come in which society, from politics to art, reorganizes itself into two orders or ranks: the illustrious and the vulgar. That chaotic, shapeless, and undifferentiated state without discipline and social structure in which Europe has lived these hundred and fifty years cannot go on. Beyond all contemporary life lurks the provoking and profound injustice of the assumption that men are actually equal. (1968: 7)

Goodrich nonetheless pinpoints the reading of 'The Dehumanization of Art' as a key moment in his intellectual formation that crystallized his understanding of his Charge as an artist. Baxandall's reflections on the question of influence in *Patterns of Intention* can help us make sense of Ortega's importance for Goodrich.

> If one says that X influenced Y it does seem that one is saying that X did something to Y rather than that Y did something to X . . . If we think of Y rather than X as the agent, the vocabulary is much richer and more attractively diversified: draw on, resort to, avail oneself of, appropriate from, have recourse to, adapt, misunderstand, refer to, pick up, take on, engage with, react to, quote, differentiate oneself from, assimilate oneself to, assimilate, align oneself with, copy, address, paraphrase, absorb, make a variation on, revive, continue, remodel, ape, emulate, travesty, parody, extract from, distort, face up to, master, subvert, perpetuate, reduce, promote, respond to, transform, tackle . . . —everyone will be able to think of others. Most of these relations just cannot be stated the other way round—in terms of X acting on Y rather than Y acting on X. To think in terms of influence blunts thought by impoverishing the means of differentiation. (Baxandall 1985: 59)

Baxandall here takes us beyond simply saying that Goodrich missed Ortega's fundamental elitism and directs us instead to focus on how he fastened on a certain thread in Ortega—a thread that seemed to Goodrich to articulate his own sense of how the established art world was failing the working-class people among whom he grew up and with whom he identified. What Goodrich picked up on in Ortega was his account of modernism's rejection of ordinary life as lived by the mass of the population. Two passages that Goodrich *did* underline are these: 'Life is one thing, art is another—thus the young set [the artists of modernism] think or at least feel—let us keep the two apart' (1968: 31) and, a little earlier, 'What is behind this disgust at seeing art mixed up with life? Could it be disgust for the human sphere as such, for reality, life?' (1968: 29). What Goodrich took from Ortega was, above all, his argument that modernism, the art of the 'young set', had removed art from its embeddedness in everyday life. For Goodrich, Ortega articulated his own alienation

from the hot-house environment of his elite art school, a world that seemed separated by an unbridgeable gulf from the working-class world in which his emotional identity was rooted. For Goodrich personally, art school had opened up a world of wonders that had enriched his life, and yet, in his head, as he stressed to me, there was always the question from those he had grown up with: 'What are you doing at art school? What's it *for*?' And, for Goodrich, this was an absolutely legitimate question, a question to which the kind of artist he aspired to be must have an answer.

Ives, like Goodrich, had grown up in a working-class community, and for him, too, the art world was cut off from ordinary life: 'There was a big world out there that wasn't touched by galleries, there was the general public that hadn't been really engaged in this creative process in the way that we thought was possible.' Although Wheeler-Early herself came from a professional, middle-class background (to use the British class nomenclature), she, too, was convinced that, as she put it, 'art needed to address itself to the world again'. At the same time, however, Goodrich, Ives and Wheeler-Early were very much products of a training in the fine arts, Kristeller's Art with a capital A. They may not have wanted to be gallery artists, but their aesthetic criteria were those of the gallery. At this point, we could say what they wanted to do was to find a way of slaying the dragons of class privilege that guard the aesthetic treasures of the art world and to take those treasures back into the world.

One aspect of traditional fine-art aesthetic practice that Goodrich, Ives and Wheeler-Early were determined to reject was its profound individualism: the Romantic notion of the artist working alone to give expression to his innermost soul. As a woman, Wheeler-Early had an added incentive to reject this quintessentially male figure. This Romantic view of the artist is still alive and well. Take the Royal Academy Schools, where Ives studied, which explained to potential applicants on its 2010 Web site: 'The kind of artists we hope to attract are those who have complete commitment to their work, manifest potential for creative growth and *a passionate resolve to generate an original and personal vision.*'[3] Goodrich, Ives and Wheeler-Early were determined to turn away from this kind of individual creative practice. In my interviews with them, they frequently mentioned the cinema as an example of the kind of collaborative creativity they had in mind. Creating a space for themselves and their more collaborative practice involved both imagining a different kind of artist and constructing an alternative art history in which this different artist had a recognized place. It meant challenging the dominant narrative of the triumphant individual artist hero for ever evolving original and personal visions.

3. From http://www.royalacademy.org.uk/raschools/prospectus/, accessed 10 June 2010, my emphasis.

We can see Wheeler-Early doing this in the passage quoted earlier, where she places herself in a counternarrative stretching from the medieval craftsmen who worked anonymously on the great Gothic cathedrals, to William Morris, to the Russian constructivists designing everyday objects. We can think of this alternative art history as something like a *longue durée* within which Art with a capital A is simply one episode. And, in this alternative narrative, that key figure in art history, the patron, has been transformed. As Wheeler-Early put it: 'The public was the patron now, and if the public were the patron, then it only served to strengthen our ideas about how much more they should be involved than they were; these people in whose name everything was being done, and yet none of it was reaching them.'

But if the Charge 'make art that speaks to working-class people!' was relatively clear from the outset, it was also rather vague. This was not the same kind of Charge as Baker's one of 'Bridge!' or even Picasso's in the case of *Portrait of Kahnweiler*. How to realize it? Part of the problem the artists faced was their Charge's inherent tension between an art school–derived notion of art and art history, albeit a somewhat alternative one, and more popular, commonsense notions. It seems quite likely that many of those on whose behalf they wanted to use their visual expertise would have shared the tabloid view of the 2004 Momart fire and the contemporary art it destroyed: a deserved comeuppance for all the producers of 'all the overpriced, overdiscussed trash that we have had rammed down our throats' (Meek 2004).

What makes the Free Form story particularly interesting in the context of an exploration of the use of visual art expertise is that it was through practice, not theory, that the Free Form artists worked through this contradiction. From time to time, particularly in the early years, they did produce documents in which they attempted to explain their Project, and justifications were needed for funding applications, but their theory was often implicit rather than explicit, and their approach always pragmatic. Essentially, they learnt by doing, looking for any opening that seemed to offer interesting opportunities; it was primarily through their responses to specific Briefs that the Charge they had set themselves assumed a concrete form. The process, however, was a gradual one; genuinely collaborative forms of aesthetic practice that brought together artist 'experts' and the working-class people they wanted to reach took some time to emerge.

AN ART WORLD BRIEF

The first Brief came about through Goodrich's links with the RCA, and it is Goodrich's account that is my main source here. In 1969, the RCA was approached by an arts adviser to the London borough of Redbridge who was

looking for some RCA students to work with one of the borough's secondary schools (high school in American terminology), Fairlop School. The idea, as Goodrich recalled, was to 'make the environment more conducive to children understanding the value of the visual arts'. Ultimately, after the three RCA students who had initially agreed to take it on fell out with each other, the project was taken over by Goodrich (recently graduated from RCA), Ives (still completing his degree at the Royal Academy), and a former Walthamstow student, Joe Snowdon. The three formed themselves into an organization they called Visual Systems—a name that reflects the art school language of the time.

At this point, Visual Systems consisted of little more than a name and a telephone. It certainly did not provide any of those involved with an income they could live on; Ives had a summer cleaning job, and Goodrich was teaching part time at a secondary modern school in Whitechapel. Wheeler-Early was still at College in Manchester, but, although not formally a member of Visual Systems, she and Goodrich were in a relationship, and she, Goodrich and Ives engaged in long discussions of the project. Snowdon continued to participate in Visual Systems for a year or so, but, as Goodrich and Ives remember it, he was never a very committed presence, and, since I was not able to talk to him—he died some years ago—he does not feature in my account. It was not until a few years later that the name of the organization was formally changed to Free Form, but, given the continuity of the underlying aspiration of what I have termed the Free Form Project, for the sake of clarity I use this name for the Project even when talking about the Visual Systems years. In the next chapter, I look in more detail at how and why this shift in name came about and what it says about the direction the organization was taking.

Visual Systems were asked to come up with a proposal for Fairlop School by September 1969, and the three artists spent the summer developing their ideas. Their aesthetic influences were predictable ones for late-1960s art school products. They included, for instance, the Russian Constructivists, the Bauhaus, and colour field artists such as Rothko and Morris Louis, but the artist who probably had the most influence at this point was the British sculptor Anthony Caro.

Goodrich remembers the excitement of planning the Fairlop project.

> We spent all summer, which was a long period, I think about eight weeks, producing ideas for this school. We went and photographed it, and we talked to the art adviser (we didn't talk to anybody else) and then we set about drawing drawings, introducing ideas, decided to make models of the whole place, and introducing state of the art solutions to this school. By the time we finished it . . . virtually every part of the school had been transformed in some way! . . . It was full of influences of the current state of painting. Our whole thing was about how to introduce colour and perception of visual things in the school.

Come September, Visual Systems organized an exhibition at the school of their ideas and waited to see what the reaction would be. It was definitely mixed:

> We got the 'Wow, wow, fucking wicked, wow, great!' from all the art-nicks, all the art teachers and the more turned-on staff, which was about four or five of them! And they brought in a number of kids who were the best artists and they went, 'yeah, great, wow'. So there was a culture there that recognized that what we were doing was of value. But then there was sullen silence by the rest of the teachers and one or two snidey objections by the teaching staff, mutterings under their breath, 'Over my dead body!' and then I thought, 'Well, okay, that's predictable, and that's what you would get,' but then when the kids came to see it, en masse, it was almost a mirror image—you had the 'Yeah, wow, great, let's blow the school to bits!' attitude, and then there was the middle ground which said, 'Why do you have to do this in our school? What for? What value is it? What's it going to do?' And, in a way, that sounding in the middle ground was the most important.

In hindsight, this presentation was a crucial turning point for Goodrich and Ives. Suddenly they realized that, in devising their solution to the Fairlop Brief, they had engaged only with the art world. Goodrich described this Road to Damascus moment as follows:

> All of a sudden, we twigged it by talking about it that evening. We said, 'What's the matter with us? We've actually spent eight weeks working in grand isolation as if we were studio artists challenging each other, influencing each other, producing ideas without any reference to the context whatsoever! Only the context of the art adviser.'

This flash of illumination changed everything. The next day, they were due to present their exhibition and their proposal to the Essex County Council's Educational Department. But, instead of presenting the proposal they had worked so hard on, they came up with a completely different one, which said in essence,

> We don't want to do any of what we've just designed. What we want to do is spend three months actually working in the school to work with the staff, the students and parents to come up with imaginative solutions which will take into consideration their views, their attitudes, their understanding, which will be an educational process in itself.

Some years later, proposals for artists working in schools would become very popular in Britain, and nowadays they have become standard practice in many schools; in 1969, however, this was a quite revolutionary idea. It certainly

did not appeal to the Essex Education Department bureaucrats, who in any case did not much like what they saw of the existing exhibition. They were, however, in a slightly awkward position. Whatever they thought of this example of cutting-edge art, not only were these designs produced by artists linked to one of the country's premier art colleges, the project also had backing from the Arts Council, and the officials were probably anxious not to seem entirely philistine. In the event, they came up with a compromise: definitely no artists working in the school and no major art project, but the artists could carry out some of their designs in a corner of a far-flung playground. Before their Damascus moment, Goodrich and Ives would have been happy to accept this option, but, now, doing some pure art project in isolation seemed pointless, and they turned it down, reasoning, as Goodrich explained, that if 'all they're asking us to do is do something without involving anybody else, then we haven't got our message across'. For Goodrich, this abortive project marked the beginning of what I am calling the Free Form Project. He and the others were now committed to the belief that 'If you're going to do anything, you've got to it with other people'. And those people cannot simply be art world insiders.

One way of summing up what the Fairlop project taught Goodrich and Ives is that they had been working to an art world Brief. Within the art world, their proposal was perfectly intelligible and demonstrated clearly their visual arts expertise, but, to those not literate in art world discourse, it was essentially meaningless. This lesson, however, was not all that was to come out of Fairlop; the Fairlop project itself may have failed, but it would lead to an opportunity which in the coming months would present Goodrich, Ives and Wheeler-Early with a very different Brief involving a new practical education.

INTO THE 'COMMUNITY'

Word of the aborted Fairlop project had spread locally, intriguing another of the Essex County Council Education Department's arts advisers, who asked to meet with the artists. After talking with them, although still far from clear as to what they were proposing, he was interested enough to make them an offer. As Goodrich recalls, he told them:

> I've got an old building, which is an old prefab[4] [on Jutland Road] down in Plaistow [a district in the East End of London] which is going to be demolished soon.

4. Prefabs were prefabricated buildings built after the war as temporary replacements for houses and other buildings destroyed by German bombs. Many of them remained far longer than their original anticipated life and, perhaps surprisingly, came to be much loved by many of their residents. There are still a few surviving prefabs, which some conservationists are fighting to preserve.

> Perhaps you could take that and use it as an experiment? And you could use it as a studio. But I've got no money—I can't pay any wages, and I don't really know what you're offering anyway, but, if you can demonstrate it down there, maybe we could start to develop ideas.

Goodrich and Ives immediately went to take a look at the building, a remnant of a school that had been demolished. What they found was:

> This big prefab construction, right in the middle of a demolition site, . . . and it was dumped upon: it had hillocks and hillocks; the loads of lorries that had dumped stuff around it. The remainder of the school had just been pulled down, but this building had been left for some unknown reason—it was obviously something to do with the contractor's contract on demolition. It had been forgotten . . . So there it was, and it was going to be there for at least a year.

In the event, the two artists were able to stay there until the end of 1972, about two years. To Goodrich, it seemed like a dream come true: 'We were absolutely thrilled—we'd got a studio (and it wasn't going to cost us anything) and it was an opportunity to start these experiments.'

Goodrich and Ives, about to be evicted from the flat they were sharing, immediately moved in, and the building became a live-work studio. Wheeler-Early was travelling in Europe when the studio was being set up so was not directly involved at this point. The living conditions in the prefab were fairly Spartan, although a friendly local electrician with an interest in art befriended them and 'helped out' with some rather unorthodox electricity and gas connections. Still, even if they were living in the middle of a demolition site that locals used to dump their unwanted rubbish, they had their studio. As it turned out, the location of the Jutland Road prefab would play an important role in the translation of the general aspiration of the Free Form Project's initial Charge into specific aesthetic practices.

Goodrich and Ives's new studio and home was in London's East End. This term originally applied to the districts lying immediately to the east of the medieval walled city of London, but, as London grew, the area thought of as the East End has continually shifted and expanded; currently it includes the boroughs of Barking & Dagenham, Hackney, Havering, Newham, Redbridge, Tower Hamlets and Waltham Forest and covers an area of 318.64 km^2. In 2004, it had a total population of 1.5 million. The East End has long been associated with poverty. For centuries, the spatial organization in London was that 'the manufacturing, processing and finishing trades, in all their unpleasantness and with all their concomitant dangers, would be sited in the industrial quarter of the east' (O'Neill 2000: 14). And, in the nineteenth century, the industrial revolution helped turn the East End into a feared slum. Conditions improved somewhat during the twentieth century, but it remained an area characterized by insecure employment and overcrowded, substandard housing. In

the mid-twentieth century, the docks, which had provided one of the area's economic mainstays, began moving downstream. By the 1980s, thanks to the Container revolution, all the docks and their associated employment had gone.

Poverty and hardship, however, are not all there is to the East End. It has a powerful existence as an imagined space; both East Enders themselves and Britons in general have a clear image of who East Enders are and where they live. For many, both inside and outside the area, East Enders represent the most deeply rooted and authentic Londoners: theirs is the London of barrow boys and cockneys—supposedly a genuine cockney is someone born within the sound of Bow bells (the bells of the city church of St Mary-le-Bow)—as well as notorious 1960s underworld figures such as the Kray twins. A central image is that of the extended working-class families celebrated in British films and documented in sociological studies, such as Young and Wilmott's classic of 1962, *Family and Kinship in East London*. And the familiar stereotypes of loveable, characterful cockneys live on, particularly on television, as in the popular BBC soap opera *EastEnders*. This imagined East End is for many the very embodiment of an authentic working-class 'community', tightly woven together by threads of kinship and hardship.

A WARMLY PERSUASIVE WORD

The concept of community is central to the concept of community art, and it merits a little teasing out. It is, as Raymond Williams noted, a 'warmly persuasive word' conjuring up the imagined organic *gemeinschaft* of a more humane premodern world (1983: 76). It is also a commonsense term that people use without feeling any need to define it, and yet exactly what defines a particular group of people as a 'community', and in what sense they constitute a distinct entity can be hard to pin down. In the modern imagination, it is bound up with much older Romantic narratives of nation and dreams of once-existing *gemeinschaften:* community tends to come trailing misty visions of 'the people', the *volk,* imagined as somehow living in a more 'authentic' world than that of the rarefied realms of elite power. At the same time, these associations are implicit rather than explicit, unstated but suffusing the notion of 'community' with a particular emotional charge. Its vagueness, coupled with its positive associations, makes it popular with politicians of all stripes. In 1997, for instance, Britain's then Prime Minister, Tony Blair, gave a speech in the East End launching his government's National Strategy for Neighbourhood Renewal. The carefully selected venue was Ocean Estate, a rundown council estate[5] built in the

5. Housing built and managed by local councils. Prior to the Thatcher revolution, this was the standard form of social housing in Britain.

interwar period. The speech explained what was wrong with earlier policies: 'So much of the policy of the 1950s era failed because it was top-down, paternalistic, well-meaning, but failed to challenge. It is now very clear that doesn't work. But it is also clear what does work. *What works is when communities are empowered to control their own destiny and shape it;* where the opportunity is matched by responsibility' (Blair 2001, my emphasis). The 'warmly persuasive' term 'community' here casts its rosy glow over Blair's claim. Who could argue with the 'empowering' of 'communities'? And yet, if we stop to think about it, in what sense could the approximately 6,500 people living on Ocean Estate be said to be a coherent entity, a community, an actor it is possible to 'empower' to 'control and shape' its 'destiny'? The question is not whether Blair and his government desired such empowerment; I am happy to accept that they did. The problem is: how could the 'community' itself—however we want to define it—possibly achieve this? How could the estate's residents, for instance, themselves create the employment opportunities so desperately needed in this area of chronic unemployment?[6] How could they take up 'the challenge' of transforming the fabric of their dilapidated estate, its ageing housing stock and bleak public spaces, or 'control and shape' such a transformation? What would such empowerment look like in practice?[7]

Despite—or perhaps because of—its vacuousness, 'community' remains an inescapable term for those wanting to work in poor neighbourhoods; community seems rarely to be evoked in the context of rich neighbourhoods. It is not surprising that the Free Form founders, along with a number of other artists who shared their desire to take art out of the gallery, adopted the term 'community artists'. The Free Form story is part of the rise and fall of the wider community arts movement, and I give an account of that history in Chapter 4. But first I want to look at how the Free Form founders engaged in practical ways with the 'community' amongst whom they found themselves living and how that began to shape their aesthetic practice.

BACK TO THE ART WORLD

Once they were settled in their Plaistow studio, Goodrich and Ives began trying to put into practice some of the ideas for using colour in the environment

6. According to a 2001 BBC World Service Web posting, more than a third of the men on the Ocean Estate were unemployed; http://news.bbc.co.uk_news/1118242.stm, accessed 4 June 2007.

7. A different kind of critique of the concept of 'community' that has been very influential in recent years is that of the philosopher Jean-Luc Nancy. See his *The Inoperative Community* (1991), for instance.

they had developed while working on the Fairlop School proposal. Their first idea was to transform the studio's facade with colour. Tackling a whole building, however, proved to be something of a challenge; preparing and then repainting the entire surface of the building turned out to be extremely labour intensive, particularly given that Ives was still a full-time student at the Royal Academy and Goodrich by now working full time in a metalwork factory. They did complete the project, but neither Goodrich nor Ives was entirely satisfied; it simply did not work as they had hoped. They concluded, as Goodrich explained, that, rather than trying to paint a whole building, 'what we should be doing is doing temporary things: things which were transitional, which brought about the same kind of change.' This solution of focussing on temporary events would shape the aesthetic practice of the Free Form Project for its first ten years and would remain significant even when the organization shifted to more permanent environmental work.

Goodrich and Ives may have had their transformative moment at Fairlop and may have been critical of the elitist world of gallery art, but, as artists, they were still firmly located within that world, and Ives's final year show at Royal Academy was approaching. Goodrich and he had now been collaborating intensively for about a year, and they felt strongly that Ives's show should be a joint effort based on the ideas they were developing at Jutland Road: 'We were convinced that artists didn't have to work in isolation' (Goodrich). Even if it meant putting his degree in jeopardy, Ives was determined to take a stand on this. Also, no permanent work would be exhibited; the exhibit would change every day. Goodrich found himself learning a lot of valuable skills at the metalwork factory that had not been part of his art school training, and, using these, he and Ives began working on the idea of a structure that would provide a changing environment.

Goodrich described the central idea. This was,

> [T]o define, visually, internal space by making marks. So we started to make marks in mid-air: how to do that? We discovered this material that was a plastic webbing produced to wrap oranges in, but if you got it as a roll, it was almost like a line and it came in very iridescent colours: greens, blues; very sharp. So we thought we could spin that in the volume of the building, creating a grid-structure which would be suspended on nylon gut, so the whole thing looked like you had created writing in the air, or lines in the air, which worked. And then, each day, we'd change that. We also then taped up all the inside of the studio with this wonderful sticky-tape we got which was two inches wide—so we gridded out the inside of the studio. Each day we photographed it, and then we had a back projector and we got the slides processed, and we showed the examiners yesterday's work. Then we got some lay-flat tubing, which was tubing made for plastic bags; if you pass air through this roll, all of a sudden you've got an immediate building structure, and so we started to make buildings in this room with this lay-flat tubing. And then, on

the opening day of his exhibition, this lay-flat tubing went everywhere! And so we made our splash: Jim [Ives] got his degree.

Ives's show can be seen as resonating with other artwork being done at that time. In that same year, 1970, Christo and Jeanne-Claude were beginning work on *Valley Curtain,* their project to suspend a giant curtain across a Colorado valley, and the sculptor Richard Serra, who also drew on skills learnt working in a metal factory, was making his free-standing Prop Pieces. In Edinburgh, 1970 would also see the first British show of the German artist Joseph Beuys. Ives and Goodrich's ideas, therefore, were utterly intelligible within art world discourse. Ives and Goodrich themselves were also seeking out and engaging with other artists interested in new ways of making art.

An important influence in these early days was the British sculptor and painter Maurice Agis. Trained at St Martin's School of Art, with postgraduate studies in the Netherlands, Agis traced his artistic lineage from the Constructivist and De Stijl Schools of abstraction. Ives and Wheeler-Early had got to know Agis when he was teaching at Walthamstow, and, around the time of Ives's show, after hearing Ives and Goodrich give a talk at Walthamstow about their Fairlop proposal, he invited them to visit his studio to see the work he had done with his collaborator, Peter Jones. This consisted of huge inflatable coloured forms.

On his 2006 Web site, Agis described the work Ives and Goodrich would have seen in the following terms:

> They [Agis and Jones] sought to create spaces whose function was aesthetic and the stimulation of the senses in the viewer, providing the public with a release from the chaos and fragmentation of the senses in daily urban life. They created *Spaceplace,* installations that explored the relationship between simple lineal and rectangular asymmetric elements and human beings.[8]

This work excited Goodrich and Ives enormously, as did the fact that Agis and Jones had turned away from mounting their installations in galleries. Agis explains why on his Web site:

> [Agis and Jones] received the Sikkens International Prize [1968] for 'their conception of spatial structures and for the significance of those concepts in the urban environment.' These were easily assembled and transported constructions that needed the protective shell of a museum or gallery. Agis and Jones realised that those spaces, welcome as they may be, withheld the intensity of the relationship needed by their public to feel the sensory charge as if they were in privacy and

8. From http://www.dreamspace-agis.com/webesp/agis.htim, accessed 11 June 2006.

unselfconscious. The public had to be able to drop their guard, and enjoy the release of a primal response. They were asked to exhibit in a number of major European City Museums. They declined. The next step was to install their artwork in public urban spaces.[9]

This determination to take art out of the gallery and to make interactive art impressed Goodrich and Ives strongly.

Meanwhile, Goodrich, Ives and Wheeler-Early were becoming part of a loose collection of similarly minded young artists, all exploring new ways of making art and being artists. These included the alternative theatre group Inter-Action (founded in 1968), led by the charismatic American Ed Berman; the performance troupe Welfare State, founded, also in 1968, by artists and lecturers associated with Bradford Art College; and Action Space. There were also a number of radical architects looking for alternative ways of working, such as Cedric Price and the group Archigram. Nonetheless, while Visual Systems may have committed itself to more collaborative ways of working, their work and their aesthetic practices, as Ives's Royal Academy show illustrates, were still firmly based in the world of gallery art. The aborted Fairlop School project may have convinced them, as Goodrich put it, that 'if you're going to do anything, you've got to it with other people'—and that those people could not simply be art world insiders—but they were still some way from developing ways of working that put this into practice. Fortunately, there was another group at hand: the children living on the doorstep of their Jutland Road base. These children would present them with a Brief quite different from the art world Briefs with which they were familiar.

'WHAT'S IT FOR, MISTER?'

A technique that would become central to the realization of the Free Form Project was workshops that brought together artists and nonartists. These workshops provided a space in which artists could share their expertise with nonexperts and nonexperts could contribute their knowledge and develop their creativity while learning specific skills. It was at Jutland Road that this technique had its origins.

Beyond the hills of rubbish surrounding the Jutland Road studio was a solid working-class neighbourhood. The local children's playgrounds were the streets, and, to those children, two strangers living in a dilapidated old prefab on a demolition site were a source of endless fascination. Once the summer came, Goodrich and Ives found themselves beset by hordes of curious and

9. Ibid.

sometimes quite intrusive children. A prefab with its paper-thin walls does not provide a lot of privacy, and so, as a way of managing the children, they began running art workshops. The initial idea, Goodrich explained, was that they would

> [l]et the kids in and they can experiment with materials and we'll tell them what we're doing . . . And then we would do things like play football with them, you know, when they got bored with that—the threshold for boredom was very low, I must admit! But, it did actually work, because after a while we had a nucleus of kids that would come most evenings, they'd do something for half an hour/three-quarters, then we'd go out and play football, then we'd say, 'We're going down the pub, see you later guys; see you tomorrow.'

The workshops may have begun largely as a form of self-defence, but Goodrich and Ives rapidly realized that this could be a way of putting into practice something of what they had hoped to do at the Fairlop School: 'Well, actually, this what we were trying to do in the school—get the kids involved in something here' (Goodrich). But what exactly was it they wanted to get the kids involved in? They certainly wanted to open the children up to the world of visual creation that the artists themselves had discovered at art school. But always there were the difficult questions, questions that could not be answered in ways that would make sense to the children using the aesthetic language of the art world.

> They'd start asking questions about what we were doing, 'Why are you doing it that way? What's that for? What does it do?' And it was the same—this innocent enquiry was still there, and we weren't able to give answers in a simple way! We weren't able to say, 'The milkman brings the milk every morning which you put in your tea.' They wanted an answer like that: 'The doctor cures your ailments, and that's why he's valuable.' They wanted the same answer for the artist—'What does the artist do?'—which made sense to them, but you can't answer that question very easily. (Goodrich)

The workshops, however, began to provide ways of exploring the visual world in concrete tangible ways that did not have to be articulated in words.

At the time they came up with the children's workshops, Goodrich and Ives were developing work for a big multimedia exhibition, *Market 70,* organized by Agis and Jones. Funded by the Arts Council through its New Activities Committee (NAC), the exhibition was to include many of the like-minded artists with whom Goodrich and Ives were now in touch. NAC (which changed its name the following year to the Experimental Projects Committee) had been set up by the Arts Council in 1969 explicitly to cater for the needs of new types of art that seemed to fall outside the remit of the existing Arts Council panels. Agis and Jones had proposed 'a participatory exhibition of nongallery art; effectively,

art which was multimedia, transitional, experimental, dealing with new materials, new forms, etc.' (Goodrich). The exhibition would be in a nongallery venue, a large empty space under what was then Central London Polytechnic (now the University of Westminster), since the sterile gallery environment was seen as militating against the intense participation they were seeking (see Agis's statement quoted earlier). Goodrich and Ives' piece for *Market 70* was 'an overhanging structure from which was hanging a series of moving triangular, coloured panels which changed as you walked (you're meant to walk through these things), but they changed in density and colour; you were walking through an environment of colour that changed that was also touching you' (Goodrich). The other artists were putting forward all kinds of ideas: 'there were sound platforms incorporating dancers, there were guys doing things with lights, there were people starting to do real structures with inflatable tubing, there were people doing things like events' (Goodrich). But while the aspiration may have been for a new kind of participatory exhibition outside the gallery, the nature of the participation and the form of the exhibition remained firmly rooted in the world of the gallery. Rather unexpectedly, however, their work for this exhibition would lead Goodrich, Ives and Wheeler-Early to a new way of responding to their general Charge and to the implicit Brief the Jutland Road children, rather than the art world, had given them.

The exhibition was to take place in November 1970, and Goodrich and Ives spent the summer working on their piece and running their workshops with the local children, which at this point they still saw as essentially separate activities. Wheeler-Early had returned from her travels and was now very much an integral part of Visual Systems. She had recently begun teaching at a local, secondary-level boys school, where she would remain for two years. Her teaching experience gave her valuable skills in working in more structured ways with children, while at the same time her work at Jutland Road with Goodrich and Ives was informing her teaching. For all three artists, it seemed that they were now finding ways to answer some of those difficult questions: 'All of a sudden what we're talking about is a better language to actually get your ideas across to kids. And dealing with the "What's it for, mister?" kind of question and pushing that in other directions and getting them involved' (Goodrich). Given that they now had such a strong relationship with the local children and that *Market 70* was supposed to be about viewer participation, why not have something like a dry run at Jutland Road? Here, it seemed, was the perfect opportunity to put their ideas about art and participation into practice in a context that was most definitely not that of the gallery: 'We're talking about doing this [i.e. this new kind of art] in the community—why don't we do it in our own community as an experiment? Not with the things we'd put in the actual, real exhibition, but we'll improvise' (Goodrich). And so, in the spirit of this era of happenings, events and

festivals, they decided to put on their own event over a weekend and invited all the like-minded artists with whom they were in contact—a large number by now—to make a contribution.

They decided to call it the Free Form Fun Event—the first time the term 'Free Form' was used. The inspiration for the name came from free-form jazz. Both Ives and Wheeler-Early were jazz enthusiasts, and the concept of 'free form' seemed to capture their aspiration for openness and experiment that was also structured. The organization's name, however, remained Visual Systems; it would be another three years before Visual Systems formally changed its name to Free Form Arts Trust. It is significant that the name Free Form emerged in the context of the first event organized by the artists where the 'participating' audience was not a typical art event audience but people from the surrounding neighbourhood. We can see, in fact, the shift in name from Visual Systems to Free Form Arts Trust as one reflection of the Free Form founders' journey from the studio-based practice of traditional fine artists to an aesthetic practice genuinely located outside the gallery world.

FREEDOM AND STRUCTURE

In hindsight, Goodrich, Ives and Wheeler-Early all see the original 1970 Free Form Fun Event as a key moment in their search to find ways of using their artistic expertise and being artists that resonated with the Charge they had given themselves. This is Goodrich's remembrance of the event:

> We invited the Scratch Orchestra [an alternative music group combining professionals and nonprofessionals founded by Cornelius Cardew, of which Wheeler-Early was a member for a time] and Inter-Action and Action Space, [and] a lot of artists we knew: 'Come down and do something, you have to do something: something live, something temporary' . . . A three-day fun event. We made this big maze [out of scaffolding and cloth] and then we decided we would do painting the walls and, I have to admit, it was the most disastrous wall painting you've ever seen in your life! And then Barbara [Wheeler-Early] got hold of it and made something better of it because she structured it: it's not about just giving the kids the brushes and saying 'Yeah, you can do anything—freedom!' It was actually about creating structure in which people could then achieve something—it was one of those salutary lessons. It was quite clear lots of things would turn to chaos because you didn't create structure. But structure didn't mean formality, that people don't have freedom to do things: *structure meant freedom to do things and achieve something well, as opposed to fail.* But we were developing theories about it—it's important to have the right to fail, too! Anyway, we had this thing, it was in balmy, lovely weather—and it was fun, and it was chaos, and it was mad, and it was exhausting, and the kids had a fantastic time, and the ice cream men turned up and made a fortune! (My emphasis)

Note Goodrich's stress here on the relationship between freedom and structure and on the importance of expertise: 'It's not about just giving the kids the brushes.' The role of the artist here is seen as 'creating structure in which people could then achieve something'. Note also how Goodrich is clear that the artists' expertise enables them to decide what constitutes 'achieving something well' and what represents 'failure'.

Wheeler-Early, for her part, stressed how the wall painting was the first seed of what would eventually become a central focus of Free Form's work: working with local groups to improve their built environment in a way that gave them a genuine, decision-making role. For her, the wall painting 'was really a statement that people could be involved in decorating their environment and making a mark on their environment. And it was much admired [by local people], even though it was very, very raw and simple.' Ives emphasized the performance element:

> So suddenly from being people that were predominantly visual, here you were creating settings for other things as well. In the backs of our minds we were probably starting to think about performance, but we weren't quite there at that stage.

Everyone involved felt the event had been a success. Large numbers of local people came, and the artists involved were enthusiastic. The event had undoubtedly attracted people—predominantly children—who were not part of the normal gallery world. But what kind of event had it actually been? To try and find out more about local reactions beyond those of the children and others who had actually attended, the artists decided to send out a questionnaire, which local children were charged with distributing. The children, because of their strong relationship with Goodrich, Ives and the others, put pressure on the adults to respond, and there was a good response rate. Included in the questionnaire, to which the feedback was overwhelmingly positive, were questions such as: What do you think it was? Who should organize it? Who should pay for it? Should it happen again? Goodrich gave this account of the answers they got:

> 'What was it?' It was just called a play scheme: I'd never heard of a play scheme—I didn't know what a play scheme was! The next thing it was called: an adventure playground—I'd never heard of an adventure playground—these were new languages to me. But that's what we had done as far as they were concerned. They thought it had been organized by the council, and so [the response to the question] 'Who should pay for it?' was 'The council' and to 'Should it happen again?' 'Yes, definitely—each holiday!' So we realized that what we'd created for local parents was a holiday play scheme.

A number of the artists they had invited also likened the event to an adventure playground. This was a time when the adventure playground movement

was enjoying great success, and the ready identification of the Free Form Fun Event with an adventure playground is understandable. Interestingly, the first adventure playground, then termed a junk playground, was an unofficial, improvised area for children's play set up surreptitiously on some waste land in Copenhagen in 1943 during the German occupation.[10] The organizer, John Bertelsen, believed that children needed places where they could create their own worlds. The key difference between conventional playgrounds, with their fixed equipment, and the junk playground was that in the junk playground children actually created the structures, often temporary, in which they played. While accepting that there needed to be some adult supervision, Bertelsen insisted that 'children are themselves the creators' (quoted in Norman 2004: 18), and, under his guidance, 'the children improvised their dens and earth caves from bricks, boards, fir-posts and cement pillars' (Norman 2004: 17). At the end of the war, the idea was brought to Britain and taken up by various influential philanthropists. The name was changed from 'junk playground' to the more appealing 'adventure playground', and during the 1950s and 1960s an increasing number of these playgrounds were set up, often on one of the many World War II bomb sites still to be found in British cities. In general, the playgrounds tended to be located in poorer neighbourhoods in which there were few areas for play other than the street. The initiators were frequently a group of local parents who would also organize the volunteers who ran them. In the early 1970s, the progressive local London authority of the time, the Greater London Council (GLC), began setting up its own adventure playgrounds and taking over a number of the voluntary ones.

It is easy to understand why the local people who had come to the Free Form Fun Event and who were familiar with the idea of adventure playgrounds associated the two. While Goodrich, Ives and Wheeler-Early may not have been thinking in terms of adventure playgrounds, the basic idea very much resonated with what they had done, particularly the open-ended, processual aspect of it, even though for them their event remained centrally about the creation of art. As Goodrich remembered, they thought,

> Yes, what we've actually created here is a new way of children playing, which is more to do with culture and art and making things as opposed to playing hopscotch or football. It's a new way for pure play, an educative way of people playing which had relationships to the work we were doing in the Fairlop project, but now it was temporary and transitional as opposed to permanent.

A few months later, the *Market 70* exhibition itself (for which the Free Form Fun Event had supposedly been a trial run) took place. The exhibition, which

10. My account here is based on Nils Norman's 2004 account of the adventure playground movement, *An Architecture of Play*.

included Goodrich and Ives' coloured maze structure, was favourably received by the art world, but to Goodrich, Ives and Wheeler-Early it felt a little flat after the excitement of the Fun Event. *Market 70* may have been located in a non-gallery setting, but the relatively small numbers who visited it were essentially a normal art world audience. The Fun Event, by contrast, had succeeded in attracting a large and nonart world audience. But while to both artists and audience *Market 70,* with its Art Council backing, was unambiguously an art event, none of the responses to the Fun Event questionnaire made a connection between the Fun Event and art. As Goodrich remembers, 'nobody said "art". [If people were asked:] "How do you think Martin and Jim earn their living?" it was like, "I think you're artists, but I don't know what you're doing this for!"' For local people with no knowledge of the contemporary art scene, there was no relationship between this anarchic three-day event and what they understood as art; for them, it was play, and it was primarily for children.

For Goodrich, Ives and Wheeler-Early, however, the way the event was identified did not matter. As artists, they were confident that their visual expertise included knowing what constitutes art, and in their eyes what they were doing was definitely art. It did not worry them if local people did not see it that way. Indeed, if fulfilling the Charge 'Make art that speaks to working class people!' meant stripping away the gallery associations that for many people are precisely what legitimate objects and events as art, then such stripping away could be indeed a way of solving a basic problem inherent in their Charge. In other words, the experience of the Free Form Fun Event suggested that, if they were to be the kind of artists they aspired to be, then maybe they had to make art that did *not* seem to be Art with a capital A; that Art, in the eyes of the working-class audience they wanted to reach, was too identified with an elite and alien world of privilege.

The Free Form Fun Event seemed to offer at least a partial solution to the problem of how to make art that drew people in, transforming them from reverent, passive worshippers at the shrines of high art into active, often irreverent, participants. But, while Goodrich, Ives and Wheeler-Early were committed to making art that would speak to the needs of working-class people, their aesthetic *language* was still rooted in the art world. It was not that they were trying to give people access to the sacred objects of 'Art'; if participation in such an event opened up the world of museums and galleries to those who felt, in Grayson Perry's words, that such place were 'not for the likes of them', that was fine, but that was not their aim. What the artists wanted the children who besieged their Jutland Road studio to discover were new understandings of colour, form and space, new ways of looking at the world and themselves—all of which are forms of discovery central to art world discourse. Implicitly, the artists were defining the problem inherent in their Charge as the need to satisfy two somewhat contradictory demands: to produce art that escapes the elitist

associations of Art with a capital A but that still fits within an art world understanding of art. One way of responding to these conflicting demands is through play. On the one hand, play offers something like a freeing of art from Art, opening the prison of the insistence on a reverential, quasi-religious seriousness when in the presence of Art; on the other hand, play within the art world links to the by now thoroughly canonical strand of surrealism. Play would remain an important element of Free Form's work, as would a certain playful surrealism.

FUN EVENTS V. ARTISM LIFEISM

After the first Free Form Fun Event, using the positive feedback from their questionnaire, Goodrich, Ives and Wheeler-Early applied to the Visual Arts Panel of the local council, Newham, and managed to secure some minimal funding to organize more neighbourhood events geared towards children in other parts of the borough. The funding was for projects that would provide benefits for local people, particularly children, through art. It is significant that, as early as these first events, it was often the projects' promised social benefits, rather than their purely artistic value, that were attractive to funders. In other words, it was the artists' potential expertise in addressing social problems, rather than their specific artistic skills, that made their projects fundable.

The Newham Council funding was supplemented by money raised from jumble sales—the artists' devoted army of jumble collectors among the local children ensured these were remarkably profitable—and free materials provided as a form of sponsorship by various local manufacturers. In the eighteen months between the first Free Form Fun Event and their leaving of Jutland Road, in 1971, Goodrich, Ives and Wheeler-Early, together with a growing group of like-minded artists, used these funds to organize a series of Fun Festivals located in specific neighbourhoods.

Workshops with local children were always central. As Wheeler-Early recalled, they felt that they were responding to a genuine hunger on the part of the children. To the artists, it seemed these often unruly and sometimes violent children were almost desperate to be involved. Denied the opportunity to participate, the artists felt, they would have turned destructive, but, as long as they were included and given things to do, they threw themselves into the various activities, discovering new worlds of colour, form and space through active making. Another important component of the Fun Festivals was spectacle. One of the first, for instance, celebrated Guy Fawkes Day and featured fireworks in a choreographed fire show. Elaborate fire shows, often with fire eaters, subsequently became an important element in many of the Fun Festivals (see Fig. 4).

Figure 4 Free Form fire show with King Kong, 1970s (photograph and copyright: Free Form Arts Trust)

We can see the Fun Festivals as a solution to the problem constituted by the Charge the artists had given themselves, coupled with the Brief given to them by the local children. Free Form continued to organize the festivals in different East End neighbourhoods throughout the 1970s.

The mid 1970s and early 1980s were a time when racism seemed to be on the rise throughout much of Britain, with neo-Nazi, anti-immigrant parties such as the National Front[11] attracting growing support, especially at the local level. In an effort to counter this racism, a number of black organizations and Left-leaning political groups came together in a broad antiracist movement, which attempted, through organizations such as Rock against Racism, to take the struggle onto the territory of the racists' own popular culture. Free Form was a part of this wide coalition, and one aim of its later Fun Festivals, particularly in the East End borough of Shoreditch, was an attempt to bring together the borough's council estates, where racism was often rife, in the context of a more positive and friendly rivalry. These events, as we shall see in Chapter 6, were remembered fondly by some locals many years later.

With their energy increasingly going into the organization of neighbourhood-based Fun Festivals, Goodrich, Ives and Wheeler-Early were moving away from

11. Shane Meadows's 2006 film *This Is England,* set in 1983 Britain, captures very vividly the culture of National Front racism of this period and the character of its appeal.

art world events, but at this point they were still interested in creating and showing artworks with other artists. A decisive turning point came in 1971. Together with Agis and Jones and building on the *Market 70* exhibition, the artists organized an event they called Artism Lifeism as part of the 1971 Harrogate Festival. Every year, Harrogate, a fairly staid northern city, hosts a music festival. The very unstaid Artism Lifeism brought together a wide range of artists, a number of whom had participated in the first Free Form Fun Event, including conceptual artists, such as Robin Klassnik (who would later found the influential Matt's Gallery), alternative theatre groups, such as John Bull's Puncture Repair Kit and Welfare State, and performance artists, such as Jules Baker. Fig. 5 shows Wheeler-Early's piece for this event: 'Architectonic Paint Rags'. All the contributing artists shared a commitment to presenting work in spaces other than conventional gallery ones. The local press, however, were not at all sure about artists, in this instance Klassnik, spray-painting grass and even a passing dog's tail or the procession headed by a rider on a horse leading a carnival of performers down the High Street and in and out of Marks and Spencer; articles about artist vandals began to appear in the local newspaper. From the perspective of the Free Form Project, however, there was another, more important tension than that between the traditional High Art Harrogate festival and the more conceptual and radical Artism Lifeism. On the one hand, there were those, such as Agis and Jones, who were interested in

Figure 5 'Architectonic Paint Rags', Barbara Wheeler-Early, Artism Lifeism, 1971 (photograph and copyright: Free Form Arts Trust)

making artworks that would provide spectators or participants 'the release of a primal response' (see the earlier quotation from Agis's Web site) but who were committed to retaining their links with the world of gallery art. On the other hand, there were those, such as Goodrich, Ives and Wheeler-Early, for whom fulfilling the Charge to 'Make art that speaks to working-class people!' seemed more important than establishing a place for themselves within that gallery world. Ives remembers coming away from Artism Lifeism—a name he thought hideously arty and pretentious—thinking this was not the direction in which he wanted to go: 'We have got to involve the public, we have got to engage the public, this is what we are about.' This decision to give priority to the Charge of engaging with a working-class audience and seeking out Briefs that came from that working-class world rather than from the art world would be crucial in shaping the aesthetic practices that would come to define the Free Form Project.

After Artism Lifeism, the Free Form artists, unlike many of their early collaborators, such as Agis or Klassnik, rarely mounted events or presented work in recognized art world venues. It is important to note that the rejection of these venues resulted from their positive commitment to their Charge, rather than any explicit rejection of the art world itself. As we shall see, the Free Form artists would seek to make their vision a legitimate part of that art world. What they rejected was the gallery world. In practice, however, turning their back on the art world's legitimizing institutions and its accepted ways of making art would, over time and perhaps inevitably, lead to their marginalization. But it is important to stress that, from their perspective, this marginalization was an unintended and sometimes frustrating consequence of where they were being propelled by their commitment to their Charge and the Briefs they were now taking on to fulfil it. In their eyes, what they were doing *was* part of the *longue durée* of art, however awkwardly it might fit with the prevailing assumptions of the curatoriat. For instance, Goodrich, Wheeler-Early and another Free Form artist we shall meet in the next chapter, Diana England, all told me independently about a comment made by the painter Sir Lawrence Gowing, at the time one of the art world's luminaries, when he visited them in the mid 1970s as the head of an Arts Council assessment team. By this point, Free Form was receiving a modest revenue grant from the Arts Council. But there were also those in the Arts Council who saw the organization's work as overly populist and who were looking for ways to end their funding. In the course of Gowing's visit, it became clear that he had been sent in the hope that he would produce a damning report. In the event, however, Gowing, who had not previously known much about them, was extremely impressed with what he was shown. As Goodrich recalled, he announced to the assembled artists at the end of his visit: 'I was told that you were the poor relations of the Arts doing substandard work of no consequence, but I consider

you to be the rich relations; you're opening up new avenues and new opportunities which many of us have not even thought about.' For the artists, this was an enormously important endorsement of their expertise as visual artists and their conviction that what they were doing was indeed 'good art'. As they saw it, the work they were doing represented forms of collaborative work that both engaged 'nonexperts' in substantive ways and produced high-quality artwork; the problem was the blinkered elitism of a curatoriat unable to recognize this.

As they moved away from art world events like Artism Lifeism and committed themselves to genuinely 'involving the public', the Free Form artists began to turn increasingly to performance. The next chapter tells the story of this performance turn.

–3–

From Performance to the Environment

It's always the popular theatre that saves the day.

—Peter Brooke, *The Empty Space*

By the end of 1971, their free tenure of the Jutland Road studio had come to an end, and Goodrich, Ives and Wheeler-Early were confronted with finding not only a new studio space but also somewhere to live. Goodrich and Wheeler-Early located another short-life council-owned building for which they paid a minimal rent and which again served as a live/work studio. Ives, meanwhile, moved into his own separate living accommodation, although he was still working closely with Goodrich and Wheeler-Early. Together with what was by now a sizeable if shifting group of affiliated artists, they continued (still using the name Visual Systems) to organize festivals and other live events. A growing number of the artists with whom they were now working came from a performance rather than a visual arts background, drama students rather than art students, and these performers began increasingly to shape the group's aesthetic practices. In this chapter, I explore this collaboration between visual artists and performers: how it played out in terms of aesthetic practice and how (and why) the two groups ultimately parted ways, with the visual artists continuing as Free Form and the performers forming a new organization, Cultural Partnerships. It was after this split that Free Form shifted its focus to more permanent environmental work and began to seek Briefs based on helping people, particularly those living in impoverished neighbourhoods, find solutions to problems of their built environment.

The first Free Form neighbourhood festival was the 1972 Canning Town Free Form Fun Festival, a seven-week programme of different live arts events, many with a strong participatory component, held on the Keir Hardie Estate in Canning Town. One visitor to the Festival was Joan Littlewood, the wayward genius then running Theatre Royal Stratford East. Littlewood, like the Free Form artists, was passionate about making art, in her case theatre, that would reach working-class people, and she immediately suggested a collaborative project. The story of this collaboration reveals something of the difficulty of bridging the gulf between high art and popular culture.

'I'M AFRAID THIS WHOLE HORRIBLE BOX TAKES PRIORITY'

Littlewood was undoubtedly one of the most influential figures in postwar British theatre. Working in a theatre located in the East End rather than the West End home of middle-class theatre, Shaftesbury Avenue, her productions in the 1960s, as British playwright David Edgar put it in 2006, 'popularised a high-energy, rough and ready, anglicised version of Brecht's suddenly influential political theatre' (2006: 9). In the early 1970s, Stratford, the home of Littlewood's Theatre Royal, was a somewhat desolate place, supposedly in the process of being 'developed'. The local school had just closed, and there were many empty sites, left vacant by developers in hopes of future profits. Despite Littlewood's declared aim of creating a 'people's theatre', while her theatre may have been more successful at attracting working-class audiences than traditional West End theatres, to local people it was still essentially an outpost of alien middle-class culture. Responding in a letter to Edgar's article, one of those who had worked at Theatre Workshop commented, 'I can assure David Edgar that while we did everything we could to attract an East End audience they preferred to go up west for their entertainment. If the posh Sundays didn't like a Joan show the theatre was virtually empty' (Chapman 2006: 4).

Littlewood herself was well aware of the problem. Understandably, she was excited when she visited the Canning Town Free Form Fun Festival and discovered a group of artists who did seem to be attracting local people. Her idea was that Visual Systems would organize a programme of art events, to be called Stratford Fair, intended to bring her theatre out of its box and into the local community and to get the local community into the theatre. The early 1970s were a time when cheap package holidays, particularly to Spain, were taking off in Britain, and Littlewood's theatre put on a show, *Costa Packet,* the theme of which was that there was no need to travel abroad for your holidays; you could have a holiday right here in Stratford. Stratford Fair, to be held outside the theatre while *Costa Packet* was playing, would provide that holiday experience and demonstrate that Stratford had its charms; it too could be made a 'fair' place. Littlewood would pay Goodrich £20 a week for two months to organize the Fair.

Goodrich and Visual Systems, however, felt they needed more substantial funding, and Goodrich set about writing an application to the Arts Council. The Free Form founders may have been moving away from the established art world and its galleries, but they had no doubt that what they were doing was art. The art world, for its part, was also exploring ways of moving beyond the gallery, as evidenced by the recent establishment of the Arts Council's Experimental Projects Committee (see Chapter 2). The Canning Town Festival itself had secured some modest funding from the Greater London Arts Association (GLAA), the London regional association of the Arts Council at that time. Initially, Littlewood,

who had a long history of rejection by the Arts Council, was sceptical about Goodrich using his time on fund raising, but the application was successful, and Littlewood received £2,000 for Visual Systems to run Stratford Fair.

Many artists besides Goodrich, Ives and Wheeler-Early contributed to the Fair, a number of whom, such as the former academic and French scholar Michael Hecht, would go on to work with Free Form later. As with the other Fun Festivals, the programme of events was aimed primarily at children. The derelict area round the theatre, which included the abandoned school, was transformed. Robin Klassnik, who had participated in the first Free Form Fun Event, brought his installation *Hedge* (a privet hedge which he had previously exhibited in Hornsey Library). There was also a sandpit and sprinkler hoses. A committee, consisting of children, parents and artists, was set up and made decisions as to how the playground was to be run and policed.

Workshops were a central element of the Festival. Ives organized workshops for visual arts, music making, drama and even maths games. A mural painting workshop made use of one of the walls of the derelict school. With Wheeler-Early as overall supervisor, the children began the work and were then joined by their mothers, who in turn persuaded the fathers to help. The result, although fairly crude by the standards of the murals Free Form would later create, was the first serious mural produced by the organization, and, according to Wheeler-Early, it was much appreciated by those who worked on it. Initially, the Council agreed that the playground could be used for workshops for two weeks, but when they tried to close it as scheduled, the children held a demonstration and the Council relented, allowing it to remain open until the official end of the Fair a month later.

Although Stratford Fair succeeded in attracting local people, Littlewood's ambitious plans to bring the theatre outside and the community inside never quite happened. And, ultimately, for Littlewood, however committed in principle she might have been to a people's theatre, taking her theatre out of its box was not possible. Goodrich remembers her saying, 'Well, when push comes to shove, I'm afraid this whole horrible box [i.e. the theatre] takes priority.' Ultimately, we could say, however passionate Littlewood may have been about bringing her theatre to 'the people', she was not willing to let the working-class audiences she hoped to reach shape her Brief in any radical way. Her theatre may have been called Theatre Workshop, but the workshop element was always limited to its professional actors.

FROM VISUAL SYSTEMS TO FREE FORM ARTS TRUST

The work involved in the Fun Festivals was exhilarating, frenetic and non-stop. By the end of 1972, everyone was beginning to feel a little burnt out; it

seemed a moment to take stock and reflect on what they had learnt and how to carry things forward. One thing was clear: they wanted to remain based in the solidly working-class East End; they had little or no interest in establishing a presence in the gallery world. Then, in February 1973, Goodrich learnt of yet another council property designated for demolition, an old butcher's shop in the East End borough of Hackney. Hackney had considerable emotional resonance for Goodrich. Until 1949, when Goodrich was six and his parents had moved out to one of the new council estates built after the war, the family had lived in Hackney. In the 1930s, his paternal grandfather had been Mayor of Hackney and was subsequently elected to Parliament as Labour MP for Hackney in the Labour landslide of 1945. Over the coming years, Hackney would become a significant funder of Free Form, and Goodrich's family connections were helpful in opening a few doors when Free Form first began applying for money from Hackney Council.

The initial agreement with the council was that they could occupy the building, 38 Dalston Lane, one of Hackney's main through roads, at a minimal rent for six months. In the event, Free Form would stay there until 1997. Goodrich and Wheeler-Early moved into the modest living space above the shop, with the old shop itself and its large garage providing extensive studio space. By this time, Visual Systems as a formal entity had more or less collapsed, and the lease of the building was taken out in Goodrich and Wheeler-Early's names, although Ives would remain a major player for another couple of years in what was about to be renamed Free Form Arts Trust. Even after leaving, Ives continued to work with them on specific projects from time to time.

Fired with renewed enthusiasm by the new building, Goodrich, Ives, Wheeler-Early and Hecht decided to mount an exhibition in the studio space showcasing, through photographs, drawings and other records, all the work that had been done since the initial Fairlop School project. Significantly, perhaps, it was Hecht, the former academic, who stressed the importance of documenting the work done—the journey so far, as he put it—in both images and words. This 1973 exhibition, titled *The Growth of Public Art,* also served to launch the Free Form Project Centre. The Centre's title is again an indication that the organization's name was in practice now Free Form, not Visual Systems. The guide to the exhibition explains and promotes the new Centre, stressing that art 'must respond to the needs of the community' (Free Form 1973). The language here indicates both how the artists were increasingly seeing the realization of their general Charge as responding to Briefs that came from the 'community' and their emphasis on the social benefits of artistic expertise. The Free Form Project Centre was seen as a way of eliciting from the 'community' specific problems, to which the artists' expertise could provide solutions. In the event, as we shall see, the full realization of this idea would have to wait until Free Form

set up its Design and Technical Aid Service (D&TAS) some ten years later. The D&TAS work is discussed in later chapters.

The exhibition guide lists forty-five individuals and organizations as having been a part of the previous four years' work and helping to put the show together. Around eight of these, including Goodrich, Ives, Wheeler-Early and Hecht, were keen to continue working together on a regular basis. When the exhibition closed, this group met and agreed to set themselves up as a new organization to carry the work forward. It was clear, however, that this would require more substantial funding, and for this they looked to the Arts Council. To facilitate grant applications, the Arts Council recommended that they become a registered charity.[1] This would have a number of advantages, including exemption from most taxes. Becoming a charity meant that they would have to become a company with an independent Board of Directors, in line with the regulations of the Charity Commission, the body that oversees all British charities. The artists agreed to this, naming the company Free Form Arts Trust. Formal recognition as a registered charity came in 1975. In view of later debates over the political role of 'community arts' (discussed in Chapter 4), it is worth noting that registered charities, although they are allowed to engage in political activity to further their charitable aims, are explicitly barred from being political organizations.[2] In making this move, therefore, the Free Form artists were consciously opting for a role that was, in formal terms, nonpolitical.

PERFORMANCE

From the first Free Form Fun Event, the festivals and other live events, with their stress on participation and process, provided a strong push in the direction of performance. This, it seemed, was an effective way of gathering the kind of audience Free Form wanted and getting that audience to participate in the making of 'art' (see Figs. 6 and 7). Not surprisingly, the incorporation of performance into their events attracted a growing number of young performers from a drama background who were intrigued by what they saw and wanted to be part of this new way of being artists. Their presence, in turn, further strengthened the performance strand. Following the *Growth of Public Art* exhibition, artists from a performance, drama or education background became a significant part of Free Form's group of artists. In later years, tensions would develop between the performance-based and the visual art-based

1. The British equivalent to the US nonprofit.
2. See *CC9 Speaking Out: Guidance on Campaigning and Political Activity by Charities* (The Charity Commission 2008: 5).

Figure 6 Hackney Marsh Fun Festival, Triceratops inflatable, 1970s (photograph and copyright: Free Form Arts Trust).

Figure 7 Street Participatory Theatre, Fumbelo Fellini, 1970s (photograph and copyright: Stan Gamester).

artists, but initially and for a considerable period there was a highly productive interaction between these two strands.

The young artists, whether they came from a fine-art or a performance background, enthusiastically embraced what they saw as Goodrich, Ives

and Wheeler-Early's anarchic challenge to the bourgeois art world. Some of them came and went fairly quickly, but over the next few years there was a solid core who began working with Free Form on a more permanent basis. It was those from a visual arts background who would stay longest, however. Some, such as Alan Rossiter (see Fig. 8) and Hazel Goldman (see Fig. 9), would still be major figures in the organization when I was doing my fieldwork, in 2004/5. Both Goldman and Rossiter trained in fine arts at Chelsea School of Art, Goldman in sculpture and Rossiter in painting. Another Chelsea-trained visual artist, who would be a part of Free Form for nearly twenty years, was Diana England (see Fig. 10). After studying painting at Bristol Art School, England would go on to a postgraduate, fine-art printing course at Chelsea.

Rossiter explained how, for artists like him, Free Form's work was in tune with

Figure 8 Alan Rossiter, 2009 (photograph and copyright: Kate Goodrich).

Figure 9 Hazel Goldman, 2009 (photograph and copyright: Kate Goodrich).

a spirit of the time in terms of alternative arts and street theatre, pub theatre. It seemed to coincide, I think, with that generation of artists and like-minded people coming out of art school who were gifted—often from working-class roots, the first [working-class] generation to actually come through really—and wanted to work in a different way.

What was perhaps different about this historical moment was that, while there had been artists from working-class backgrounds before, they had generally accepted the reality that becoming artists meant assimilating into an essentially bourgeois art world; these young artists, whether visual artists or performers, attempted at least to resist this assimilation. A passage in Gramsci's prison notebooks in which he talks about what a new progressive literature would look like resonates with the aspirations of these artists:

Figure 10 Diana England, 2009 (photograph and copyright: Kate Goodrich).

The premise of the new literature cannot but be historical, political and popular. It must aim at elaborating that which already is, whether polemically or in some other way does not matter. What does matter, though, is that it sink its roots into the humus of popular culture as it is, with its tastes and tendencies and with its moral and intellectual world, even if it is backward and conventional. (1985: 102)

And yet, particularly for the visually trained artists, there was always the inherent tension—implicit in Gramsci's characterization of popular culture as likely to be 'backward and conventional'—between high and popular art. Those from a traditional fine-art background might be genuinely committed to making art that would speak to working-class people, but, as the initial Fairlop School proposal had demonstrated, the visual culture they had absorbed at art school was somewhat remote from 'the humus of popular culture'. The performance strand helped them sink at least a few roots into that humus.

An important early Brief which centred on performance was a three-year collaboration (1973–1975) with the Combination community theatre group at the Albany Empire. The Albany had begun life as one of the nineteenth-century philanthropic centres established in working-class neighbourhoods to improve the lives of the poor. In the early 1970s, what was then The Brighton Combination, based in Brighton, had been invited to the Albany, located in Deptford, in the East End, to reimagine it as an arts centre. The Combination, who defined themselves as a community theatre group, had known the Free Form artists since their Brighton days, and they now asked Goodrich and Wheeler-Early to design and build sets for their shows. Goodrich and Wheeler-Early then asked Robin Klassnik, who had participated in several of their events, including Stratford Fair, to work with them at the Albany. Excited by the prospect of working with a professional theatre group, the artists were determined to do more than create conventional sets. Committed to a more interactive art, they set about dissolving the conventional boundary between the space of performance and the audience, with the aim of creating total environments (see Fig. 11). An important influence here were a number of innovative European theatre groups, such as the French Le Grand Magic Circus, an exuberant troupe of actors, clowns, animals and magicians. Around this time, such groups often performed in London at alternative arts venues.

Figure 11 Performance Albany Empire, 1979 (photograph and copyright: Free Form Arts Trust).

The experience of working on shows with the professionally trained Combination actors helped develop the performance expertise of the organization. Both Goodrich and Wheeler-Early see this collaboration as a key influence that helped shape their future aesthetic practice. In 1974, drawing on this experience, they devised another Brief for themselves: to bring Free Form Fun Festivals to children in deprived inner-city areas across the country. The solution they came up with for this Brief was a two-part travelling arts workshop: a Free Form Mobile Visual Workshop, led by Diana England; and a Mobile Roadshow, headed by Cilla Baynes. Baynes began her career with Free Form, after training in drama and education. Later, she would go on to cofound the still-thriving Community Arts Northwest in Manchester. Funded by a grant from the Gulbenkian Foundation to take art workshops, geared primarily to children, to different areas around the country, the Mobile Workshops and the Mobile Roadshows brought together visual art and performance. Working out of a van, the Roadshow performers would gather local children and, together with them, would create a performance (see Fig. 12). Alongside this the Mobile Workshops would organize various activities such as silk-screen printing.

Baynes described to me how the Mobile Roadshow operated. Having arranged to run a workshop with the local council, the Roadshow team would arrive and identify themselves to the local children according to one of a range of scenarios, such as, for instance, the Hollywood Film Project. In this

Figure 12 Mobile Roadshow, 1978/9 (photograph and copyright: Free Form Arts Trust).

scenario, the performers would tell the children they were the cast and crew of a movie that was about to be shot:

> And of course all the set had gone somewhere like Istanbul and we couldn't do this movie, and all the kids would end up saying, 'We'll do it, Mister, we'll do it Mister!' And then the children were divided into groups, and they would devise their story, leading on from the central narrative of the initial story. [They] were given a structure to work within, and within that structure they could do *anything*. They could go to the moon, they could re-create the world, they could go away to sea.

England explained how at first 'the kids really thought you were from Hollywood . . . but then gradually they would see through it and you'd give them a way to seeing through it so that they knew that you were all doing a kind of make-believe thing.' The Mobile Workshop artists would run workshops for the children in which they would make all the costumes, masks, props and so on. The children then performed the scenarios they had devised, and these were filmed.

Workshops, as I have noted, were, right from Goodrich and Ives's days at Jutland Road, central to the Free Form artists' response to the problem their Charge set them. Through structured workshops, the artist experts would introduce the workshop participants to different skills, encouraging them to develop their own creativity. An important aspect of any workshop, as Wheeler-Early stressed to me, was that it led to some actual product: a silk-screened badge, for example.

The Mobile Roadshow and Workshop ran for a number of years, providing the artists with a valuable education in how workshops could be used effectively with different groups. As Goldman remembers,

> The diet of work was so varied and wide, and we worked as a team producing this work. Working with communities on all sorts of workshop-based arts events meant that you built up in yourself, if you like, a dictionary of resources: processes and ways of working that you could almost pull out of a hat and say, 'Well, this might work in [this] situation. This might not.' Or 'This is better.' Or, 'If you do it that way you will surely get me into trouble, mate.'

The workshops were extremely open ended. The artists certainly had their own aesthetic criteria, and they were committed to providing the workshop participants with the highest level of skills possible within such a workshop format, but the priority was giving children a way to express their own creativity.

Up to this point, virtually all Free Form's events were primarily geared to children, even if the Fun Festivals advertised themselves as 'fun for the whole

family'. From the very first Fun Event, their playful, interactive approach was seen by local people as essentially something for children, although often the work with children, as with Stratford Fair's mural painting, drew in parents. Increasingly, however, partly as a result of their experience of the fun festivals, adults began asking for events designed for them. This Brief would, through Free Form's collaboration with Alan Rossiter, lead to the creation of an arts centre aimed at adults, rather than children.

A year or two after graduating from Chelsea Arts School, Rossiter began work as the senior play leader at the GLC-funded Hackney Marsh Adventure Playground. The Playground drew children from Kingsmead Estate, a Hackney council estate with a fearsome reputation as a place of marauding children, wild families and decaying property. Rossiter remembers it as an estate where 'a lot of children had forgotten what it was like to play'. Rossiter first came across Free Form when he visited Stratford Fair. This led him to involve them in a large-scale fireworks show he organized at the Playground. He and Free Form then collaborated to organize a fun festival, the Hackney Marsh Fun Festival (HMFF), in which the neighbourhood children from the Adventure Playground played a prominent role. Rossiter and Free Form continued to work together; some of the scenarios used by the Mobile Roadshow performers, for instance, were originally developed by Rossiter in his work on Kingsmead. The HMFF itself, as happened with several of the neighbourhood festivals, became a regular event with its own organizing committee, chaired by Michael Gray, a prominent activist and local historian. In HMFF's third year, Gray was approached by a local social worker, Joe Noble, who asked if the HMFF Committee was interested in joining an effort by local community groups to turn a disused nineteenth-century library in Homerton (part of Hackney) into a centre serving a range of local community groups. The Committee, which was already looking for a place to hold regular meetings and a more permanent venue for its growing programme of events, was very much interested, and a joint campaign was launched to persuade Hackney Council to allow the library to be transformed into an arts centre. The council finally agreed, and, in 1976, the library, renamed Chats Palace, was reborn as an arts centre. The centre was used by a wide range of community groups, including Free Form and HMFF. It was run by a Management Committee made up of representatives of the different groups and chaired by Gray. A small grant from GLAA funded a programme of live arts events and paid the salary of a festival coordinator for the first year. This coordinator was Rossiter—the title artistic director, as he explained, would have been considered too hierarchical—and he took the idea of play, albeit play geared to adults rather than children, to the new venue. During its first year, Free Form ran a series of workshops. They also worked with the Management Committee to secure a grant from a government job-creation scheme, which over the course of the next year paid for the

transformation of the library, under Free Form's supervision, into a purpose-built arts centre. Over the years, further grants were secured, and Chats has now been operating for more than thirty years. Rossiter remained as artistic coordinator until he left to become a full-time member of Free Form in 1984.

At a time when many art centres were being established, this one was unusual in that it originated in the demand of a working-class rather than an art-world audience and, unlike Littlewood's Theatre Workshop and most traditional arts centres, succeeded in attracting a largely local audience. All the Chats Palace live events were rooted in the local community, both in their subject matter and in their performers, many of whom were local residents. This was an ethos quite different from the more high-art one of most arts centres. To open Chats Palace, for instance, Rossiter and Free Form, who drew on their Albany Empire experience, devised *The Hackney Show,* a theatre performance telling the history of Hackney. Goodrich describes how they 'went round all the community centres in the Hackney area and all the local areas doing this show and then invited people to come to Chats Palace to see the show and [then at the end of the show asked them] to be the creators of the next show'. A whole series of shows, most notably an annual lavish Christmas show, were created in this way, with Free Form organizing workshops for volunteers in which the new shows would be developed. The substantive role of local people in *creating* the shows themselves, rather than simply serving as spectators, makes this endeavour very different from that of even such avowedly populist theatre groups as Littlewood's.

Joan Littlewood's aspirations for a People's Palace played a role in the naming of the new venue, however. It was Michael Gray who came up with the name Chats Palace; he picked it partly, according to Rossiter, because it resonated with Littlewood's People's Palace and partly as a tribute to the Palace cinema that had once existed on Chatsworth Road. The general thinking behind the naming of the new venue gives a good idea of the spirit of the place and the determination that it should be somewhere working-class people would identify with and to which they would want to go. This is how Goodrich remembers it:

[The library] was on Chatsworth Road . . . Alan [Rossiter] was always saying, 'Well, when I was a kid, I used to go to the local Palace . . . it was like, "Yeah, the Palace, let's go to the Palace!"' Magical name. Glitter! A 'good night out' feeling rather than 'the community centre', which you knew that people were going to go, 'Well, I don't want to go there—it's full of social workers!' So it was called Chats Palace; it was definitely marketing itself along the line of 'it's a place of entertainment', it's like Caesar's Palace.

A major inspiration for the performance strand, whether at Chats Palace or the work of the Mobile Roadshow team, were older forms of popular theatre,

such as *commedia dell'arte*—something that was also true of many of the avant-garde theatre groups on whose work they also drew. In describing the scenarios used by the Mobile Roadshows, for instance, England explained, 'The basic structures the children were given were something like a modern *commedia dell'arte,* with stock characters from melodrama, like the baddy, the damsel and Jack the butcher's boy, the innocent. In Free Form's case, as England's stock characters suggest, they also drew on the very British traditions of nineteenth-century pantomime and music hall, but not, it should be stressed, in a way that tried to re-create the original historical forms. Rather, they picked up on the many traces to be found in contemporary British popular culture, as evidenced, for example, in television comedy shows—both the more highbrow *Monty Python* and the definitely lowbrow *Benny Hill*, for instance, drew heavily from these older comedy traditions. They also made extensive use of popular music. Taking these familiar, popular elements, the artists would help people use them to tell their own stories. We can think of them as trying genuinely to listen to the popular culture within which those they were trying to reach lived and to make use of its language. It is interesting that, when it came to performance events, the artists did not seem to have the same fear of lapsing into kitsch and sentimentality that they did in the case of visual culture.

In Gramsci's terms, both Chats Palace and the Mobile Roadshow and Workshop can be seen as having sunk at least a few 'roots into the humus of popular culture'. It is worth noting, however, that, in Britain, this is probably easier to do in the case of performance than in the case of visual culture. The British tradition of live performance available to the Free Form artists is both enormously strong—theatre is widely recognized as one of Britain's greatest cultural strengths—and less sharply divided into elite and popular than are the visual arts. I find it difficult, for instance, to imagine an event equivalent to the Momart fire (discussed in Chapter 1) in the sphere of live performance that would be likely to arouse quite such gleeful schadenfreude.

While the Free Form artists were committed to listening to those they wanted to reach and were happy to use their cultural vocabulary, they were also committed to their own artistic vision; the solutions they sought for their Briefs were not simple re-creations of existing popular culture. England expressed it like this:

> Throughout all of my time at Freeform—and I've always felt I shared that with other people—[I felt that] that whatever their particular aspiration was, there was an artistic aspiration behind it all, whether it was in a small detail of a little mosaic and how you involve people or whether it was some bigger notion of people coming together in a way through a show at Chats Palace and involving them in making the costumes and [learning the] dance. All of those sort of things.

The performance and time-based events of the early years were crucial in giving shape to the Free Form Project as it moved from aspiration to actual aesthetic practices and social relationships. In line with the intertwining of visual art and performance, one of the first environmental projects developed out of a festival the organization staged in Liverpool in 1973.

DEAD FISH AND TOTEM POLES

The impetus for this festival came not from the art world but from a Liverpool social worker, Chris Elphick, who was based in Granby, one of the most impoverished areas of an impoverished city. Elphick was visiting London to meet with people at Centreprise, a recently established radical bookshop that happened to be just two doors away from Free Form's Dalston Lane base, where *The Growth of Public Art* exhibition was showing. Noticing the exhibition, Elphick wandered in to take a look. Excited by what he saw, he asked if Free Form would be interested in coming to Granby to run a series of arts workshops with local children to culminate in a festival. Free Form was interested, a joint proposal was written, and Elphick secured modest funding from the Elfreda Rathbone Society, an organization dedicated to helping young people learn. This grant paid for a Free Form team, led by Goodrich, to go to Liverpool for six weeks.

Granby, located in Liverpool 8, the city's historically black district, was a harsh and violent place in the 1970s, and rife with racial tensions. Even the Free Form team, used to working in the far-from-genteel East End, were shocked by the violence and wildness of the children with whom they had to work, which they still remember vividly. For one of the team, Eva Newnham, 'there was an incredible culture of vandalism and wrecking and violence. It was like going to a war zone.' Goodrich's response to the situation, as remembered by Newnham, was to start from the very violence of the children: 'he actually got hold of the violence, and he said, "Right, we'll have an *It's a Knockout* [a popular, and very physical, TV game show of the time], we'll really do something physical."' In a makeshift arena, a complicated and demanding obstacle course was constructed, including a slippery pole which Goodrich kept wet by wielding a hose, over which the children scrambled, competing for prizes. 'And this, of course, contained the children. Because it was physical, you know, and it wasn't mainstream at all—I think if any health and safety officer would have come along they would have completely gone apeshit! But it was the response to this situation that we found ourselves in.' In other words, the Briefs the Free Form artists were taking on were teaching them to think on their feet and to listen to those they wanted to reach. The Festival culminated with various performances by the Free Form

team, including a fire show, and the whole event was judged enough of a success for it to be repeated the following year and for the next four years after that.

In 1974, by which time there had been two Granby Festivals and Free Form was both liked and trusted by local residents, Elphick and some of these residents again turned to the organization for help in a struggle they were waging with their City authority, Liverpool City Corporation. Some Granby residents and Elphick had asked the Corporation to do something about four derelict sites on local estates they had identified as particular eyesores. The Corporation's response was an offer to asphalt them. Enthused by the success of the Granby Festival, the residents demanded more; they suggested that they be turned into community gardens, allotments or play areas. The Corporation attempted to rebuff them, claiming that it would be too expensive. The residents persisted, demanding that the Corporation give *them* the £2,000 asphalting would cost so that they could organize the work themselves. This did not appeal to the entrenched and traditional Corporation, and things began to get increasingly tense. In a pattern that would be repeated a number of times over the years, an awkward situation for which there seemed no easy solution became an opportunity for Free Form: here was an organization with accredited artists that seemed professional enough for the Corporation to recognize it as capable of supervising such a project. It was agreed that Free Form, not the local residents (although it was understood that Free Form would be working with those residents), would be given a budget of £500 to transform one of the sites as a demonstration project to show what could be done on a very modest budget. A team, directed by Wheeler-Early and Ives, assembled a group of local people (a government job-creation scheme paying for their work on the site) who set about the transformation. First the artists talked with local residents to find out what they wanted. Then, taking the suggestions they were given, the artists constructed a series of scale models to show how these ideas might be realized. The artists then organized more meetings with residents, at which, using an approach now called 'planning for real', people were given the scale models and a site plan. By moving the models around the plan, they could explore various options and decide what they liked best. The artists took detailed notes of their responses and, on the basis of these, came up with a final design.

Under the direction of the artists, local residents, who included a number of carpenters and others with artisanal skills, then carried out the landscaping (see Fig. 13). Workshops were organized to teach various skills. These included the making of mosaics and the construction of concrete paving slabs for pathways and sculptural wooden seating. Running through the whole design was a surreal playfulness. Ives remembers participants building a pond

Figure 13 Constructing Granby mosaic, 1974 (photograph and copyright: Free Form Arts Trust).

out of fibreglass, encased in which were real dead fish, and creating totem poles from old telegraph poles. Wheeler-Early gave this account:

> We did the first mosaic mural on the wall with people, with broken tiles and china and stuff. And it was fantastic. It was very raw. Again, because in Liverpool 8 the streets were like everyone's front room, we had this communal seating on the corner where they could all sit and talk, and there was a little stage where the kids could do their performances. And all their mosaic work was embedded in the pathways and so on, and there was planting.

One of those who worked with them, a black Liverpudlian from the area named Lenny Cruickshank, created a new organization, the Diggers, which took on the task of carrying on the work on the remaining three sites. The Diggers continued to exist and to work locally long after these three sites were

completed. In 2004, Cruickshank, then chair of the Lodge Lane Regeneration Group, was still fighting to get the government to listen to local people and to stop them from demolishing Liverpool 8's Lodge Lane area (Girling 2004). The Granby landscaping work was never intended to be permanent; nonetheless, it lasted for a surprising number of years and was, in general, well looked after by local residents. While acknowledging the rawness of the work, Wheeler-Early noted:

> Now the Arts establishment would look at what we did and say in design terms we could have done more than that. But no designer was taking on those issues, and, if they'd have done it without involving [local people], it would have been smashed to pieces. But that project was not ruined. So *quality,* you have to see quality in context.

Goodrich, Ives and Wheeler-Early all identify this initial, small-scale environmental project in Liverpool as marking the beginning of what would some years later, in the early 1980s, become the organization's primary focus. More permanent work with those living in deprived neighbourhoods seemed, especially to the visual artists within Free Form, to offer ways of using their expertise which would allow them to be the kind of artists they aspired to be. Even though the assumption that visual art was about the creation of static objects had begun to be challenged, art school training in the 1960s was based on the making of physical objects, and the specific expertise the visual artists had acquired in the course of their formal training was very much grounded in that creative tradition. In part, therefore, the shift to environmental work can be seen as a return to a focus on what the Free Form founders thought of as specifically visual arts expertise. In Goodrich's eyes, this new direction could be seen as picking up on the Free Form Project Centre, launched at the time of *The Growth of Public Art* exhibition. That Centre had been intended to show that, as Goodrich explained in 2001, 'artists could work in a public context with social responsibility, addressing issues of need, and come up with good solutions and good ideas.' Environmental work of the Granby type, they felt, would enable them to fulfil this mission, and they began to look for more opportunities of this kind closer to their Hackney base. This area of work, however, would really open up only in the late 1970s with the expansion of government funding for urban regeneration.

Once the organization began to move in the direction of more permanent environmental work, it became clear that they needed people with accredited architectural qualifications—in part because of the kind of insurance needed for such work. They began, therefore, in the 1980s, to recruit people with this expertise: first an architectural assistant and then, later, an architect. They also began working with landscape architects.

THE ENVIRONMENTAL TURN

Not all the performance-oriented Free Form artists, however, were happy about the shift in focus to more permanent environmental work. Strains began to develop between the visual artists and the performers, who were themselves shifting towards film- and video-based work. The visual artists' shift to a more architectural focus made them increasingly aware of the importance of achieving the professional standards expected of more permanent projects. After all, if the idea was to create something that might last for years, it was important to provide people with something that they would be happy to live with over the long term. The performers, who also tended to a more radical politics, had different concerns, and the two strands began to pull apart. Around 1983, the various tensions exploded into a bitter dispute, which ended with the performers and the visual artists parting ways.

Interestingly, while the triggering factors may vary widely, a major dispute that ends up splitting the organization seems to be an almost inescapable moment in the life cycle of such groups. At around the same time that Free Form was going through its breakup, for instance, two of the organizations that had participated in Free Form's earliest events, Welfare State and Inter-Action, were torn apart by somewhat similar disputes involving both personality clashes and conflicts over their organizations' mission. The Free Form dispute, too, involved personality clashes, but at its heart was the question of the future direction of the organization: should it focus on performance or on more permanent environmental work? Disagreements over the organization's political identity added to the tension. While the performer faction argued for a more explicitly confrontational and oppositional stance, the visual artists saw this as threatening their official status as a charity—a status on which so much of their funding depended. After months of bitter wrangling, the dispute was submitted to the independent Advisory, Conciliation and Arbitration Service (ACAS), and an agreement was reached that the visual artists—Goodrich, Wheeler-Early, England, Goldman and Rossiter (Ives had left by this time), the architectural assistant and the landscape architect, and some others—would remain as Free Form, while the performers would form a new organization, Cultural Partnerships. Cultural Partnerships continued their video-based work and then, in 1987, formed a partnership with Matchbox, a theatre group working with people with disabilities, to launch a new group, Acting Up, to work with people with mental disabilities. Acting Up is still in operation. In this study, however, I focus on the environmental work and those who remained as Free Form.

For those who continued as Free Form, the dispute marked a distinct watershed: from this point on they would define themselves as a visual arts–based organization, with a central focus on environmental work. The slogan they

would later adopt reflects this focus: 'Making art*work* for the environment'. Given the deliberate shift away from performance-based work in the 1980s, it is particularly important to stress how closely entwined the two strands were for a number of years and how Free Form's aesthetic practices as a visual arts–based environmental organization grew organically out of the festivals and performance-based work. Even when I was carrying out my fieldwork in 2004/5, Free Form had not totally abandoned a performance element. The completion of significant stages of all the environmental projects continued to be marked, for instance, by elaborate, carefully planned celebrations, often involving performers, fire shows and the like. And, in some projects, as I describe in Chapters 8 and 9, performance could still be central. Nonetheless from the mid 1980s on, Free Form's major focus became projects that could help those living in impoverished neighbourhoods improve their built environment not only physically but socially, albeit in relatively modest ways.

One way of looking at this shift is as a development of the artists' original Charge, from 'Make art that speaks to working-class people!' to 'Use art to help people solve problems stemming from their built environment!' Linked to this development of their basic Charge was a new emphasis in their approach to the Briefs they were taking on. A central element of the Briefs shaping the neighbourhood Fun Festivals and the whole performance strand had been a determination to tap into the cultural worlds of those they were trying to reach, and, while the artists may have seen themselves as responding to local people's needs, as when Wheeler-Early refers to the hunger of the children with whom they worked on the Fun Festivals (see Chapter 2), the Briefs themselves had been devised by the artists, and it was the artists who tended to define the needs to which they were responding. With the turn to environmental work, the Briefs taken on began increasingly to originate with problems in the built environment that those living in impoverished neighbourhoods had themselves identified. The primary mechanism used to solicit these Briefs was the free advice service the artists set up: the Design and Technical Aid Service (D&TAS), which offered help with tackling environmental problems. The next chapter examines the history of the D&TAS and the wider context of the emergence of 'community art' and 'community architecture' which made it possible. This history of the D&TAS begins to suggest some answers to one of the questions I posed in the Preface, namely whether it is possible to imagine mechanisms through which ordinary, 'nonexpert' inhabitants of contemporary cities of the global North—especially those living in its more deprived neighbourhoods—could be included in genuine, if small, ways in the shaping of their built environment.

–4–

Community Arts and the Democratization of Expertise

> We wanted to make the professions be available to people. To work *for* them and not work *against* people.
>
> —Barbara Wheeler-Early

Free Form set up their Design and Technical Aid Service (D&TAS) in 1982. Its aims were defined as follows: 'To assist communities to improve their living and working environment in partnership with other agencies. To provide a full architectural service, promote the use of arts, crafts and decoration in environmental improvement works and encourage partnerships on urban and environmental regeneration schemes to create "a sense of place"' (Free Form nd). It is significant the D&TAS was envisaged as serving *community* groups. This was a time when the community arts movement in Britain was becoming increasingly confident and powerful; community arts, its advocates argued, offered new possibilities of more democratic forms of art and new ways for art to act as a catalyst for social change. The Free Form artists were very much part of this movement; beginning with the 1973 Canning Town Free Form Fun Festival, they had come to call what they did 'community arts' and themselves 'community artists'. By the early 1980s, community arts even had its champions within the traditionally high-art-favouring Arts Council. The growing acceptance of community arts as not merely legitimate but perhaps even important was certainly linked to larger political forces, but it was also the result of a struggle waged by community artists themselves—a struggle in which Free Form was a significant player. Free Form and the D&TAS can be seen both as products of a particular historical moment and as helping to create that moment. In the event, this moment would be relatively short lived, but it saw the birth of a number of new ways of imagining what being an artist might mean and how artistic expertise might be used.

Architecture, too, was swept up in the general zeitgeist, with a group of influential architects arguing for 'community architecture'. It was the community architecture movement in particular that provided the context for Free Form's D&TAS. I do not have the space to look at the history of community arts and

community architecture in any detail; it is important, however, to locate Free Form within this history.[1]

THE RISE AND FALL OF COMMUNITY ARTS AND COMMUNITY ARCHITECTURE

In the 1960s, the term 'community arts' had begun to be used by practitioners in theatre, visual arts, film and video, print and music in the USA, a number of European countries and elsewhere. The plural 'arts' was preferred to the singular 'art' since the movement included a wide range of different arts. I use the singular 'community art' when I am specifically talking about the visual arts. During the 1970s, the community arts movement in Britain succeeded in carving out an acknowledged space for itself within the art world. Exactly what community arts *was,* however, tended to be left a little vague, in part because breaking down the boundaries between different art forms and between art and nonart was often the goal of its practitioners. In practice, what defined community arts was more of a shared ethos than any specific aesthetic practices. Owen Kelly, in his 1984 polemical history of the movement, *Community Art and the State: Storming the Citadels,* quotes approvingly the definition given in a Greater London Arts Association (GLAA) policy paper—a definition which the policy paper was careful to call simply its 'terms of reference':

> [T]he term community arts does not refer to any specific activity or group of activities; rather it defines an approach to creative activity, embracing many kinds of events and a wide range of media . . . The approach used in community arts enjoins both artists and local people within their various communities to use appropriate art forms as a means of communication and expression, in a way that critically uses and develops traditional art forms, adapting them to present day needs and developing new forms . . . Community arts proposes the use of art to effect social change and affect social policies and encompasses the expression of political action . . . Community arts activists operate in areas of deprivation,

1. Academics have not studied the history of community arts in Britain in any depth. The main accounts that exist are written by community arts practitioners: Su Braden's *Artists and People* (1978); Owen Kelly's *Community Art and the State: Storming the Citadels* (1984); Malcolm Dickson's edited volume, *Art with People* (1995); and John Fox's *Eyes on Stalks* (2002). The journalists Nick Wates and Charles Knevitt's *Community Architecture: How People Are Creating Their Own Environment,* (1987) and the community architect Graham Towers's *Building Democracy: Community Architecture in the Inner Cities* (1995) provide accounts of the community architecture movement.

using the term 'deprivation' to include financial, cultural, environmental or educational deprivation. (1984: 1–2)

In my account of Free Form, I have stressed the centrality of the workshop to their creative practice. The Free Form artists were not alone, however, in using a workshop technique; indeed, the use of workshops can be seen as one of the characteristics of community arts. Within the visual arts, community art encompassed a general sense of an art that was not gallery art, that was collective rather than individual, and that addressed itself to those living in 'areas of deprivation' not normally reached by the established arts. As I noted in Chapter 2, it tends to be assumed, as here, that 'communities' are areas of deprivation; Mayfair, Islington and other prosperous neighbourhoods, it would seem, are not thought of as communities.

However fuzzy the definition, many of its practitioners had no doubts that community arts not only offered effective ways of addressing issues of deprivation but constituted a political programme. For such community arts activists, 'the use of art to effect social change', as the GLAA policy paper puts it, was central to their mission. Kelly, as his subtitle, 'Storming the Citadels', indicates, certainly did see community arts as 'critical art', the mission of which was to turn those involved into 'conscious agents of world transformation' (to use Rancière's formulation quoted in Chapter 2). Social mission and politics, however, were not all community arts were about: for many, and this included the Free Form artists, community arts also represented a legitimate and important new direction in the arts. Nonetheless, as in the case of the local councils which had provided funding for Free Form's neighbourhood Fun Festivals, what attracted potential funders tended to be the promised social benefits—as long, that is, as these stopped short of radical social change. A crucial factor here was the widespread consensus that Britain's cities were facing major problems. By the mid 1970s it was agreed by politicians, planners and the lay public that the development schemes of the 1960s and their tower-block solutions for public housing, had failed; a new kind of urban development was needed to address the devastation of so many inner cities, and whatever form this development might take, there had to be greater investment in the inner cities. This consensus led to a major increase in government funding for urban regeneration by the Labour government then in power. This new funding became something that community arts organizations, such as Free Form, could tap into; it was urban regeneration money that would fund Free Form's D&TAS.

Within the art world, however, community art remained suspect. Benign condescension was often the best it could hope for from the art establishment. The response of one reviewer, Sarah Kent, to a 1976 exhibition organized by the community arts organization Tower Hamlets Arts Project at

the prestigious London Whitechapel gallery captures the prevailing sentiment among the curatoriat. It is worth noting that her review appeared not in some high-art journal but in the mainstream listings magazine *Time Out*. Kent is quite clear:

> Community art and gallery exhibitions seem to me to be ideologically opposed: community art is justified by the quality of the involvement of participants and not the end product. To present them for exhibition, therefore, seems absurd and suggests delusions of grandeur inappropriate to the purpose, function and political stance of community arts. (quoted in Walker 2002: 134)

There was, however, an influential minority within the curatoriat who were becoming convinced that, as the Free Form artists remember Lawrence Gowing putting it, far from community artists being 'the poor relations of the Arts doing substandard work of no consequence', they were in fact 'the rich relations . . . opening up new avenues and new opportunities which many of us have not even thought about' (quoted in Chapter 2). So how was this recognition achieved—recognition of an approach to the arts that went so against the grain of both art world and commonsense understanding of what makes art 'good'? Key here was the Association of Community Artists (ACA). The ACA was founded in 1972 by Goodrich and two other community artists: Maggie Pinhorn, a filmmaker whose experience of the heavily union-dominated film industry had provided her with a compelling example of the power of organization; and Bruce Birchall, who ran the West London Theatre workshop. That year, all three attended an Arts Council–funded two-day seminar on community arts at the Institute of Contemporary Art (ICA), at that time one of the foremost centres in Britain for avant-garde art. The ACA was born out of their postseminar discussion in a local pub: what was needed, they agreed, was an organization to represent their needs and to lobby the Arts Council for increased funding.

Goodrich, Pinhorn and Birchall were all pragmatists rather than theorists. Or, perhaps more accurately, their theory tended to be embedded in their practice rather than articulated in manifestos. As regards the ACA, they felt very strongly that what was needed was a broad, inclusive organization with room for the many and varied manifestations of community arts—a field they saw as both emerging and fluid. What was important was that the ACA present a united front to the Arts Council, government and other funders. Later, this inclusive, pragmatic approach would come under attack from the more doctrinaire and explicitly political faction within the community arts movement, and, by the early 1980s, this faction had taken over and displaced the original founders. For Kelly, for instance, the ACA, through its lack of a clear theoretical position and its opportunism, allowed the community arts movement to be stripped of its political muscle and reduced to no more than 'one more worthy branch of whatever this government [that is, the Conservative government of

Margaret Thatcher] chooses to leave of the welfare state. Meals on wheels, homemade scones, inflatables and face painting: the kindly folk who do good without ever causing trouble' (1984: 1). An important point here, however, is the legal limitations faced by any community arts organization registered, as Free Form and a number of others were, as charities. As I noted in the context of Free Form's decision to become a registered charity, a charity organization, while it can lobby for its aims, cannot act as an explicitly political organization.

The ACA certainly believed in lobbying, and, initially at least, this involved direct and very public confrontations with the Arts Council. For instance, Pinhorn described to me how they used to organize large and carefully choreographed demonstrations when the Arts Council was meeting. The ACA demonstrators would station themselves outside the large window of the meeting room with boards designed by Goodrich on which were slogans countering those of the Arts Council. Instead of the Arts Council's 'Few but Roses', for instance, they would proclaim 'Masses of Art by Masses of People' and—referring to the statistic that the Arts Council spent 99 per cent of its budget on art that reached 1 per cent of the population—'1% of the budget for 99% of the people'. Even Kelly acknowledges the success of ACA's lobbying.

> [The ACA] were interested in the possibilities of funding, in finding out what money was available and how they could best lobby to make more available. Over the next seven years, they were extraordinarily successful at this. The ACA became *the* body which the grant-giving agencies recognized as speaking for community artists. It grew to have an active membership in all the regions of England coordinated by a national steering committee, and its members developed the capacity to organize conferences at which information could be shared and funding issues discussed. (Kelly 1984: 12)

Another pioneer of community arts in Britain, Sally Morgan, echoes this assessment. Looking back in 1995, she wrote: 'In my opinion ACA was the single most important element in the forging of the community arts movement. Through it we discovered each others' work and ideologies . . . it provided a network for practitioners that was never bettered' (1995: 17).

Overall, the ACA provided a means through which the community arts movement could present a united front to the arts establishment that was difficult for the Arts Council to ignore. Part of the problem for the Arts Council, as Robert Hewison notes in his history of the relationship between art and politics in postwar Britain, was that, right from its founding as the Council for the Encouragement of Music and the Arts (CEMA), it had a contradictory mission. The Council was there to maintain high standards in the arts, but it also had a mandate to make the arts more widely available. According to Hewison,

84 COMMUNITY ART

'Although by 1945 this conflict had been resolved almost entirely in favour of art and the professional artist, an assumed obligation to act as a form of social service has always exerted a contrary pull against the Council's responsibility for "standards"' (Hewison 1995: 34). In the 1970s, when the art world in Britain was under attack from many quarters for its perceived elitism, it was awkward for the Arts Council to appear to be simply turning its back on its social service obligations. And, in 1974, thanks largely to the campaigning of the ACA, the Arts Council set up a Community Arts Panel. In its first year, the panel was given £176,000 to distribute in grants to community arts organizations, and this was doubled to £350,000 in its second year. These represent considerable sums in comparison with the minuscule funds previously available for community arts, even if community arts never received more than a couple of per cent of the total public subsidy for the arts. Nonetheless, by the late 1970s, community arts seemed an established part of the art world, with an exciting future ahead of it (see Fig. 14).

Figure 14 Free Form poster, 1979 (photograph and copyright: Free Form Arts Trust)

Harold Baldry's Arts Council 1981 commissioned report, *The Case for the Arts,* reflects the optimism. Baldry was an eminent classicist and senior academic who had served on various Arts Council panels, including the Community Arts Panel, for a number of years. He was both excited and cautiously optimistic about this new development in the arts, writing:

> In my view community arts must still be regarded as an experiment—an experiment in 'cultural democracy' of great importance not only for the immediate stimulus and enjoyment it can provide, but because its long-term results—or lack of results—will throw light on the question 'arts for whom?' which is vital for the future of our society. (1981: 147)

Among the various community arts organizations Baldry discusses in *The Case for the Arts,* Free Form is mentioned as 'one of the most successful groups' (Baldry 1981: 143).

Within the Arts Council establishment, however, community arts enthusiasts like Baldry were always a minority. For those on its visual art panel, community art tended to be seen as an overly populist approach that produced substandard art—an attitude reflected in some of the comments made by Arts Council evaluators about specific Free Form projects (see Chapter 6). Ultimately, it was this hostile view that would prevail. In reality, community arts was always an awkward fit within the established art world, and its moment in the sun would turn out to be relatively short lived. As enthusiasm for community arts began to wane in the 1980s, its support within the art world was further weakened by the devolving of its funding to the Arts Council's regional associations. In addition, community art to many people—and not only within the ranks of the curatoriat—came to be associated with amateurish, poorly executed murals on the worst of the worst estates. In truth, one has to say, some of the work done was poorly designed and executed. But probably more important was the chill wind of Thatcherism that blasted the political consensus that had opened a space for community arts.[2] In 1981, when Baldry declared his theme in *The Case for the Arts* to be 'the inevitable emergence of the taxpayer as the main future patron of the arts' (1981: 4), he was reflecting a general consensus in Britain among politicians and the curatoriat. The inevitability of this for Baldry, as for many others, was beyond question. He writes confidently: 'unless Armageddon or a revolutionary transformation of society comes upon us, this development will continue into the future' (1981: viii). In the event, however, the Thatcher revolution, seen by many in Britain as

2. The Conservative Party, led by Margaret Thatcher, came to power in 1979, ushering in eighteen years of Conservative rule during which British politics moved decisively to the Right.

indeed something of an Armageddon, would sweep away such entrenched entitlements to public patronage. In this harsh new world, private patronage, particularly by big corporations, and ever more complex private and public 'partnerships' became the norm. It seems to me that it is these seismic changes, rather than, as Kelly argues, the community arts movement's lack of a clear political programme, that explain its decline. In any event, by the 1990s, the hard-won space community art had established for itself within the art world in Britain had essentially disappeared, even if community art retained legitimacy as a form of social welfare.

Community artists were not the only ones experimenting with new forms of 'cultural democracy' in the 1970s. A number of architects were also thinking about how to give working-class people genuine input into the design of their built environment. This movement—always a loose network that included a wide range of approaches and philosophies—came to be called community architecture, and for a time it attracted considerable attention from British funders and policy makers.[3] A high point was the election, in 1976, of 'the movement's most able politician and propagandist, Rod Hackney' (Wates and Knevitt 1987: 27) as president of the prestigious Royal Institute of British Architects (RIBA). But, after a brief flowering, community architecture, like community arts, withered. Its demise was officially proclaimed in 1989 by Hackney's successor as RIBA president, Max Hutchinson, who declared: 'Community architecture is dead' (quoted in Towers 1995: 217). Nonetheless, for a few years, the community architecture movement facilitated funding for some interesting initiatives, including Technical Aid Centres.

One of the earliest Technical Aid Centres was NUBS (Neighbourhood Use of Buildings and Spaces), established in 1975 by Free Form's former collaborators Inter-Action to provide a free architectural service to community groups. It was in the early 1980s, however, that the idea really took off, with technical aid centres springing up throughout Britain. In 1983, a nationwide Association of Community Technical Aid Centres (ACTAC), of which Free Form was a founding member, was set up. The Association's aim was defined as 'bringing together community groups with professionals, skills and information to aid in the creation and realization of community based projects that embodied an element of environmental awareness'.[4] For a time, the organization was very active, but it could not survive the loss of the architectural establishment

3. Nick Wates and Charles Knevitt's 1987 study, *Community Architecture: How People Are Creating Their Own Environment*, written at a moment when community architecture still seemed the wave of the future, provides an account of the development of the movement in Britain.

4. From http://www.liv.ac.uk/abe/actac/frontend.html, accessed 25 July 2008.

COMMUNITY ARTS AND THE DEMOCRATIZATION OF EXPERTISE **87**

and government funders' support. The remnant ACTAC Web site from which I took the definition of its aims also explains that 'when previously supportive government agencies all failed to produce further funding a few years ago the organization was gradually wound down. None of the subsequent bids for funding were successful so the organization ceased as such in 1999.'

It was within this larger trajectory of the rise and fall of community arts and community architecture that Free Form's D&TAS came into being, flourished for a time, and then, as funding fashions changed, had to reinvent itself. My account of the D&TAS focusses on the nature of the expertise it provided and the location of the Free Form artists and their expertise within the D&TAS projects. A major part of this story is how the experience of these projects further transformed Free Form's aesthetic practices and aesthetic language. My account brings together the artists' accounts and memories with those of some of the 'nonexperts' who participated. All the voices I quote come from tape-recorded interviews I conducted between 2001 and 2005.

EARLY ENVIRONMENTAL WORK IN HACKNEY

For the visual artists within Free Form, the Granby environmental project in Liverpool had opened up a new way of fulfilling their Charge, and they were eager to find more Briefs of this kind. London's East End had plenty of neglected, unlovely corners that seemed to be crying out for the kind of small-scale, imaginative transformations Free Form had helped bring about in Granby. But it was only in the late 1970s that funding for such projects began to open up. In the autumn of 1978, the Labour government then in place launched Operation Clean-up, which allocated money for environmental improvements in impoverished inner-city boroughs. Hackney Council was granted £300,000 to be spent on environmental improvements to the borough before March 1980. By this point, the Council planners had come to recognize Free Form as an organization doing interesting work in 'the community', and Free Form was awarded a small grant from the Operation Clean-up monies to improve a derelict corner of a new council estate. As the site was at the junction of Daubeny and Redwald Roads, the project became known as Daubeny Road. Just what it would involve and how it would be carried out was left open.

The availability of the Operation Clean-up monies meant that, although the funding offered—£16,000—was modest, it was vastly more than the £500 available for the Granby project. For the Free Form founders, this seemed the perfect opportunity to revisit some of the ideas they had first conceived in the context of the abortive Fairlop School project. In Goodrich's words, 'All of a sudden, the opportunity to do the things we'd first thought about way back in 1969 (creating environmental change) was back on the agenda, and we had

88 COMMUNITY ART

budgets suitable to achieve them.' At the same time, the aesthetic language and practice of the Free Form Project had travelled a long way since Fairlop. This Brief would centre on collaboration between artists and local residents, although, once again, those most actively involved would be children, rather than adults.

The first use of the Operation Clean-up grant was to pay for a Free Form team, led by Goodrich and Goldman, to run workshops with local children in which the imagery for the project was developed. The children also learnt skills, such as the making of mosaics, which allowed them to participate actively in the making of the artwork (see Fig. 15). By this point, Free Form's mosaic work, influenced by Antonio Gaudi's as well as others', had become far more sophisticated and professional than the first experiments in Liverpool. The workshops culminated in the creation of a large mosaic mural with plant imagery, trellis work, and the landscaping of a small area in front of the mural.

Figure 15 Working towards a mural design, 1980 (photograph and copyright: Free Form Arts Trust)

In 2005, I interviewed one of those who worked on this project as a child, Carlos Pardo. Although Pardo later moved away from the area and professed that he did not have much interest in 'art', he had warm memories of Free Form. At the time of my interview, he was the manager of a branch of a chain of stores that hire out equipment to small contractors and homeowners. It was one of the artists employed by Free Form at the time of my fieldwork, who had happened to rent a piece of equipment from Pardo's store, who had suggested I interview him. Apparently, as soon as Pardo had seen Free Form's name on the rental agreement, he had begun reminiscing fondly about his experience of the project. Although he would have been only around six at that time, Pardo still has vivid memories of participating. He explained to me: '[The project] was the end of Redwald Road, the corner of Daubeny Road, and it was literally an area where they used to dump rubbish. And they turned it into a rockery and did mosaics, and everyone did their own initials in the mosaics.' What Pardo sees as particularly valuable about the project was how it drew people together. The estate was very new, with a lot of single-parent families, 'so they had a lot of kids in a very small area, where they didn't have anything to do. There was no playground.' 'It was only when Free Form started coming in that people got to know each other,' he added. When I asked him what had stayed with him from the project, it was this he stressed:

> The great thing I liked about it is that it actually got the community together, all the children. Everyone got to know each other more. And it also kept the kids off the street, all the trouble and everything else, because they were too busy. And they were actually enjoying doing their own mosaics and having their initials there and knowing it was going to stay there for a very long time. And I believe it's still there to this day.

As Pardo remembers it, as long as the children who had participated were living in the area, they respected it: 'The kids left it alone because they'd done it. So there was no graffiti, no damage, no stones hit on it. It was just left alone.' It is worth noting that Pardo twice mentions the children putting their initials on the piece. It is as if leaving their mark in this way allowed them to claim ownership. Pardo also remembers the adults enjoying the space once it was finished: 'It was somewhere they could sit about and just relax. Some of the people on the actual end of the terrace got their chairs in the summer time and had the chairs along [the strip of planting in front of the mural] while talking to each other. So it turned into a little community area bit. It made the area look much better than it was.'

The Daubeny Road project was followed by two similar projects also funded with similarly modest grants from Hackney Council: the City Garden, in 1980, and Evering Road, in 1982 (see Fig. 16). The City Garden involved Free Form

90 COMMUNITY ART

Figure 16 Evering Road mural (created in 1982), 2009 (photograph and copyright: Kate Goodrich)

and local residents again turning a rubbish-strewn corner, this time on the main Kingsland Road, into a little seating area backed by a mosaic and trellis-work mural. The name City Garden was intended as a call for other such derelict sites to be transformed into gardens; the imagery developed in the workshops with local children celebrated a famous nineteenth-century plant nursery, which had occupied a nearby site, and its nurseryman, Thomas Fairchild (author of the first book on urban gardening). Evering Road was yet another little oasis created with local residents. It featured a mosaic celebrating the street parties held to mark Queen Elizabeth II's coronation and her Silver Jubilee, showing a street party framed by a giant willow tree, representing, as Goodrich explained, the presence of the country in the city.

The Operation Clean-up funds may have allowed the Free Form artists to revisit the ideas of environmental work they had first imagined in the context of the original Fairlop School proposal, but the aesthetic character of the projects and their imagery had moved a long way from the work of the colour field artists who had originally inspired them. I examine the process of developing imagery for projects through workshops in more detail in Chapter 6 when I tell the story of one of the larger D&TAS projects, Provost, and again in Chapter 9 in the context of a more recent project.

PROVIDING ACCESS TO EXPERTISE

For the Free Form artists, their experience of developing and working on these small environmental projects was increasingly coalescing into a distinct way of using their expertise. Here, they felt, were Briefs which cried out both for collaboration with the people living in these impoverished neighbourhoods and for solutions rooted in visual arts expertise. There was a problem, however. Potential funders seemed to have difficulty grasping what exactly these solutions were. Were they art? Did they represent a different kind of planning? Community outreach? They just did not seem to fit comfortably into any of the preexisting conceptual boxes. As Wheeler-Early put it, 'It didn't have a name, so we weren't getting support for it'.

This was particularly frustrating given that there seemed to be more and more government money going to local councils for urban regeneration. In the early 1980s, Operation Clean-up itself was incorporated into the new Environmental sector of the Inner City Partnership Programme, which was itself part of a larger initiative, the Urban Programme. The Urban Programme was launched by the Labour government in 1977, just two years before Thatcher's Conservative government would sweep it from office, but the Programme continued into the Thatcher years. The funding available to Hackney under the Partnership Programme grew from £580,000 in 1979/80 to £1.3 million in 1985/6. Then, in the early 1980s, the Labour Greater London Council (GLC), London's overarching local authority, which had ousted the Conservatives from power in London in 1981, instituted the Community Areas Programme.[5] This was a policy aimed at helping impoverished inner-city London boroughs such as Hackney gain greater access to government funds.

It seemed that all this funding should be opening up opportunities for an organization like Free Form, particularly since much of the regeneration money came with strings that presented local councils with a dilemma: the money was supposed to go to local 'communities', not directly to the Council. But who or what was the appropriate 'community' entity with which the Council could deal? The 'communities' envisaged by the Community Areas Programme, for instance, were not actual entities with formal institutional structures but rather those far-harder-to-pin-down informal communities based on a localized sense of belonging. However elusive such 'communities' may be in the real world, they tend to be a powerful presence in the pronouncements of politicians and policy makers, such as Prime Minister Blair's speech on Ocean Estate quoted in Chapter 2. Given the contradictory reality of communities,

5. The Left-leaning GLC, headed by Ken Livingstone, was a particularly irritating thorn in the flesh of Prime Minister Margaret Thatcher, and she succeeded to abolishing it in 1986.

elusive in the real world while a simple fact for policy makers and politicians, what the councils needed in this instance were intermediaries capable of working with these elusive shadowy beings and of working with them on improvements to the built environment. Free Form, by now recognized in Council circles as having expertise in working with the 'community', should, particularly given its increasing environmental focus, have been well placed to act as one of these intermediaries for Hackney Council. Potentially, as in Granby, what confronted local officials as a problem could be an opportunity for the organization. But, to take full advantage of this, the work had to be explained in language intelligible to local politicians and council officials.

A term that seemed to be in the air in the early 1980s was 'technical aid'. Technical aid, as I explained earlier, was the name used by the growing community architecture movement for their mechanisms for making professional expertise available to those living in impoverished neighbourhoods. Technical aid, it seemed, offered Free Form the 'name' they needed to describe their environmental expertise to the Council. With this name, the organization was in a position to put itself forward as an intermediary between Hackney Council and the 'community'. Free Form now had several people with planning and architecture skills working with them, and they, together with Wheeler-Early, wrote a funding proposal. Using the language of technical aid, the proposal requested support for a free design service that would help local groups apply for regeneration monies. The basic idea was that, in Goodrich's words, 'any community group could come to this facility [D&TAS] and say, "We've got a problem on our estate which is to do with the environment, this is what the problem is. Could you help us to make the case to make a bid to the Urban Programme?"' The Council liked the idea, and Free Form's D&TAS was one of four such services funded by the GLC. From 1982 and continuing for approximately ten years, this funding paid the salaries of three professionals (an architectural assistant, a landscape architect and a visual artist). This provided a crucial core of expertise available free to any local group. As the D&TAS work expanded, artists from outside the organization might be contracted to work on specific projects or a particular element within a larger project. In the project discussed in Chapter 6, for instance, the metalworker Stuart Hill was commissioned to manufacture the decorative railings designed by Goodrich.

The D&TAS was very popular, receiving hundreds of enquiries each year; Free Form was by now well known in the area, and their shop front in Dalston Lane provided a walk-in centre where information and explanatory leaflets were available. Reflecting Hackney's multilingual character, by 1991 leaflets had been produced in more than ten of the languages spoken locally, including Turkish, Bengali, Punjabi, Gujerati, Swahili, Hausa, Somali and Amharic. An individual, a tenants group, or some other organization would hear about the

Service, often from a community development officer or other local official, maybe at one of the meetings the Council organized to publicize the availability of funding for regeneration, and ask for advice as to how to improve an estate or tackle a local eyesore. One or two of the Free Form team would then visit the estate or other site and meet with local people, listening to their concerns and getting an initial idea of the place. There would then be subsequent meetings in which the Free Form team would help people develop ideas for feasible projects and write up funding proposals, which would include detailed technical drawings of the planned work, to be submitted to the Urban Programme or some other funding scheme.

A key point here is that, however keen the government might be for 'the community' to be 'empowered', those living in social housing with no design or architectural training cannot simply redesign their public spaces themselves. They need access to those who do have those skills, people with the expertise to help them think through what they want and what is possible, and to produce the detailed technical plans required. As Wheeler-Early stressed, 'it wasn't that we were deprofessionalising anything, but we wanted to make the professions be available to people—to work *for* them and not work *against* people.' The basic model here is that of the D&TAS acting, first, as a consultant able to provide professional advice and lay out different possibilities and, second, as an advocate and agent able to clear a path through dense bureaucratic thickets and turn ideas into concrete realities. In the eyes of the Free Form experts, the relationship was that of client and employer, with local groups employing them much as a wealthy client might an architect.

All the prefeasibility work prior to the securing of funding for the project was provided free. The D&TAS's core funding subsidized the many hours spent visiting different groups, listening to them and working on possible solutions. Once the 'community' group had been granted funding, it would pay Free Form or some other organization to carry out the work. By this point, approximately half the organization's income was coming from the revenue grants it received, with the other half coming from the fees it was paid to carry out projects—often from grants the D&TAS had helped a tenants association or other local group secure. There was no requirement that a group which Free Form had helped in this way use Free Form to do the actual work, but the strong relationship built up during the work on the proposal meant that usually they did. The whole process might well extend over a number of years and involve a series of separate projects, the organization's core funding enabling them to work intensively with people over a long period and to provide a high standard of work at a relatively low cost.

Over its ten years existence, the D&TAS carried out more than 100 projects. Many of the individual projects were quite small, along the lines of Daubeny Road and the other early Hackney projects, but there were also bigger projects

that extended over a number of years. Workshops of one kind or another, involving local people, were central to the process of developing ideas for specific projects and for carrying them out. Once the organization shifted to an environmental focus, the problems defined by the overall D&TAS Brief and the specific problems of individual D&TAS projects played a major role in shaping the artists' aesthetic language and practice and the kind of the relations they established with the 'community'. In the next two chapters, I explore the nature of that shaping through an examination of two of the larger D&TAS projects, Goldsmiths and Provost. The chapters can also be seen providing an example of what a collaborative relationship between artist experts and those who may 'know' a lot about where they live but do not have formally accredited expertise might look like—to go back to one of the questions I raised in the Preface.

–5–

Responding to Local Needs: Goldsmiths

[T]he art is very, very important, because it gives colour; it gives direction . . . people feel they've achieved something because they've had a little input.

—Dee Emerick, Goldsmiths Estate Tenants Association

One of the earliest and largest D&TAS projects began in 1982 on a particularly bleak and rundown Hackney council estate, Goldsmiths (see Figs. 17 and 18).[1] As with a number of the D&TAS projects, the work done on Goldsmiths does not fit easily into traditional understandings of what constitutes 'art'. The very process of focussing their visual expertise on finding solutions to problems that the 'community' itself had identified pushed the artists yet further from the concerns of the gallery world. As I noted in Chapter 3, we can see the artists' Charge as having shifted from 'Make art that speaks to working-class people!' to 'Use art to help people solve problems stemming from their built environment!'

Goldsmiths Estate has a mix of older low- to medium-rise walk-up apartment blocks built between the two World Wars and newer medium- to high-rise blocks built in the 1960s and 1970s. When the project began, the building stock was in very poor condition, with a number of derelict properties. According to the 1981 census, the estate had 196 flats (some of which were vacant) and a total population of 461 persons living in 160 households. It was racially mixed, with approximately equal numbers of white British-born, Irish and Afro-Caribbeans, together with a small number of people from the Indian subcontinent and Turkey. As in the rest of Hackney, unemployment was high. The estate's local reputation as rough and dangerous made it unpopular with Hackney's council tenants, and, once housed there, people found it difficult to move, since this required finding a council tenant from elsewhere willing to move to the estate. This did have one positive result: because so many of the tenants had lived there for years and knew each other well, there was a cohesiveness amongst them. This was reflected in a strong tenants association—or, rather, two tenants associations. Until 1982, when Hackney took over the whole estate, its ownership

1. In addition to interviews with the Free Form artists and Goldsmiths tenants, this chapter draws on the Report, 'Extending Participation', on the Goldsmiths project that Wheeler-Early wrote for UNESCO in 1985 (Free Form 1985).

96 COMMUNITY ART

Figure 17 Goldsmiths Estate before D&TAS project (photograph and copyright: Free Form Arts Trust)

Figure 18 Goldsmiths Estate after D&TAS project (photograph and copyright: Free Form Arts Trust).

was shared between two local authorities: the older properties, generally the ones in worst shape, were owned by Hackney Council, the newer ones by the GLC. This led to considerable confusion as to which authority was responsible for what, and large parts of the estate, especially the common public areas, ended up neglected by both. Prior to 1983, when they merged, Hackney and GLC tenants each had their own tenants associations, and there was a history of tension between the two parts of the estate. Once they started working on the estate, the Free Form team found itself having to navigate between the two factions.

It was one of the leaders of the Hackney blocks tenants association, Dee Emerick (see Fig. 19), who brought Free Form to the estate. She and another tenants association member approached Free Form at a meeting organized by the GLC to explain its new Community Areas Programme and its eligibility rules. Representatives of the D&TAS team were there, as were a number

Figure 19 Dee Emerick 2009 (photograph and copyright: Kate Goodrich).

of other consultants to whom local groups could go for advice. Emerick was looking specifically for help in refurbishing the estate's dilapidated games pitch, something for which she had been trying unsuccessfully to find money for some time.

The issue of the games pitch had been raised with the tenants association by the estate's young people, but the focus here also fits a common pattern. According to Goodrich, this wanting 'to do something for the kids is usually the first thing most community groups talk about'. However many problems there may be—on Goldsmiths, for instance, 'their internal property was terrible: there was damp everywhere'—what people want is 'to do something for the kids'. Equally typically, those running the Goldsmiths tenants association and providing the driving force were almost all women. It seems that the work that goes into making 'the community' a more pleasant place to live, which frequently involves a lot of unpaid labour, tends to be seen by both men and women as essentially the responsibility of women; implicitly, at least, it is viewed as part of their maternal role as homemakers. The list of attendees of one Goldsmiths tenants association meeting with the GLC Housing Department reflects the gendered nature of such community work: almost all the officials were men, while all but one of the five tenants association committee members attending (including the chair and the secretary) were women (Free Form 1985).

Dee Emerick was one of the most dynamic of the Goldsmiths women. Born in 1932, Emerick grew up in London and has lived most of her life there. She moved with her family to Goldsmiths in the early 1960s, and, within a year or two of her arrival, she and a few of the other tenants, encouraged by the local community officer, had set up a tenants association for the Hackney-owned part of the estate. At the time of my fieldwork, by then in her seventies and still living on Goldsmiths, Emerick was still active in the tenants association, of which at different times she has been chair, secretary and treasurer. When the D&TAS project began, she was secretary, and since she was unemployed, she was able to devote a lot of time to the association. I interviewed her about her experience with Free Form in 2005.

FOOTBALL AND MOSAICS

Both the tenants association and Free Form were eager that there should be a good turnout for the tenants' initial meeting with Free Form on the estate, not just a few dedicated activists. To this end, invitations were delivered to every flat. At this first meeting, it was agreed that the priority should be the renovation of the games pitch and that this should include some landscaping

round the pitch. The landscaping suggestion came initially from the artists, who were keen to give the games pitch its own individuality, something that would make it 'special'. A tenants' design group, composed of the tenants association committee and any interested residents, was set up. An important and influential part of this group were the young people who had originally pushed for the pitch's refurbishment. The D&TAS team was led by Goodrich, Wheeler-Early, Goldman and the architectural assistant they had recently employed, Christopher Shanks. Another important member of the team was a landscape architect, Georgina Livingstone. A series of eight workshops on the estate were organized in which the design group worked through various possibilities with members of the Free Form team. The group's recommendations were reported back to the tenants association at meetings which were also attended by the relevant GLC and Hackney Council officials. Wheeler-Early's UNESCO Report lists examples of the decisions reached by the tenants' design group. One issue discussed was how many games the pitch should accommodate. Although there were some girls among the original group of youth who had approached Emerick, it tended to be the boys and their keenness for a football pitch that dominated. Nonetheless, it was agreed there should also be accommodation for games played by girls.[2] And then there was the question of what kind of fencing to use. 'The tenants decided that an extra strong fence was required to contain the pitch but that there should be no locked gates, so that people wouldn't be deterred from making use of it or be prompted to vandalize the fence out of frustration.' It was also urged that floodlights should be provided 'so that the pitch could be used at night, but in a controlled way. It was agreed that games wouldn't go on after 9:30 pm' (Free Form 1985: 31–2).

Two months after their first meeting with Free Form, the tenants association successfully applied for a grant under the Community Areas Programme—central to the expertise the GLC saw intermediaries such as Free Form providing were the skills needed to write fundable applications. The Tenants Association were awarded £95,000 to refurbish their games pitch. Few of the young people who were such an important part of the design group had jobs, and both the tenants association and Free Form were keen that as many as possible should be employed, even though it would only be for a few weeks, to carry out the basic clearance of the site. The D&TAS team helped Emerick and the tenants association overcome the many bureaucratic hurdles to make this possible and ensure that they would be paid a proper wage for the job. Emerick told me how many of these young people who worked on the project, now grown men, still use the pitch: 'Although they've moved away, grown up and got families, they still come back and play here.'

2. In early-1980s Britain, football (soccer) was very definitely a boys game.

For one man at least, the Goldsmiths project provided a path to more permanent employment. Ian Christie was a twenty-three-year-old Afro-Caribbean man who had been one of those pushing hardest for the renovation of the games pitch. Once the planning got under way, he became an articulate and forceful presence in the tenants' design group. He was then employed on the site clearance work, and later Free Form employed him on other D&TAS projects. By the time the UNESCO Report was written, he had a full-time supervisory job with the Manpower Services Commission (a government agency set up in the 1970s to help create jobs for the unemployed).

The refurbishment of the pitch itself took eighteen months, and its completion was celebrated on 10 June 1984 with a football tournament and festival. By this point, in large part because of the enthusiasm generated, the initial project was being seen by Hackney Council as Phase I of a larger renovation project that would involve a more wide-ranging landscaping, with an estimated cost of £140,000. It was envisioned that Phase II would be part of a major rehabilitation of all the estate's apartment blocks to be undertaken by Hackney Council, a plan for which the tenants association and Free Form had argued strongly. Emerick stressed to me how the enthusiasm generated by the initial environmental work had made it much easier to mobilize the tenants to agitate to have their concerns taken seriously by the council. She explained: 'When I wanted somebody to come from the Town Hall for a meeting with me, I'd say I want twenty, thirty people [and] they'd be there . . . I think if we hadn't actually stood up and said our piece we would have got palmed off with what they thought.' We can see this as an example of how such a project can help bring into being an actual 'community' able to act collectively.

Free Form continued working with the Goldsmiths tenants on Phase II, which included both landscaping and the creation of an under-fives play area. And, even after the completion of Phase II in 1986, the relationship with Goldsmiths continued into the early 1990s with a series of smaller projects and other forms of support. The relationship was strengthened by the fact that Emerick had become chair of the D&TAS, visiting tenants and other groups both locally and further afield to help explain to them what the D&TAS was offering. She also attended conferences and meetings where those to whom the work needed to be explained were the planners and politicians. I asked Emerick how she saw Free Form's role in shaping the various elements of the Goldsmiths and the other D&TAS projects. As she remembered it, they had provided advice, but it was the tenants' ideas that prevailed:

> I'd like to do whatever, whatever—which a committee decided, I mean I didn't just do it off my own back without any consultation—and then Free Form would come down and we would put our ideas in. If we needed advice they would give it, but

they never forced it on you, never said, 'Well no, you should have this and you should have that.' It was the tenants' ideas from beginning to end. And until the tenants were absolutely satisfied with what they'd got, the project wouldn't start. They had to be absolutely satisfied with what they wanted and what they were going to get. And mostly what they decided, they got. I mean obviously there might have been a snag here and there that was unforeseen, but then that's going to happen anyway, so you do need the expert advice.

It is worth stressing here Emerick's framing of Free Form's role as being to provide 'expert advice' and to help the tenants work through the various possibilities. When I asked her specifically about the design element, she mentioned the under-fives play area and a 'planning for real' exercise similar to that used in Granby: 'The mums of the Mothers and Toddlers Group actually did come up with the ideas. And then we had a fellow Chris [Shanks] . . . And Chris came with a scale model. It was put on the table and then it was able to be shifted, moved or changed.'

Emerick also talked about the mosaics that were an important feature of the Goldsmiths project, as they were for so many of Free Form's environmental projects during the D&TAS period. One of the advantages of using mosaics was that they allowed local people's initial ideas for images to be worked up by the Free Form artists into large-scale designs that, when carried out in mosaic, looked satisfyingly 'professional'. In addition, the mosaic technique, which could be taught in workshops, enabled a wide range of individuals to participate in the making of the finished piece. Mosaics, for instance, were designed in sections in such a way that individuals could take home the section on which they were working and finish it there—something that was particularly useful for women with small children. Emerick mentioned the mosaics when I asked her about the significance of the 'art' element of the project. She began by stressing her lack of artistic skills: 'I'm not an arty person me. I can't stand it. I like doing the admin bit.' She went on to explain how, for her, the importance of the mosaics and the artwork generally was that they gave people a sense of being involved:

> [People think] there's something going on there. Even I go and put a little bit of mosaic in, I've had an input. And it draws people in, even just through curiosity. And then they come in and they go, 'Oh! That's good, I'll get involved in that,' and they do! . . . the art is very, very important, because it gives colour, it gives direction . . . people feel they've achieved something because they've had a little input . . . it keeps the interest there and the involvement.

Overall, Emerick sees the D&TAS projects as helping to bring estates like Goldsmiths together. 'They can achieve a lot of harmony among people by

drawing people together when they do these [preliminary feasibility studies] because everybody has a chance to have an input. It does create more harmony in the particular environment. And they can participate and they get a sense of belonging.' Both Emerick and the artists also stressed that this does not mean everybody has to take part in the actual making; participation can take many forms. It could be something as simple as serving drinks to those doing the actual work or helping to hand out leaflets updating people on the project's progress.

I asked Emerick about the celebration that marked the opening of the games pitch. Dynamic organizer that she was and is, Emerick was clear that she needed Free Form to organize a celebration on that scale: 'When the football pitch was finished, we had a big football festival, and Brian Segmore, our then MP, he attended. And we had all these teams playing with each other, and the police came and played a game. It was really good but I could never organize that, you know!' She also had this to say about the role of celebration in general:

> It is important because people on the estate can see something's going on . . . you keep them informed as much as possible but then you have a celebration to open it and that means that more people can actually participate, be involved on that day. And it draws them in, it really draws them out from their places. And I think it's a really good part of the project because people then talk about it . . . and people can meet other people. Especially if you've got people just moved into the estate and don't know anybody. We would be there the TA [tenants association] and, if you see people standing and you can see they don't know anybody, then you go and introduce yourself and you introduce them to other people. You can also tell them what is going on in the [community] hall and round on the estate. So it also gives us a good chance of communicating with people that we otherwise might not see.

Emerick's point here—that the celebratory marking of a project is important because 'people then talk about it'—reflects the reality that a crucial part of something, such as an art project, registering as an 'event' tends to be the creation of it *as an event,* through its being talked about and shared by a group of people. I shall come back to this point in Chapter 9.

A crucial skill, which Emerick credits her experience with Free Form as giving her, is the ability to write funding applications. This expertise has allowed her to continue applying for funding for all the many groups she works with now, such as the Community Resource Team for the Elderly. In the past, as she remembers,

> Hackney Council were much freer with their money . . . they used to give us a certain amount of money with which we could hold little, lovely garden parties, indoor

parties, outdoor parties, entertainment, outings and all that. And we used to get about £600 a year from them. But then that all stopped, so now you have to look for outside agencies, And, really and truly, it's only my experience of working with Free Form that I'm able to fill all those forms in, about twenty pages! So that has stood me in good stead because I can still carry on, applying for funding.

OF DISTRACTION AND EXPRESSION

The D&TAS can be seen as marking a further evolution in the Free Form Project, which took the artists still farther from the world of gallery art. In her UNESCO Report, written in the early stages of Phase II of the Goldsmiths project, Wheeler-Early feels it necessary to explain this:

> The work on the [Goldsmiths] project has been something of a departure from Free Form's usual area of work in that it has not, to date, required the same degree of traditional artistic skills. However, the company's aim of bringing about community involvement in all stages of work in a project remained central to their programme. (1985: 39)

The expertise the artists provided and the work that was done on Goldsmiths certainly stretches the definition of artistic expertise considerably beyond that conventionally associated with the fine arts. And a number of powerful figures within the Arts Council, particularly some of those associated with the visual arts panel, had their doubts. I discuss their specific problems with the D&TAS work, in particular its imagery and aesthetic language, in more detail in the next chapter. But, lurking behind the discomfort these projects aroused in some members of the curatoriat, it seems to me, we can glimpse some of the baggage that comes with a traditional understanding of art as Art with a capital A. The D&TAS work, for instance, challenges the assumption that true Art is not made to order since what defines it as Art is in part that it is an artist's individual creative expression. It also calls in question the idea that genuine Art demands a spectator's focussed attention. Before going on to look at another D&TAS project, Provost, I want to pause to look a little more closely at these assumptions of focussed attention and individual expression.

One such assumption is that, when in the presence of an Art object, the spectator should adopt a particular stance: focussed, earnest, and quasi-religious. Indeed, it could be argued, as Gell does, that, 'In so far as modern souls possess a religion, that religion is the religion of art, the religion whose shrines consist of theatres, libraries, and art galleries, whose priests and bishops are painters and poets, whose theologians are critics, and whose

dogma is the dogma of universal aestheticism' (Gell 1992: 41–2). In line with this essentially Romantic notion of art, spectators are required to give their full concentration to the art object. To facilitate the proper reverential concentration, modern galleries tend to take the form of the familiar white cube, from which all potentially distracting clutter has been removed and within which a hushed silence is expected. Since this is such a taken-for-granted part of the gallery experience, it can be difficult to recognize how particular, even perhaps peculiar, this expectation is. It was not always so obvious. Larry Shiner tells us how, at the end of the eighteenth century, 'When part of the Louvre Palace was turned into a public museum during the Revolution, signs had to be posted asking people not to sing, joke, or play games in the galleries but to respect them as the sanctuary of silence and meditation' (2001: 135).

The proper focussed concentration demanded by authentic Art with a capital A can be contrasted with entertainment which merely distracts. Walter Benjamin, in his justly famous article 'The Work of Art in the Age of Mechanical Reproduction', quotes a shudder of disgust at what is seen as the undemanding nature of films, which captures perfectly the despair of the highbrow for that which does no more than entertain unthinking lowbrows. One Duhamel, Benjamin tells us, terms movies

> a pastime for helots, a diversion for the uneducated, wretched, worn-out creatures who are consumed by their worries . . . , a spectacle which requires no concentration and presupposes no intelligence . . . , which kindles no light in the heart and awakens no hope other than the ridiculous one of someday becoming a 'star' in Los Angeles. (1973: 241)

As Benjamin notes, 'this is at bottom the same ancient lament that the masses seek distraction whereas art demands concentration from the spectator.' Rather than trying to deny this distraction, however, Benjamin goes on to consider what absorbing art through distraction implies:

> Distraction and concentration form polar opposites which may be stated as follows: A man who concentrates before a work of art is absorbed by it. He enters into this work of art the way legend tells of the Chinese painter when he viewed his finished painting. In contrast, the distracted mass absorbs the work of art. This is most obvious with regard to buildings. Architecture has always represented the prototype of a work of art the reception of which is consummated by a collectivity in a state of distraction. (1973: 241)

Once architecture (one of the five major arts making up the modern system of the arts identified by Kristeller (1990a: 164–5), which I discussed in Chapter 1) is brought into the equation, it immediately calls into question any simple

understanding of distraction as by definition bad and the wrong way to approach art. Architecture, as Benjamin suggests, provides an instructive model for thinking about how we absorb and respond to a wide range of products of human creativity and imagination.

> Many art forms have developed and perished . . . But the human need for shelter is lasting. Architecture has never been idle. Its history is more ancient than any other art, and its claim to being a living force has significance in every attempt to comprehend the relationship of the masses to art. Buildings are appropriated in a twofold manner: by use and by perception—or rather, by touch and sight. Such appropriation cannot be understood in terms of the attentive concentration of the tourist before a famous building. On the tactile side there is no counterpoint to contemplation on the optical side. Tactile appropriation is accomplished not so much by attention as by habit. As regards architecture, habit determines to a large extent even optical reception. The latter, too, occurs much less through rapt attention than by noticing the object in incidental fashion. (1973: 241–2)

I want to draw attention here to Benjamin's point that we experience architecture physically and, very important, not simply, and often not primarily, through sight but through touch. To these senses could be added hearing and smell. Think of an airport, a railway station or a hospital, each with its own audio landscape and its particular mixture of smells.

The example of architecture suggests a model of the 'art' object very different from that of the Romantic sacred relic, with its demand for total focussed concentration. The fact that the users of a building simply feel comfortable in it, noticing it 'in incidental fashion' rather than paying it 'rapt attention', can indeed be taken as a sign of its success as a piece of architecture. As, Benjamin's contemporary, Robert Musil, noted, 'Anything that constitutes the walls of our life, the backdrop of our consciousness, so to speak, forfeits its capacity to play a role in that consciousness' (Musil 2006: 66).

Memorials are an interesting case in point. Some are located on sites dedicated, whether wholly or in part, to memorialization: the Washington Mall, a battlefield or a cemetery. On such sites we have either deliberately sought out the memorial we encounter or happened upon it in a space we already know is intended to be about memorialization, just as churches are the realm of the sacred and the museum or gallery the domain of Art. But when memorials are not located in clearly demarcated spaces of memorialization, they tend to fade into the scarcely registered backdrop of daily life. Musil describes the invisibility of so many of the large monuments that dot most major cities:

> Every day you have to walk round them, or use their pedestal as a haven of rest, you employ them as a compass or a distance marker; when you happen upon

the well-known square, you sense them as you would a tree, as part of the street scenery, and you would be momentarily stunned were they to be missing one morning: but you never look at them, or do not generally have the slightest notion of whom they represent. (2006: 65)

Musil may have been talking about the representational heroic statues of his time, but his comments are also relevant to the contemporary monoliths of public art that have become just as expected a feature of today's cities. Most of those who encounter them as they go about the city seem rarely to accord them the kind of focussed attention demanded by the Romantic artwork in its normal gallery habitat.

One important way in which sculpture by Picasso, Henry Moore or some other Great Artist that adorns the modern public square differs from the General on His Horse or the Declaiming Politician is in that it is assumed to be the individual expression of the artist who produced it. Equating art with work that represents the self-expression of the individual artist, however, rules out not merely more traditional monuments but a wide range of creative work. There is, for example, the long tradition of signs painted for inns and shops, the gardens created for the wealthy, book illustration and, more recently, the public lettering and other signage that play such an important role in defining the particular physical character of the London Underground, the New York subway system and the Paris Metro. There is a history to this exclusion: as the fine arts achieved their dominance in the late eighteenth century, everything that was seen as serving some utilitarian purpose tended to be relegated to what was now considered to be the far less prestigious realm of craft. This was particularly true of the visual arts. In Britain, a key moment is the establishment of the Royal Academy, in 1769, under the presidency of Joshua Reynolds. The official title of this institution (the painting school of which one of the founders of Free Form, Ives, would attend some two hundred years later) was Royal Academy in London for the Purpose of Cultivating and Improving the Arts of Painting, Sculpture and Architecture; Reynolds, much to the fury of William Blake, ensured that no engravers, coach painters, metalworkers or other craftsmen could be elected to it.

Memorial art, it seems to me, is an especially interesting example of creative work that is not about the self-expression of the artist. Memorials, even if invisibility tends to be their fate unless they are clearly located within a space of memorialization, are put there to communicate a message to the viewer, and usually, moreover, a rather specific message. The maker of the memorial has been given the task of embodying a specific sentiment in an appropriate and effective physical form; the memorial is not supposed to be that maker's own personal expression. I am thinking here not only of major monuments such as Musil's invisible monuments or Maya Lin's powerful and

much-written-about Vietnam Veterans Memorial but of family gravestones erected to the memory of individuals. Even in these times of mass-produced gravestones, there are still some that are hand carved by a stone mason, and the making of such a headstone involves a conversation, as Charlotte Howarth, an artist we shall meet again in Chapter 9, explained to me.

Howarth is a stone carver, and, as is the case for many stone masons, commissioned headstones are part of her bread-and-butter work. Her approach to the design and creation of individual headstones provides a good example of the nature of the mediated expressiveness characteristic of the memorial. Most headstones nowadays are mass produced. An individually designed and carved headstone made by a craftsperson like Howarth is the exception. Inevitably, such a headstone is expensive; nonetheless, Howarth's clients are not all wealthy. She explained, 'You meet all sorts of people who are unsatisfied with what they can buy in the monumental masons trade to represent somebody they've loved. They feel incredibly let down by what's on offer.'[3] Quite often, people call on Howarth when they are struggling to come to terms with a particularly distressing death: the death of a child, for instance. She stressed how she needs to be a good listener:

> Often the last thing [clients] do for their loved one is to erect a memorial to them, and some people find it very difficult. It's funny because you have to represent a person that you've never met, you have to try and find out about them and somehow get a feeling for them . . . I would never do what I think, I would never restrict a client to my personal style or taste, I don't ever need to see the stone again, I don't have to like it, but I do know it has to be well designed and well executed, beautifully designed and beautifully executed. I would never go for little birds and things, but that's what clients like, and they have to be beautifully carved, and so you build up a dialogue with your client. The drawings go backwards and forwards and you suggest things and they make alterations and changes.

I asked her if her clients knew what they wanted:

> Some people do; some people just use you as somebody to make their specifications; some people have got an incredibly fixed idea of what they want. Some people have no idea what they want, and I talk to them, I show them how I develop designs with other clients, and sometimes that gives them ideas. I think you have to take each job separately, and you know quite quickly when you meet with people the type of input they're looking for. You quickly come to realize who is leaning one way or another just by their response to the work you've done previously . . . it's really important not to dominate them with your own taste and let

3. This and subsequent quotations are taken from an interview I conducted with Howarth in 2005.

them choose their own thing and not be elitist or snobby about something like that because they have to look at it forever and I never have to see it again if I don't like it. But I would still do everything beautifully. I've done some jobs that I hate and people have said that's gorgeous and I'm just sick of it. I just think it's too frilly for my personal taste, but I would never let my client know that, and I would always try and do it beautifully and not be bitter about it. You can't do memorials with bitterness.

Howarth's approach demonstrates a concern to use her creative skills to bring into being a memorial that her clients recognize as 'what they wanted', even if they did not know what that was before she helped them discover it. As a stone carver, Howarth is certainly expressing something here, but the initial impetus for it was not hers, and the artistic language she uses may not be her mother tongue. Indeed, we can see here something of the same tension between the aesthetic language of the trained artist and that of popular culture that is inherent to the Free Form Project. In essence, Howarth defines her role as that of a medium through which her clients—thanks to her expertise—are able to find *their* creative expression. Part of her expertise, however, involves her using elements of her own aesthetic language—note, for instance, how she insists 'I would always try and do it beautifully'—in that work of mediumship.

The kind of mediated expressiveness described by Howarth is in many ways similar to the way the D&TAS team saw their role on Goldsmiths Estate. The Free Form artists' work with the tenants was never intended to lead to the creation of Art objects demanding spectators' full and focussed concentration. Rather, it was about making art that would be 'consummated by a collectivity in a state of distraction', to use Benjamin's phrase. The initial idea to focus on the refurbishment of the games pitch came from the tenants, and the D&TAS team were happy to take this as their priority. Free Form, however, also saw their Brief as opening up the Goldsmiths tenants to new possibilities and creating a games pitch that would satisfy the artists' aesthetic vision. It was this that led to widening the project to include mosaics and the landscaping of the area surrounding the pitch. The fencing surrounding the pitch was also carefully designed, incorporating decorative ironwork and the rounding of the corners to make the fence less of an eyesore and more a decorative feature in its own right. The D&TAS team saw themselves as using their expertise to make the Goldsmiths pitch 'special', something that the Goldsmith tenants would feel was particularly theirs.

A major component of the Brief as the artists interpreted it was finding mechanisms that would give Goldsmiths residents a central role in shaping the particular form the refurbishment project would take. Crucial here were the tenants' design group and the structured workshops that gave people the

opportunity to explore different possibilities. Part of the expertise of the Free Form team was knowing what was and was not possible and how to explore the different options with the tenants in ways that would allow them to make informed decisions. The design group meetings also allowed tenants with different priorities and different concerns to thrash things out: to arrive at the compromise, for example, of open access, a floodlit pitch, but no games after 9.30 p.m. Once it had been agreed that the pitch should have floodlighting, there was also a lot of discussion, as Wheeler-Early notes in her Report, of what kind of lighting there should be. Christie and the other young people wanted to make sure that the light fixtures would be ones they could maintain themselves, since a perennial complaint of council housing tenants was their being forbidden from carrying out any maintenance themselves and then having to wait forever for the council to come. Free Form was able to arrange for lights that could be easily lowered for routine maintenance, such as the changing of bulbs.

Much of the work done on Goldsmiths would not fall within commonsense definitions of 'art'. In her account, Emerick clearly valued the 'art element' but did not see the project as a whole as an art project. For her, as in her comment quoted earlier, that art element was important in that 'it keeps the interest there and the involvement.' And it was the involvement and the way that the project brought the estate together and allowed its residents to shape its rehabilitation that she especially valued. At the same time, the D&TAS's stress on the importance of genuine collaboration and the artists' willingness to relinquish some of their control were taking them ever farther from the curatoriat-dominated world of the gallery. Nonetheless, in the eyes of the artists, the work on Goldsmiths remained rooted in a visual arts approach. In some D&TAS projects, however, more conventional 'art' elements played a larger role. The next chapter tells the story of one such project on another East End estate, Provost, where artists and residents worked together to create a large mural.

–6–

Making Art Collaboratively: Provost

> They were really brought together with the mural and with the planting, but with that mural everybody had a little bit of it.
>
> —Mary Walker, Provost Estate Tenants Association

The D&TAS project on Provost Estate began in 1982, around the same time as the work on Goldsmiths. As on Goldsmiths, the Provost tenants association had approached Free Form for help with applying for money from the GLC's Community Areas Programme. This was not, however, the estate's first encounter with the organization. One long-lasting result of the Free Form neighbourhood Festivals (see Chapter 2) was the Shoreditch Festival, as of 2010, still an annual event. Provost Estate had participated in an early Shoreditch Festival with a Halloween theme. Leading up to the event, there were workshops for local children in which they made costumes and other Halloween paraphernalia. On the day itself, all the children, dressed in their costumes, marched in a grand parade around the various participating estates, ending up at the site of a huge bonfire—to which each estate had made its own contribution—where Free Form staged an elaborate fire show. In 2003, I interviewed some of those prominent in the Provost tenants association at the time of the D&TAS project.[1] One still had vivid memories, more than twenty years later, of the children with their Halloween lanterns: 'You got the little night lights in them, and they paraded as proud as they could be. They paraded around the streets with their little lamps.'

PATHS AND PLANTINGS

Provost is an estate of approximately the same size as Goldsmiths. Built in the years leading up to the Second World War, its layout is typical for British social housing of that period: five-story blocks, each with approximately forty separate flats, grouped together on a common plot sandwiched between a series of main roads (see Fig. 20). As of 2005, Provost was still social housing owned by the local council (originally Shoreditch, now Hackney), although, some years after Free Form worked there, its management, in line with the general move

1. The Provost tenants' quotations in this chapter come from these interviews.

to privatization in local government, was contracted out. The blocks were by and large well built, and, since the fall from favour of the high rise, the virtues of their low-rise design with individual flats leading off walkways are once more being recognized. Nonetheless, by the early 1980s, the more-than-fifty-year-old estate was in serious need of renovation. The external spaces were particularly bleak and unlovely; what had been intended as grassed communal open space had deteriorated into an ill-lit and desolate no man's land. To make things worse, the most direct route to the local shops was blocked by a tumbled-down wall, its sorry state presumably the result of the tenants' habit of climbing over it to avoid making the long detour round. The residents included a long-established core of white East Enders together with a number of families of Afro-Caribbean and South Asian heritage, allocated housing on the estate more recently (Fig. 21 shows some long-term residents).

Once the tenants association contacted the D&TAS, a meeting on the estate was organized to discuss the estate's problems and possible solutions. The badly lit and muddy open spaces between several of the blocks were

Figure 20 Provost Estate showing mural, 2005 (photograph and copyright: Kate Goodrich).

MAKING ART COLLABORATIVELY 113

Figure 21 Provost Estate tenants June Trikilis and her father, Robert Trikilis, and a portrait of June's mother and Robert's wife, the late Elsie Trikilis, who was closely involved with the Provost Free Form project, Provost, 2009 (photograph and copyright: Kate Goodrich).

identified by the tenants as a major problem, and it was agreed that this should be the focus of the project. What was needed, the artists suggested, was a fundamental reorganization of these communal spaces. The organization of such spaces shapes how people move about on an estate, how they enter and leave it, and whether they experience it as forbidding and unsafe or comfortable and welcoming. The planners who laid out council estates tended to be more concerned with the formal geometry of the space than with how those living there would use it. The D&TAS team suggested a rethinking of the estate's open spaces using 'desire line paths'—well-designed paved paths with benches, plantings and good lighting, which would follow the routes actually used by people and create natural meeting places. An opening, for example, with a paved path leading up to it, would be made in the wall

the tenants were currently clambering over, while specially designed imaginative railings would provide added visual interest and protect the plantings. On the basis of their discussion with residents, the D&TAS team devised a coordinated plan, which was put to the tenants association. The plan was approved, and, helped by the team, the tenants association successfully applied for Community Areas Programme funds. The D&TAS team, led by Goodrich and Goldman and including Carol Stewart, an architect now working with Free Form, and the sculptor Virginia Cooper, then began implementing the plans. The organic, somewhat Gaudiesque railings, designed by Goodrich, used an innovative technique that stretched perforated steel. Goodrich got the idea for the stretched design after discovering that Provost's original railings had been made from old First World War stretchers. The railings were then manufactured by Stuart Hill, a metalwork artist.

In line with the D&TAS's mandate to work with 'communities', the Free Form team were determined to include as many residents as possible in the implementation of the project. This, however, was not easy to achieve, and for the first couple of years they worked primarily with the tenants association's approximately ten members. This core would then be joined by another thirty or so residents when they held estate-wide meetings. A complicating factor on Provost was that there were two main factions on the estate, each centred on a powerful family and each wary of the other. Goodrich and Goldman remember a lot of time spent walking between flats and talking separately with different individuals, attempting to mediate, stressing all the while the importance of getting more people involved. One problem was that the first stages of implementation, the relaying of paths and the new lighting, could not be carried out by residents, since it required skilled labour and the council had strict rules as to who could be employed. Also militating against estate-wide involvement was that the relaid pathways were concentrated in one area of the estate. As the months wore on, the D&TAS team became increasingly concerned that they were working with only a small minority of the estate's 'community' and were eager to find a way to include more people.

The solution they came up with was individual window boxes. Everyone on the estate was offered his or her own box to be fixed on the balcony walkway outside the tenant's flat. Free Form took responsibility for installing the boxes (a fairly complicated procedure given the safety concerns that the boxes be attached securely), but individuals could choose their own planting plan from a number of options. Plants and soil were then provided, and there was a communal planting day. Since most of the tenants were lifelong flat dwellers with little knowledge of gardening, the D&TAS team organized a trip to nearby Syon Park (a stately home with a famous garden) and arranged for a gardener to run workshops on caring for the window boxes. The window-box initiative succeeded in getting people from across the estate involved. About

three-quarters of the estate's households signed up, and 150 window boxes were distributed, of which perhaps a third were still in place twenty years later. Evidence of the impact of the window boxes is that, in one of my 2003 interviews with residents, this initiative, which had in fact happened two years into the project, was the first thing mentioned: 'The first thing we thought of was the window boxes . . . It was to get neighbours there, to be neighbourly, they'd talk about their plants . . . and then they started getting interested.' We could say that the window boxes began to bring into being something like an actual 'community'. This initiative also brings to mind the point Gell makes about the inadequacy of Northern definitions of 'art works' (quoted in Chapter 1), which exclude the products of 'the imaginative gardener, home decorator, or budgerigar-breeder'.

THE MURAL

From quite early on, the D&TAS team had felt that, while the creation of the paths, the new lighting and so on were central to improving the estate, the project needed something more: it needed a focal point. The new layout of the paths created a natural corner, the main feature of which was a blank brick wall with crudely drawn goal posts, against which the children of the estate played football, a source of considerable irritation to those living in the flat behind the wall. To the eyes of the Free Form artists, this corner cried out for some kind of visual statement, possibly a mural. Initially, however, the tenants were not convinced, and one of the two rival camps on the estate was quite hostile. In part, this was because the rise of community arts had led to a rash of murals on council estates, many of rather poor quality. As Goodrich recalled, a number of the most actively involved Provost residents were quite clear: 'We don't want a kids mural.' Goodrich interpreted this as meaning they did not want 'kids daubs, cartoon stuff'. And a cartoon aesthetic was indeed the visual language used by a number of community arts muralists. The association of community arts and children is not surprising, given that so many of the projects, including those of Free Form, were geared towards children. The reputation of community arts murals was also not helped by the fact that many of them were on so-called sink estates, those desolate and despised estates on which 'problem' tenants were ghettoized. In addition, many Provost tenants were convinced that *anything* put up would rapidly be graffited or destroyed.

Faced with this hostility, the Free Form team did not press the idea and concentrated instead on other aspects of the project. They managed, for instance, to get support for an idea they had used on another estate to stop children playing football against a wall: decorative railings enclosing a small

area of planting in front of the problem wall. But, as Goldman remembered, 'The idea that you could put a decorative feature [i.e. a mural] there that would work took a long time. And I remember we said, well you know, it's no problem, we won't do it yet. Because it was like, yes, they'll say no if we push it too fast.' However committed the artists may have been to putting their expertise at the service of the 'community', they also saw themselves as having an educative role, introducing possibilities that people might not have thought of and explaining how and why they might work.

Building support for a mural involved, above all, convincing people that what was being suggested was not the kind of 'children's daubs' mural people were familiar with from other estates. Over time, however, partly simply because they were spending so much time on the estate, the artists established a strong rapport with a core group of tenants, who included both the estate's dominant families, and slowly the hostility to the idea of a mural began to dissipate. Finally, after the window box initiative and more than two years into the project, this core group agreed to explore the possibilities through a mural workshop organized by the artists. The workshop would include adults as well as children, and people were asked to bring favourite images of themselves and other images they liked. Using these as a starting point, the artists posed the question of how the people of Provost thought of themselves, what they valued about who they were. One common thread that emerged was their pride in being Londoners. I have already mentioned how East Enders often think of themselves as the most authentic Londoners. The artists focussed on this, exploring the different meanings London had for people. The proposal that emerged from the workshop was a mural celebrating London and telling the story of the tenants' lives as Londoners (Figs. 20, 22, 23 and 24 show the finished mural). And, since everyone agreed on the importance of the Thames, it was decided that the specific theme would be how London relates to its waterways. Goodrich's own long-standing passion for boats and waterways was also probably influential. There remained, however, the question of the mural's imagery and aesthetic language.

The Free Form artists might have moved a long way from their original art school aesthetics in some respects, but their aesthetic language was still closer to that of the art world than to that of most of the Provost tenants, although, as we shall see, not close enough for some of the curatoriat. The Free Form artists may have originally charged themselves to 'Make art that speaks to working-class people!', but, like Gramsci, the Free Form artists tended to see a lot of popular culture, particularly popular visual culture, as 'backward and conventional' (Gramsci 1985: 102, quoted in Chapter 3). Goodrich, who produced the basic design for the Provost mural, saw the Brief the artists had been given in this instance as requiring him and the other artists to come up with

Figure 22 Provost mural with two local children, 2005 (photograph and copyright: Kate Goodrich).

images that [the tenants] could respond to and understand, and wouldn't just see as children's drawings—Most of them, even if they saw a Picasso, they'd say: 'That's children's drawing' . . . It was also moving them away from their images about what they think is beautiful, because they were stereotypical basically. So it's how to actually create the vehicle by which there was a realistic way that you could put the elements in they wanted—the water, the plants, the flying swans, and the other little bits and pieces they liked—but you could put them as a very small element or within the context of how London relates to its waterways.

Note how Goodrich's account of the role of the artist here contains an implicit claim about one kind of expertise the visual artist expert has: the artist has mastered an aesthetic language that enables him or her to find ways of translating something like the Provost tenants' sense of themselves as proud Londoners into images that people can recognize as expressing this but that also conform to aesthetic standards deriving from the art world: they should not be clichéd. This assertion of the importance of expertise is a good illustration of how, while the artists may have insisted on the genuinely collaborative nature of the D&TAS projects, they did not see their role as being simply to realize tenants' initial articulation of what they wanted. The aim was rather to

Figure 23 Provost mural, relief panel detail showing Notting Hill Carnival and street market, 2005 (photograph and copyright: Kate Goodrich).

provide mechanisms and a process through which those living in a particular place, at a particular time, could explore their desires and needs and come up with appropriate solutions. At the same time, however, an important part of that process of exploration necessarily involves the education of the experts themselves through their dialogue with the 'community'. The D&TAS collaboration with social housing tenants and others was always intended to be dialogic. The artists may have drawn on their expertise to suggest new possibilities and, to some extent, to impose their aesthetic language, but the solutions they came up with for specific D&TAS briefs and the D&TAS Brief in general were also shaped by local people. Remember Emerick's insistence, quoted in the previous chapter, that it was always the tenants or other community group who had ultimate power in a D&TAS project: 'It was the tenants' ideas from beginning to end. And until the tenants were absolutely satisfied with what they'd got, the project wouldn't start.'

Nonetheless, the artists saw themselves as having the expertise to come up with an appropriate aesthetic language for the mural. As Goodrich explained, in the workshops and in the development of the stories on the panels, they continually talked to the tenants about what, according to their trained eyes, 'worked' as images, what did not and why. They also discussed

Figure 24 Provost mural, detail of mosaic work, 1980s (photograph and copyright: Free Form Arts Trust).

more generally what makes a picture and what makes a painting 'good'. From the earliest formulation of their Charge, the Free Form founders were determined not simply to take art to working-class people but to explain what 'art' is and what it can do. For the artists, the creation of the Provost mural was not merely about the finished artwork; they saw it as a process through which those unfamiliar with the language of fine art could discover its power and learn how to use it to tell stories, much as the artists themselves had at art school. It should be emphasized that the goal here was not to introduce people to the high art of the gallery world but rather to show people how they could use aesthetic forms to tell their stories, to provide representations of their world rooted in their own day-to-day experiences. Inevitably perhaps, the collaborative process of finding ways for those living on estates like Provost to tell their own stories in visual form also took the artists' aesthetic language yet further from the received pronunciation of the gallery world.

In one of my interviews with him, Goodrich talked about how he sees the relationship between the community artist and the 'community'. For him, artists are fluent in a sophisticated visual language which allows them

> to interpret the raw ideas that come through a participation mechanism. And a lot of our successful projects, the most successful ones, which have actually achieved a high degree of sophistication, are very much to do with participation by

local people, which has then been further interpreted by artists who have created the means, the skills, whereby people's contributions can actually achieve a high standard. You simplify [what the local people have produced] so that artists can take that and transform it into something else, but the original contribution is still recognisable within it and local people can proudly claim ownership.

An important element of the Provost mural Brief was the requirement that the tenants be able to participate in its making. Mosaics were part of the solution, but the artists also decided to make use of a technique that one of the newer members of the team, Cooper, had been using in her own work, although on a much smaller scale. This involved taking small objects and impressing them into clay panels to build up images. The resulting panels, with their impressions, formed moulds, which were cast in concrete to form low-relief tableaux, which were then painted. The tenants, however, needed convincing that this casting technique could produce something 'good' and professional looking: a practical demonstration was required. Another workshop was organized, therefore, to which all attendees, including children, were asked to bring objects small enough to be held in one hand that seemed to them to represent aspects of London—a Dinky Toy car, for instance. The idea was that these small, everyday objects—which had to make an impression in clay—could be used to create a narrative. A china ornament someone had brought in, a Bo Peep shepherdess in a crinoline, was used to demonstrate the casting process. To the artists, this cheap, mass-produced object was the epitome of kitsch. Through the magic of casting, however, the shepherdess was both transformed and remained herself. In the artists' eyes, the kitschyness was stripped away, but to her owners she remained recognisable as their original ornament. The cast of the shepherdess was agreed to be a success. In 2003, I was told it had remained hanging in the home of the daughter of one of the tenants I interviewed until just a few years before, when the daughter had moved. With this demonstration of success, the idea of a mural that told stories using children's toys and other found objects gradually gained support.

Goodrich then produced a preliminary drawing, inspired in part by old medieval maps of London, in which the mural was made up of two halves: the lower a mosaic representing the River Thames, bordered at the bottom by riverside plants, and the upper a double row of 300 cm sq cast concrete panels, thirty in all, featuring major London landmarks, such as Tower Bridge, and scenes of London life (Fig. 25 shows Goodrich and tenants discussing the mural drawing, Figs. 23 and 24 details of the finished mural). The drawings for some of the panels, particularly those showing the major London buildings, were very detailed, but many were simply outlines for possible stories. Using the objects people had brought in—the toy cars, the plastic animals, a Barbie doll's bed—Goodrich and the rest of the Free Form team began to demonstrate how you

could put together different scenes: a waterside pub (the Barbie doll bed helping to form the facade) with a cricket match going on outside, a man fishing in the river, someone else going for a walk. Goodrich, who can be quite charismatic, used his drawing and the demonstrations of the technique to make the idea come alive, convincing the final doubters that this could indeed work.

This technique of telling stories by making impressions in a clay block allowed children and adults without any artistic training to participate in creating the images, albeit under the guidance of the artists. As Goodrich put it, 'It was actually quite a marvellous device because all of a sudden they could all participate . . . "Oh yes, I can make that impression. Does that really work that way round?"'

Both residents and artists agreed that the picture of London should not be a romanticized one; a major roadway with all the cars (providing a place for many children's toy cars) was included, as were a council estate and a scrap merchant complete with a demolition ball. The D&TAS team were particularly keen that the mural should represent the diversity of London, especially given the background of local racial tension: one panel, for instance, shows the Notting Hill Carnival, London's annual celebration of Caribbean music and culture, next to a local street market (see Fig. 23). Also featured in one panel, at a time when the Tory government was moving to abolish the GLC, was a small plane flying over Tower Bridge and trailing a banner declaring: 'Keep the GLC Working for London.'

Figure 25 Discussing mural design, Provost Estate, 1985 (photograph and copyright: Free Form Arts Trust).

I asked Goodrich how he would characterize the role of the tenants in shaping the imagery of the mural. For him, they were essentially 'the guardians of taste. It was like, "well, we're not having that. Well, I'm not sure about that."' Once, however, the basic theme of celebrating London and being a Londoner, had been decided on, 'it was very much led by us as an artist team [with the idea of] developing how they could participate effectively.' This participation certainly included the artists using the authority of their expertise, 'there was a lot of persuasion that went on,' as Goodrich put it. At the same time, the tenants also managed to impose their ideas. One woman, for instance, was adamant that there should be swans. Not all the tenants agreed: as one might expect, there were often differences of opinion among the tenants as to what the mural should include. Some found the idea of swans decidedly clichéd and, as one of them recalled to me, teased the swan advocate about it, likening it to one of the stereotypes of lower-middle-class aspiration exemplified by a character in the popular British soap opera, *Coronation Street*. 'We said like Hilda Ogden's wall? She's got three ducks on the wall.' The swan advocate stuck to her guns, and, in a form the artists and the sceptical tenants found acceptable, the swans were included. Goodrich used this as an example of the genuinely collaborative nature of the mural: 'We also acquiesced, you know, the swans went up. I might have said, over my dead body, but they went up.' But then there are those times when the artist and 'the community' do not see eye to eye and the artist is not prepared to acquiesce, and Goodrich also talked about this. For him, the community artist is not some simple conduit through which the community expresses itself in an unmediated way. If, for instance, 'a community' wanted to do a piece of work that was racist,

> you're not going to stand there and say, 'Oh, yes, we'll go and do a piece of work that's racist.' No, you're going to put your foot down and say, 'No, we're not going to do that.' And why. And then have the argument with them and then say, 'Okay, well, what we need to do here is talk about racism . . . let's understand our culture and the culture of other people, of how we integrate and who we are' . . . you have to be able to have that conversation with people.

In discussing the process of creating a collaborative artwork, Goodrich stressed both the need to work within a structure, such as the series of cast concrete panels making up the Provost mural, and the educative role of the artist:

> I think that Free Form has tried in all its work to provide the structure whereby people can succeed and not expose people to failure because they can't cope with that. The point is that they can make a contribution and see that they've achieved something highly satisfactory on their own terms and that the [artists] who are then going to take that and do something else with it value it. It is valued rather than just lost. Unless you provide that structure, you don't get good work. You end up with

inarticulate drawings and messages. So it's this whole thing about providing people with the use of the language, you have to do that; you have to play the 'teacher' role. I don't think of this as an enabling role. I'd rather see it as a master/apprentice role. *You know something they don't but you're willing to share what you know with them so they can participate.* It's a giving relationship . . . Sometimes pieces of work become much more to do with the artist than the original participants. I think that's fine as long as the integrity of that work is still recognized by the people who have participated in it. So even if it's radically changed, as long as they genuinely feel that they participated, I think it's perfectly okay. (My emphasis)

Goodrich here is claiming both specific expertise and an eagerness to make it available to others. This concern to share artistic knowledge could be seen as Goodrich's committed and passionate desire to replicate, as it were, his own discovery of visual language at art school for the working-class people among whom he grew up and with whom he identified but who were somewhat mystified by his decision to go to art school. Goodrich repeatedly stressed to me how he saw the Free Form Project as driven by the *passion* of the artists: for him, it embodied a completely new way of being an artist, one that demanded that artists use their expertise to open up unthought-of solutions to those with whom they collaborated.

The making of the Provost mural stretched over several years. It was cast and fixed to the wall over the course of two summers and then left to dry out fully before being painted the following summer. The painting process and the making of the mosaic of the river provide a good illustration of the kind of structured participation described by Goodrich. The mosaic was made of vitreous glass tesserae and tiles, and the children of the estate were set to work cutting up the sheets of mirror and glass into small fragments out of which the image of the river was created. Applying them, however, was very structured, as Goodrich explained:

[E]ach person [i.e. artist] would have three or four kids and say, 'We're going to do this bit today and then we're going to do it like this and then you can repeat that over there.' So they would get a little thing going, so you'd get this sort of patterning here that would happen. The painting of the cast panels, which was really more of a subtle tinting, was quite a challenge.

Key to the artists' control, Goldman explained, was a very detailed coloured rendition of the whole mural that Goodrich had produced, which everyone loved. This meant, as Goldman put it:

[I]t wasn't, 'Oh, you can't do this because I don't like you and you can't do it,' it was 'Come on, let's look at the drawing again and see what we're trying to achieve overall.' So you're getting people to see it's not just about the little bit you're

doing, it's about the whole thing. And people could buy into that because it had such a good design overall.

And, of course, those the artists were supervising here were overwhelmingly children, so the artists had both the authority of adulthood and their professional authority as experts in the visual arts. Not surprisingly perhaps, given how long the work took, those who worked on the mural, as the artists remembered it, developed a strong sense of ownership. Both Goodrich and Goldman stressed how much the making of the mural depended on a basic relationship of trust whereby the residents trusted that the artists would come up with something that they (the residents) could be proud of and that would be 'theirs'. But what did those residents themselves think?

The artists began the mural knowing in general terms, if not in detail, what they wanted to achieve. As the mural took shape, it made sense to them, as an image and as an event, in a way that it cannot be assumed to have done to the tenants. What did those who were living on Provost at the time and those who moved to the estate in the intervening years feel about the mural and the project as a whole? To try to get some idea of this, in 2003 I interviewed a group of those who had participated in its creation. In addition, Goldman and I spent a Saturday afternoon sitting in front of the mural with two of the women I interviewed, chatting with passers-by. While it is not possible to draw definitive conclusions from such limited data, they do suggest what the mural 'meant' to some tenants at least.

'EVERYBODY WAS INVOLVED IN THE MURAL'

One indication that the mural was valued by the tenants is that as of 2003, twenty years after its making, it had not been vandalized or graffited. It has also become a popular backdrop for photographs. One woman who moved to the estate some ten years ago told us how much she appreciates the mural, photographing visiting family and friends in front of the Tower Bridge section, telling them, 'now you've seen Tower Bridge, we don't need to go there.' In general the response to the mural was very positive: 'It's beautiful' was the general sentiment. Two women and two men who had worked on the mural as children walked by while we were sitting by the mural; all four stressed what a memorable event of their childhood the mural had been. Another older woman was negative about everything connected with the estate with the sole exception of the mural which she felt Provost did not deserve, remarking, 'it's a shame it can't be moved to somewhere nicer'. But this comment from my earlier interview with the tenants was more characteristic, 'Even though you live there and it's been up that long, you walk along that grass, and you still

look around and look at it. All those years, you still look at it.' It is interesting to contrast this with Musil's reflections on the invisibility of memorials, which I quoted in the previous chapter.

Goldman brought some old photos of the project in progress to our interview with the tenants. I asked the tenants what the mural 'meant' to them now. One long time tenant, Mary Walker, who had been won over to the mural after some initial opposition, told us how she had not expected a mural to survive long: 'I didn't think a mural would stay there this long. I thought once you'd all gone that would be gone too, but it hasn't.' She went on to explain, as she leafed through the photos, what the mural had come to mean to her and to the others who worked on it:

> I think of all the little kids that—a lot of them have got kids of their own now—that were doing that, all the little toys, my grandsons and that was Danny and Paul, all my grandsons with their little motors and other kids coming out, some bits of broken toys, 'can I put that in miss? Can I do that miss? Look can I do that there miss?', and all that. *They were so involved in it and it was a community brought together for that.* They were really brought together with the mural and with the planting, but with that mural everybody had a little bit of it. 'No you can't do it on this, it's my one, I've got to do it there.' You know how kids talk, and it meant so much. We see them come past, look that's my house on there. That's the one I did up there, or that's what I did there. I put that bit of glass there. . . . But then again you look at the [photo] of Peter, how healthy and young and fit he was then, now he's on dialysis all the time. You know, and you think of all those sorts of things and people that were there and died since. But they were there, there's a part of them still going on because everybody was involved in the mural. (My emphasis)

Walker's comments here seem to bear out the Free Form artists' claim that the Provost tenants developed a strong sense of ownership of the mural in the course of its making, and that the project had, at least for a time, brought into being a 'community': 'They were really brought together with the mural and with the planting'. The mural, it would seem, has both a special meaning for those involved in its making, for whom it embodies a part of their history, while for newer residents who encounter it as an existing part of their environment, such as the woman who photographs her visitors in front of it, it is, as it was intended to be, a focal point for the estate.

THE VIEW FROM THE ARTS COUNCIL

The aesthetic language the Free Form artists used for the Provost mural and the other 'art elements' so central to the D&TAS projects can be seen as developing out of an often intense collaboration between artists and residents.

But, even if it was no longer the aesthetic of the abstract painters that dominated fine-art departments at the time the Free Form founders were trained, this language was still rooted in art history. Goodrich's starting point for the Provost mural, for instance, was the visual language of old maps of London. And then, of course, there are Diego Rivera and the Mexican muralists, and the North American WPA artists, both difficult to ignore for any artists wanting to create large-scale murals that speak to working-class people. Gaudi's fantasy architecture, with its elaborate mosaics, was another important influence. At the same time, to the residents of Provost and the other groups with whom they worked, less likely to be familiar with these artistic legacies, the figurative imagery, resonating with popular art they knew and liked, was likely to appear comfortingly recognisable.

To the curatoriat within the Arts Council, however, most of whom had not been converted to the cause of community arts and remained sceptical about it, the 'art' produced in the context of these projects could appear overly populist. A characteristic comment in one internal Arts Council memo describing an evaluation visit to Free Form captures this distaste. After acknowledging Free Form's 'commitment and energy', the writer of the memo continues: 'The trouble is that their house-style, their reflexive, habitual aesthetic, is so poorly conceived; a kind of invented, somewhat false buoyancy redolent of the hippy era (sunsets, skies, birds wheeling etc.)' (Arts Council 1985a). The writer did have praise for the railings, which he identifies solely as the work of the metal artist, Stuart Hill, although, in reality, Hill had simply manufactured them from Goodrich's design. It is significant, perhaps, that the design of the railings had not involved any residents and was, in this evaluator's eyes, the product of an individual artist. As I have tried to show, Free Form's 'house style', so distasteful to this representative of the curatoriat, had emerged out of a particular kind of aesthetic collaboration. For the Free Form artists—now defining their Charge as 'Use art to help people solve problems stemming from their built environment!'—a crucial part of the overall D&TAS Brief was ensuring that the local group employing them not only played a major role in defining those problems but worked with them to devise solutions. And that meant that their aesthetic judgements had to be taken into account. They should be, as Goodrich put it earlier, 'the guardians of taste.' For many in the Arts Council, such as the writer of the memo I have quoted, this concern was no more than a sentimental attachment to an ethos that by 1985 was outmoded: '[Free Form's] roots in 1960's "community arts" have left them somewhat stranded . . . their in-house work (community playgrounds, council estates) has not kept pace with Art in Public Places [an Arts Council Programme launched in 1981 to encourage the siting of gallery art in nongallery venues].' As this comment makes clear, in the eyes of the Arts Council evaluators, Art, whether in the gallery or in public places, is the business of

accredited artists, to be judged according to the art world's artistic criteria. The problem for this evaluator is that Free Form was not commissioning '"traditional" fine artists, even those working in the commissions field, which is a pity' (Arts Council 1985a). This is a complaint that runs through the reports of the Arts Council evaluators. Another evaluator, who was part of the same team, had a similar complaint: 'little thought is given to the nature of a particular site and who would be the most appropriate artist to employ.' For this evaluator, Free Form 'does seem to be an interesting venture but the artistic quality of the work is poor. More reference to, and employment of, artists outside their established clique needs to occur' (Arts Council 1985b).

It is clear that by the mid 1980s the solutions that Free Form was coming up with to fulfil its Charge were an increasingly awkward fit within the established art world. The scope of the projects Free Form was taking on, within which traditional fine-art expertise might play a relatively small role; their insistence on the participation of nonexperts in the design and making of 'art'; and the aesthetic language they were using were all pulling the organization away from the traditional art world model of being a fine artist. This reimagining of the role of the artist expert had been shaped in fundamental ways by the nature of the problems posed by the Briefs they had taken on. Moulded by both their performance work and their environmental work, the artists' relationship to the working-class people to whom they had committed themselves was certainly different from that of a standard gallery artist. But how exactly had the Free Form artists come to be located within the creative process? This is the question explored in the next chapter.

–7–

Theoretical and Political Locations

> They were completely horrified that nobody even acknowledged me. And I said, just let them get on with it because it's their sculpture. My bit here's finished now and it's not like I'm going to be walking past it every evening and looking at it, my bit's done now.
>
> —Svar Simpson, sculptor of Lincoln Estate artwork

Hackney Council's revenue grant to the D&TAS ended in the mid 1990s, and in this chapter I look at what the Free Form Project had become by this point. Where, after some twenty-five years of working outside the gallery system, had the artists come to stand in relation to those for whom and with whom they had originally committed themselves to make art? What was their location within the art world? And how should we characterize the politics of the Free Form Project? It would be difficult, for instance, to see the D&TAS as 'storming the citadels of capitalism', to quote the subtitle of Owen Kelly's polemical history of community arts (discussed in Chapter 4); the Free Form Project was always reformist, rather than revolutionary. Neither was it critical art according to Rancière's definition—'art that sets out to build awareness of the mechanisms of domination to turn the spectator into a conscious agent of world transformation' (2009: 45). But might there, nonetheless, be ways in which the aesthetic practice of the Free Form artists could be seen as politically progressive?

ARTISTS AND ETHNOGRAPHY

In considering these questions, a good place to begin is Hal Foster's discussion of the location of the would-be progressive artist in his essay 'The Artist as Ethnographer' (1996). Foster takes off from Benjamin's 'The Author as Producer', an essay, as the title suggests, concerned primarily with literature but relevant nonetheless to the visual arts. Foster sets up his argument by quoting Benjamin's response to the modernist, and leftist, novelist Alfred Döblin. Döblin argued that progressive intellectuals cannot and should not actively align themselves with 'the proletarian front'. For Benjamin, this

is a fundamental misreading of the nature of intellectuals, one with serious consequences. In lines that still scathe, as Foster puts it, Benjamin writes:[1]

> It is quite palpable where the conception of the 'intellectual', as a type defined by his opinions, attitudes, or dispositions, but not his position in the process of production, leads. He must, as Döblin puts it, find his place *beside* the proletariat. But what kind of place is that? That of a benefactor, of an ideological patron—an impossible place. (1986: 228, Benjamin's emphasis)

'The Author as Producer' was first presented in Paris in 1934 to the Institute for the Study of Fascism, a very different historical moment from the mid 1990s, when Foster's essay was published. But, as Foster stresses, the question of the location of both progressive artists and the artworks they produce is still very much with us. He goes on to note how a number of would-be progressive visual artists have turned to ethnography in an attempt to find a more politically comfortable place for themselves. Indeed, for Foster, artists have embraced ethnography so enthusiastically that 'mapping in recent art has tended toward the sociological and the anthropological, to the point where an ethnographic mapping of an institution or a community is a primary form of site-specific art today' (1996: 185). He warns, however, that artists who take this route risk ending up in the same impossible place as Döblin's would-be progressive intellectual.

Foster's clear mapping of the location of his artist ethnographers is insightful, although, as an anthropologist who has spent a fair amount of time 'doing ethnography', I have a major reservation—a reservation Foster seems to some extent to share—about the use of the term 'ethnography' in this context. And this applies whether the artists concerned are Foster's gallery artists or those of Free Form. It is true, for instance, that the D&TAS projects always included some preliminary mapping of the 'communities' in which these projects were sited, but I find it difficult to accept either this or the mapping of Foster's site-specific artists as ethnography. While I would certainly not want to claim ethnography as the exclusive property of anthropology, from an anthropological perspective the 'ethnographic mapping' of Foster's artists *as ethnography* seems rather thin and superficial. Foster's unpacking of what he terms 'the artist as ethnographer paradigm', however, gives us a useful set of guidelines for thinking about the location of the Free Form Project and its artists.

Foster sees the paradigm itself as emerging out of 'the capitalization of culture and privatization of society under Reagan, Thatcher, Kohl and company',

1. In his essay, Foster quotes just the final two sentences here; hence my citation of Benjamin's original.

just as Benjamin's author-as-producer paradigm can be seen as a response 'to the aestheticization of politics under fascism' (1996: 172). What the new artist ethnographers are struggling over, however, 'remains in large part the bourgeois-capitalist institution of art (the museum, the academy, the market, and the media)' (1996: 172). And, indeed, the artists whose work Foster discusses in his essay all have strong links to the established art world: they show their work in prestigious galleries; are written about by art world intellectuals and critics (such as Foster); are likely to sell their work, whether to galleries, museums or individual collectors; and often support themselves and their work at least in part through teaching or residencies at art world or academic institutions. Foster goes on to note a significant shift since Benjamin's day: from a paradigm of the politically committed artist centred on the artist's relation to a *class* entity, to an understanding of the progressive artist in which it is a 'cultural and/or ethnic other in whose name the committed artist most often struggles' (1996: 173). In addition Foster pinpoints what we might call the authentic identity fallacy—the assumption that *only* artists who themselves come from a potentially oppositional group (whether in class or ethnic terms) can produce work that genuinely expresses this oppositional otherness and that coming from such a group in itself gives automatic access to such oppositional otherness (1996: 173).

LOCATING THE FREE FORM ARTISTS

Using Foster's 'artist as ethnographer paradigm', how might we locate the Free Form artists? As regards Foster's first point, 'the object of contestation', here they do seem to occupy a location different from that of the artists discussed by Foster. *Artism Lifeism* in 1971 (see Chapter 2), for instance, marked not only the founders' rejection of what they saw as the 'isms' of the art world but the end of their participation in art world gallery events. The Briefs they took on after this, particularly after the setting up of the D&TAS, came from the deprived neighbourhoods in which the projects were sited. Fig. 26, for instance, shows the construction of a landscaped garden, Hackney Grove Garden, created by a local community group and Free Form on the site of a demolished toy factory close to Hackney Town Hall. The comments of the Arts Council evaluators quoted at the end of the last chapter are a good indication of how the work they were producing was regarded within the official art world. In general, I think it is safe to say that wherever the Free Form artists may have been located by mid 1990s, they, like community arts in general, had essentially been expelled by the curatoriat from the world of *serious* art, even if their art school credentials still gave them authority as artists in less rarefied circles.

Figure 26 Landscaping Hackney Grove Gardens, London, mid 1980s (photograph and copyright: Free Form Arts Trust).

The question of the artists' relation to the market is an interesting one. Their artworks were never in any straightforward sense commodities produced for sale. From its earliest days, the organization was not interested in producing for the art market, and it continued the founders' original rejection of the gallery-artist route. Significantly, in line with their embrace of collective creativity, the individual artists responsible for specific elements of a given project did not generally sign their work. A work might be signed if it had been commissioned from an artist who was not a regular Free Form employee, but otherwise there would simply be a small plaque crediting Free Form as a whole. I opened this chapter with the explanation one of the younger Free Form artists I interviewed, Svar Simpson, gave to his art world friends, who were shocked at the lack of acknowledgement he had received for 'his' sculpture. Simpson was a student on Free Form's first intensive training course for artists interested in working in the public realm (Free Form's training programmes are discussed in the next chapter). As part of the course, he worked with council estate tenants to produce a sculpture for their estate. He explained to me how he was happy to forgo his individual ownership and acknowledgement. The reward for him came from 'Just seeing the project through, after going through all this juggling about that you've done, actually seeing the result there and installed and that the people, the clients, the local

community, that everybody is actually really happy and really pleased with it and that it has been a successful project'.

Simpson's attitude here brings us back to the anonymous medieval sculptors Wheeler-Early and the other Free Form founders claimed as forebears (see Chapter 1), the stone carvers who worked on cathedrals but did not sign their work. It also echoes the sentiments of Charlotte Howarth, the stone mason quoted in Chapter 5. A willingness on the part of artists to efface themselves from their work as recognized, named individuals is possible, of course, only for artists who do not depend on selling their work through the art market. Artists who sell their work need to establish a name for themselves within the art world; it is this that gives their work value. The trick with value here is that it involves a continual Escher-like switching between two meanings: a transcendent value beyond the wheeling and dealing of the market place and a reassuringly solid monetary value.

The Free Form artists, however, while they may not have been dependent on the art market, still needed to earn a living. Neither they nor the work they did was independent of the market. A determination to find an acceptable way of being artists capable of providing them with an adequate living was central to the founders' original vision. Wheeler-Early stressed to me how she was especially proud of Free Form's achievement of this. Goodrich, Ives and Wheeler-Early all rejected not only the gallery path but also the common one of artists earning a living from some kind of salaried job, often as a teacher, while making 'art' in their spare time.[2] Unlike a number of other community artists, they did not begin their work outside the gallery 'never expecting', as one such artist puts it, 'that anyone would want to fund us' (Morgan 1995: 16) From the outset, the Free Form founders saw themselves as doing work that ought to be supported. But from where was the necessary funding to come? For first few hand-to-mouth years, they scraped together money from various jobs, which in the case of Wheeler-Early and Goodrich did include short periods of secondary school teaching, and further education and art school teaching. The earliest projects were funded with the money from jumble sale receipts and donations of materials from local businesses, supplemented by the occasional minuscule grant. After this very early period, however, the organization's main income came from grants and income from fees, and part of this income went to pay all full-time workers a regular, if far from lavish, salary.

In some respects, the organization's relationship to the various grant-giving bodies was closer to older models of patronage than to those of the market.

2. A number of the artists employed by Free Form in later years would maintain or attempt to maintain their own separate careers as gallery artists, but my focus in this book is the essential Free Form Project, which never included such activity.

Whether funders came from the art world (e.g. the Arts Council) or were part of the government or urban renewal programs, their role was something like that of the Church and State officials, or the wealthy aristocrats who were the commissioners of so much art in the past. It is not surprising that an increasing proportion of the organization's funding, especially after community art's loss of credibility within the art world, came from local authority and regeneration sources. But what Free Form was providing to its modern patrons was often not so much 'art' as a connection with that elusive animal, the 'community'. To those who awarded them revenue grants or paid them to carry out specific projects, what they came to be seen as offering was primarily expertise in 'delivering participation', to use the language of the funding world. To some extent, the organization was in the business of selling commodities; it is just that these commodities were not primarily artworks but, rather, commodities such as 'community participation'. And 'community participation' is a commodity in great demand in the contemporary world, having become a standard requirement of many regeneration funders, even if those funders are not altogether clear as to who this 'community' is or what 'participation' means in practice. Indeed, precisely because 'community' is such an elusive entity in the real world, an organization that seems to have a demonstrated ability to work with 'communities' can be seen as having a rather uncommon expertise (see Fig. 27).

But if Free Form as an organization was selling 'community participation', where did this put them in structural terms in relation to the 'communities' with whom they worked? In *Community, Art and the State,* Kelly acknowledges that 'The communities with whom we work are not really our customers, since an increase in their support and enthusiasm will not necessarily increase our grant, just as a decrease in their interest will not necessarily decrease our grant' (1984: 106). This, however, was not true of the D&TAS—one of the reasons I find it a particularly interesting embodiment of the Free Form Project. The D&TAS provided groups—often, as with the Goldsmiths and Provost projects, a tenants association—with free advice and support that enabled the groups to write a grant. The grant itself was paid to the tenants association or other group, which then employed Free Form to carry out the work. The relationship was that of a client paying for professional expertise.

In certain important respects, Free Form can be seen as having turned its back on the art world and its legitimating institutions, but where did it come to stand in relation to Foster's second point, the shift among would-be progressive artists from identification with a class entity to identification with a cultural and/or ethnic other 'in whose name' the artist makes art? Here the fact that Free Form was a British rather than an American organization is significant. Discussions of social inequality in Britain still rely heavily on the language of class, although there is an increasing acknowledgement of the

Figure 27 Boy with his drawing, which was used in the design of street light behind him, Barking Town Quay, 1992 (photograph and copyright: Free Form Arts Trust).

significance of race and ethnicity, with class, race and ethnicity being seen as braided together in complex ways. From almost the earliest days, the Free Form artists saw the Briefs they took on to fulfil their Charge as requiring them to find solutions to problems that were shot through with questions of race and ethnicity. The original Granby Festivals, for instance, took place in a climate of racial tension, while the neighbourhood festivals of the late 1970s had an explicitly antiracist message. Ethnic and racial issues arose in many, if not most, D&TAS projects. But, while the Free Form artists were committed to putting their expertise at the service of the often very diverse working-class groups with whom they worked, they never claimed to be making art *in the name of* the working class or of anyone else, for that matter. The most they claimed was, as in the case of the Provost mural, to help those living in one particular place to find ways of telling their stories. This brings us to Foster's third point, the authentic identity fallacy.

The Free Form's founders' starting point, as I have described, was a determination to take art, in Goodrich's words, to 'the great housing estates in England where art meant nothing' (see Chapter 2). Goodrich and Ives had grown up in working-class neighbourhoods, and they still felt a strong sense of identification with those living in such neighbourhoods. Wheeler-Early, while coming from a more professional, middle-class background, was committed to a more inclusive art that challenged the prejudices of the curatoriat, which, as she saw it, prevented art from reaching out beyond the privileged confines of the art world. At the same time, all three founders were well aware that the visual language they spoke as artists was not the native tongue of most of those they wanted to reach. Their Charge, as they saw it, required them to find aesthetic language that both was acceptable to their trained artistic eyes and resonated with working-class people. The aesthetic that emerged in the context of the D&TAS projects can be seen as the result of years of dialogue, in the course of which, as the disparaging comments of the Arts Council evaluators quoted in Chapter 6 indicate, the artists travelled quite far from the aesthetic language dominant in the art world. At the same time, we certainly cannot see this language as a spontaneous or automatic result of either the artists or their collaborators' own class or cultural origins.

But if it is not, as the authentic identity fallacy claims, an artist's own class or cultural identity that determines the political character of their art, what does? Benjamin, in 'The Author as Producer', provides a useful reframing of the whole question of political location. What we should focus on, he argues, is not whether a particular artwork is progressive in its *attitudes* but how it is *situated*:

> Instead of asking, 'What is the attitude of a work to the relations of production of its time? Does it accept them, is it reactionary—or does it aim at overthrowing them, is it revolutionary?'—instead of this question, or at any rate before it, I should like to propose another. Rather than ask, 'What is the *attitude* of a work [of art] to the relations of production of its time?' I should like to ask, 'What is its *position* in them?' This question directly concerns the function the work has within the literary relations of production of its time. It is concerned, in other words, directly with the literary *technique* of works. (1986: 222, Benjamin's emphasis)

Benjamin goes on to consider the location of the producer of such works, criticizing the German writers of the 1930 who, 'under the pressure of economic conditions, have passed through a revolutionary development in their attitudes, without being able simultaneously to rethink their own work, *their relations to the means of production, their technique,* in a really revolutionary way' (1986: 226, my emphasis).

The D&TAS artworks themselves were not revolutionary. But, while they may not have challenged capitalist relations of production *as artworks,* I would

THEORETICAL AND POLITICAL LOCATIONS

argue that the *techniques* used to produce them—above all, the workshop technique—did offer a genuine challenge to the production of Art under capitalism. The former Rector of Royal College of Art, whom I quoted in Chapter 1, recognized this when he explained that he could not take Free Form's work seriously as Art because it was not 'the work of one mind, one man, one artist' but rather 'all sorts of people' (Fig. 28 shows a mural under construction). The displacement of the lone creative genius as *the* source of an artwork challenges one of the fundamental criteria determining 'value' within the art market. The workshop, central to how the Free Form Project came to be realized as aesthetic practice, is a technique that potentially makes expertise more accessible and decision making more democratic. The D&TAS projects may not have been 'critical art' as defined by Rancière, concerned as the artists were with simply helping those living in impoverished 'communities' improve, often in quite small ways, their social and built environment. But maybe they offer an example of what a more progressive location for the visual artist could look like in practice?

THE COMING OF THE AUDIT CULTURE

In certain respects, the D&TAS years can be seen as representing the most politically progressive embodiment of the Free Form Project. By the mid

Figure 28 Working on a mosaic mural, 1979 (photograph and copyright: Free Form Arts Trust).

1990s, when the Hackney Council revenue grant to run the D&TAS ended, the political winds had changed in fundamental ways. Right from its beginnings, the ground under Free Form's feet had never been stable, and the organization had always had to adapt to shifting political and economic circumstances, but the rise of what has been termed the 'audit culture' in Britain and elsewhere has transformed these circumstances in radical ways. Audit culture is defined by an insistence on 'accountability' as a central criterion of evaluation for all institutions, including all grant-giving bodies.[3] A stress on particular forms of accountability can be seen as part of the larger neoliberal revolution which has transformed so much of today's world.[4] Increasingly, any kind of funding is hedged with demands that the 'targets' to be met be clearly and minutely specified in a way that allows quantifiable assessment: anything that cannot be counted and assigned a numerical value tends to be dismissed as an allowable 'target'. For an organization like Free Form, the policing of the audit culture meant that the long hours spent building up relationships of trust and exploring possibilities with a tenants association now had to be justified by clearly specified 'outcomes'. But when you do not know what the outcome will be, in part because it depends on a dialogue you have yet to have, it is hard to come up with the necessary minutely specified and quantifiable outcomes. Once the D&TAS lost its revenue grant, which had paid the salaries of three Free Form employees, every component of every project, with its associated labour costs, had to be accounted for and funds found to meet those costs. One result was that there was far less scope for cross-subsidy between projects; all the artists had to keep far stricter accounts of exactly how they were spending their time. The D&TAS work continued, but not in the same labour-intensive way; the many unpaid hours spent working with local groups had to be drastically curtailed.

As a result of the fundamental shifts in the political and economic landscape, the organization I encountered when I began my participant observation fieldwork in 2004 had moved quite a long way from the Free Form of the D&TAS years. One question I was interested in was how the Free Form Project had fared in a Britain where Baldry's comfortable confidence in government support for the arts (see Chapter 4) sounds like a voice from a distant past and where arts organizations, like everybody else, are expected to *earn* their keep. A large Free Form project in the City of Norwich that took place over the course of my fieldwork and which I followed closely begins to provide some answers. The last section of the book focusses on that project.

3. See Marilyn Strathern's *Audit Cultures: Anthropological Studies in Accountability, Ethics and the Academy* (2000).

4. See David Harvey's *A Brief History of Neoliberalism* (2005).

III: INTO THE TWENTY-FIRST CENTURY

–8–

Free Form in 2004

> Money is very important in the history of art.
>
> —Michael Baxandall, *Painting and Experience in Fifteenth-Century Italy*

I began the participant observation phase of my study in 2004, almost twenty years after the Goldsmiths and Provost projects and ten years after the ending of the D&TAS revenue grant. What had happened to the Free Form Project as it sought to find a place for itself in a world increasingly dominated by neoliberal assumptions and an audit culture? To help answer this question, I look in detail at a project on which Free Form had embarked shortly before I arrived to begin my fieldwork. First, however, I want to provide a brief sketch of the organization I encountered in 2004 so that the reader has a general sense of the kind of organization Free Form had become.

A PROFESSIONAL ORGANIZATION

In 2004, Free Form was a highly professional registered charity known as Free Form Arts Trust, which provided employment for approximately seventy arts professionals (including permanent employees, commissioned artists and trainees). In my telling of the Free Form story, I have focussed on certain key projects which seem to me to illuminate most clearly the different steps by which a small group of art students came to reject the gallery world and gradually developed specific aesthetic practices very different from those of the traditional fine artist. Necessarily this has meant leaving out many projects. This overview fills in some of the gaps, providing some sense of the full range of Briefs taken on by Free Form in its forty-year history and what it had become by 2004.

Although Free Form was always based in London, from as early as the first Granby Festival, in Liverpool, there were Briefs, such as the Mobile Roadshow and Workshop (discussed in Chapter 3), that took the Free Form artists across Britain. In 1976, a North West Arts[1] community arts officer, impressed with the work the Mobile Roadshow and Workshop were doing, suggested

1. One of the Arts Council's regional associations.

that Free Form move its base to the North West. Unwilling to do this, Free Form proposed an alternative: Goodrich and Cilla Baynes (leader of the Mobile Roadshow team) would run a six-month training course at Manchester Polytechnic (now part of Manchester Metropolitan University) for local artists interested in developing community arts skills. North West Arts agreed to fund the course. One of the outcomes of this course was the creation of a new organization, Community Arts Workshop, under the leadership of Baynes. Community Arts Workshop later changed its name to Community Arts North West, and is still operating today.

Another offshoot, this time in North East England, developed out of a report Free Form had written with the support of the Gulbenkian Foundation, assessing the potential role of art for community-based regeneration. This report led to the Tyne and Wear Development Corporation commissioning the organization to undertake a public art project aimed at revitalizing the neighbourhood around a decaying fishing quay. Free Form assembled a team of artists, led by Goodrich, which included a number of locally based artists, and this team created a number of artworks, including a large-scale fish mosaic on the hillside overlooking the quay (see Fig. 29). The project also transformed the area's annual blessing of the fleet from a small local event into a major festival, which took place annually for a number of years, attracting at its height more than a

Figure 29 Fishscape mosaic, Tyneside, late 1980s (photograph and copyright: Free Form Arts Trust).

Figure 30 Fish Quay Festival, Tyneside, 1990 (photograph and copyright: Free Form Arts Trust).

million visitors (see Fig. 30). In the early 1990s, this group became an autonomous organization, changing its name in 1995 from Northern Free Form to Art Scope. Art Scope continued to exist until 2000. There were also projects further afield. In 2005, for instance, the British Council funded Free Form to carry out two projects in Romania.

In 2004, the organization completed forty-eight projects and took on sixty-two new ones. Its grant income that year was just over £1 million, plus £750,000 in earned income. Over the years, as I have noted, its funding sources had shifted away from arts funders. For instance, although the small Arts Council revenue grant continued until 2001, it represented an ever-dwindling percentage of the organization's total funding. Traditional arts funding sources had been replaced by local and national government programmes and, more recently, European Union (EU) regeneration funds. Significantly, in 2004, Free Form's largest Arts Council grant came from an art and regeneration programme called 'Arts Generate'. This provided South Bedfordshire District Council with the money to employ Free Form to deliver (in collaboration with other organizations) a major multiyear, arts-led regeneration scheme to improve one of the council's estates, Downside.

Securing regeneration funds, however, is by no means straightforward; a major element of the expertise the Free Form artists developed over the years was the ability to identify potential opportunities within the mounds of documents generated by the regeneration industry. Navigating a way through the

bureaucratic seas of ever-proliferating forms, with their insistence on goals, targets, measurable outputs and so on, while steering a course set by the Free Form Project was not only hugely time consuming but also demanded a particular kind of expertise. Such navigational skills were indeed an important part of the expertise the D&TAS provided to local groups, as Dee Emerick, who played such a major role in the Goldsmiths project and the D&TAS generally, noted (see Chapter 5).

For a number of years, much of Wheeler-Early's time in particular was devoted to this kind of creative fund-raising, and, by 2004, thanks in large part to her efforts, the organization had its own building, the Hothouse. In 1997, realizing that the supply of cheap, short-life council-owned property (on which Free Form, like so many artists and art organizations, had depended) was drying up, Free Form had bought a small plot of land sandwiched between the East London park London Fields and one of the main rail lines leading out of London. A major attraction of the site was precisely its need of regeneration: as Wheeler-Early told me, 'we'd always fancied being involved with a New Build project that embodied principles that we have of regenerating a bit of the worst possible blight. And this site fitted the bill because it's a contaminated brownfield site. It was an old scaffolding repair yard that was a complete rubbish tip.' With £1.5 million of regeneration money, the site was cleaned up and a building erected. The architectural firm Ash Sakuler were commissioned to design an arts complex to provide a permanent home for Free Form along with extra studio and workshop space that could be rented out to generate income for the organization. The railway arches adjoining the site were leased to provide yet more space. The complex was given the name Hothouse in memory of the great nineteenth-century hothouses that had occupied a nearby site. Completed in two phases, in 2003 and 2007, the Hothouse would go on to win a number of awards, including, for Phase 1, an award from the Office of the Mayor of London for 'Best Planned Building Contributing to London's Future' and the Mayor's 'Special Award for Planning Excellence'; from the British Urban Regeneration Association, 'Best Practice in Regeneration Award 2004'; and, from English Partnerships, 'Best Partnerships in Region Award'. Phase 2's awards in 2009 would include one from the Royal Institute of British Architects for Arts Buildings, one from the Civic Trust, and a Hackney Council design award.

The list of projects presented to Free Form's 2004 Annual General Meeting gives an indication of the range of the organization's work by this point. There were training courses organized and managed by two full-timers. These included regular sixteen-week intensive courses for artists interested in working in the public realm, which Free Form had been running since the mid 1990s. Funding for these had originally come from the EU's European Social Fund, which offered grants for the retraining of unemployed artists to make

them more employable. The courses were free and even reimbursed those attending for some minimal expenses. They proved very popular, and there were always far more applications than the twelve or so slots available. The courses were work based: working collaboratively in small groups, the trainees designed and planned actual projects, a number of which were carried out, such as the one worked on by Svar Simpson, discussed in the previous chapter. Interestingly, while funding for the courses—in line with the audit culture's demand for quantifiable outcomes—depended on the trainees' completing the requirements for a National Vocational Qualification (NVQ), none of the trainees I interviewed was particularly interested in this. They all told me that what they valued was the practical experience they gained and the contacts the course helped them make. From the point of view of the organization itself, the training course proved a useful recruitment mechanism, with some trainees subsequently being taken on full time and others working for projects on a freelance basis.

There were also other training initiatives directed at young people, which grew out of the organization's work with children. One of the forms community arts took in the 1970s, something that has now become standard practice in many areas, was the placement of artists in schools to work on specific projects with children, often over an extended period. Free Form had been one of the pioneers here. By 2004, however, this area of work within Free Form had shifted to the provision of short courses for young people ages 14–16 that involved them coming to Free Form, rather than the artists going into the schools, and more tightly circumscribed workshops offered in collaboration with local schools. Often these young people were those, in funding parlance, deemed to be 'at risk of failure', for whom funds for training were available. The courses being run in 2004 were designed to introduce young people to the creative possibilities of new technology.

Another significant area of work, which I have not yet talked about, was Free Form's work with the private sector. This began in the mid 1980s and grew out of their collaboration with the architect and developer responsible for the redevelopment of Covent Garden. The early 1970s saw a long and contentious struggle to save the old Covent Garden market structures when the wholesale fruit and vegetable market itself was relocated. By 1973, the market buildings themselves had been saved, although this did not extend to many of the existing smaller businesses and residential properties in the area. The redevelopment that was eventually approved meant, however, that, for several years, while the new commercial development was being constructed, there would be a huge building site in the centre of London, surrounded by builders' hoardings, which would be passed every day by something like 50,000 to 100,000 people. Unhappy about the prospect of this vast expanse of bare boards, the developer, Derek Parkes (who has an interest in the arts), approached the

architect before the building work began and asked, as he explained to me when I interviewed him, 'Can we do something about these hoardings, can we design them or decorate them, do something to make them more enjoyable for the passer-by?' It so happened that one of the architects of the Covent Garden development, Martin Dyke Coombes, is married to Maggie Pinhorn, who from the early Association of Community Artists days had remained close to Free Form and was one of the original trustees of the charity Free Form Arts Trust. Dyke Coombes immediately thought of Free Form, and, after some discussion, they were commissioned to provide imaginative hoardings. A Free Form team, led by Alan Rossiter, came up with designs that paid homage to the history of the market and its porters while drawing on the surrealist imagery of Magritte. Although the project did not provide much scope for collaboration with the 'community', the market porters were incorporated into the design in a small way in the form of their names, which they personally stencilled on the hoardings. They also participated, together with others living in the neighbourhood, in the lavish celebration with stilt walkers, fire eaters and other performers, which Free Form organized to mark the completion of the decoration of the hoardings (see Fig. 31).

The project, which won an Art for Offices Award, was judged a great success by Parkes, and he continued his association with Free Form, first as a Trustee, then as chair of their Board of Trustees, a position he still held in 2004. The

Figure 31 Covent Garden hoardings with a design incorporating the stencilled names of market porters, official opening, 1985 (photograph and copyright: Free Form Arts Trust).

Covent Garden project led to numerous other commissions for hoardings, as well as similar initiatives by other developers. To meet the demand, Free Form set up a subsidiary company, Art Works, dedicated to this work and led by Rossiter. For a few years, until the economic slump of the early 1990s, Art Works was very successful, employing at its height around twenty-five artists and winning numerous awards (Fig. 32 shows an example of a hoarding). In general, as with the Covent Garden hoardings, these were not projects that lent themselves to local participation; the idea was rather that they would simply improve the temporary built environment and generate income for Free Form's other work. It is telling, I think, that it was this work, which involved relatively little collaboration with nonartists, that was singled out for praise by a 1986 Arts Council evaluator. After noting that Free Form's artworks in general 'are characteristic of a somewhat old fashioned community arts aesthetic', the evaluator went on to observe that 'Free Form's commercial programme was perhaps the most intriguing of its current activities and certainly has produced its most professional results' (Arts Council 1986). Despite the demise of Art Works as a separate entity, Free Form continued to work with the private sector, expanding the work in a number of directions, from decorative tile work in underground stations to public art displays in major developments, such as Birmingham's Bullring and the Oracle shopping centre in Reading. As with the Covent Garden hoardings, while these projects did involve some elements of 'community' input, it was relatively minimal and qualitatively different from the

Figure 32 Art Works hoarding, early 1990s (photograph and copyright: Free Form Arts Trust).

D&TAS projects in that the 'community' had no say in the planning of these projects. Beginning with Art Works, Rossiter's main responsibility within Free Form became the overseeing of this public artwork and collaborations with the private sector. In 2004, Rossiter and Free Form were organizing a public art programme for a major commercial development in the City of London, Spitalfields.

Another significant initiative involving the private sector was the Green Bottle Unit (GBU). GBU was set up in 1999 to develop an innovative technology that recycles glass into high-quality decorative tiles. The tiles were used both in Free Form's own environmental projects and by a number of architects, such as Norman Foster and Partners, looking for environmentally friendly, green materials. GBU's complex technology, with its demanding health and safety regulations, meant that there was little scope for incorporating nonexperts in the production process itself. The artists involved with GBU, however, did work with schools and community groups to produce designs linked to the specific location in which given tiles were to be used. These designs were then incorporated into the tiles' surface to give them a local identity. GBU also ran regular recycling workshops for school groups.

Alongside the various new areas of work, environmental work with disadvantaged 'communities' continued as one of the organization's major activities. In 2004, Goldman had overall responsibility for these projects. Shortly before I began the participant observation phase of my study, Free Form had taken on one such project in the city of Norwich, some hundred miles northeast of London. The project continued throughout my fieldwork and was close to completion by the time I left the field in August 2005. Observing the specifics of this one project as it unfolded over the weeks and months gave me an opportunity to explore what the Free Form Project had become in twenty-first century Britain. In the next section of this chapter, I explore the project's origins. The next chapter goes on to look in detail at two of its elements, a carnival and a permanent artwork. My account is based both on my participant observation data and on interviews with a number of the key players. Unless otherwise indicated, all quotations come from these interviews.

THE NORWICH COMMISSION

Interestingly, as in Granby so many years before, the Norwich project came to Free Form because a local council was facing a problem to which there seemed no easy solution. Norwich is a relatively prosperous city in East Anglia with a long history as a major ecclesiastical centre; its magnificent Romanesque cathedral figures prominently on the city's publicity material. Within Norwich's overall prosperity, however, there are pockets of deprivation,

and in 2000 Norwich City Council had put in a bid for more than £4 million in government regeneration funds to be spent on one of its more rundown wards, Catton Grove. The bid was turned down in part because the proposal was deemed deficient in community participation. A few years later, in 2003, another attempt was made to secure funding for Catton Grove. This time, the group applying was the Cat 'n' Fiddle Partnership, a Local Community Forum group made up of residents and a few local councillors. These Partnerships were a Labour government initiative intended to provide greater community input into local and national government. The name of this particular group derived from the two areas, Catton and Fiddlewood (both within the Catton Grove ward), covered by the Partnership. The application to the Office of the Deputy Prime Minister (ODPM) was for funds to establish a community arts centre as part of a new school that was about to be built. The ODPM liked the idea and awarded £350,000 to Norwich City Council to implement it; the Partnership itself would not have been able to administer such a large grant.

Once the grant had been awarded, however, it became clear that the proposal was simply not feasible: there was no revenue source to run an arts centre, and in any case the school fell under the jurisdiction of Norfolk County Council, rather than the City Council. The problem the City Council faced was that they had already signed an agreement with the ODPM that the money would be spent by March 2004. The council was in something of a quandary: simply admitting defeat and handing the money back was not an attractive option, but how to find a way of spending the money on environmental improvement that could claim, as was required, to involve both 'art' and 'community participation'?

At the beginning of 2004, with the money still sitting unspent, Free Form entered the picture. In January, the City Council had appointed a new community development officer, Emma Bacon. More or less on her first day, she was handed the project and told she had two months to spend £350,000 on arts-linked projects. As a first step, Bacon initiated a small project with the British Trust for Conservation Volunteers (BTCV), contracting them to organize local volunteers to work on conservation tasks. BTCV would continue to be an important player in the project, although, as a conservation-oriented organization, they would always be working to a rather different Brief from Free Form. Wondering how on earth she could satisfy the requirement for *arts*-linked projects, Bacon asked the advice of a colleague. This colleague, who had recently attended a talk on Free Form given by Goodrich and who knew others with whom Free Form had worked, suggested that maybe this was an organization with the necessary expertise. After some checking, Bacon emailed Goodrich to ask him if Free Form would be able to deliver an arts project involving the local community. Goodrich was interested and came to Norwich to meet with

Bacon and other council officers. After some negotiation, it was agreed that Free Form would take on the project. This solved the council's problem, since the £350,000 could be handed over to Free Form, meeting the ODPM's deadline for the council to have spent the money, while Free Form would have time to prepare and deliver appropriate projects.

This agreement also put the organization in a strong position vis-à-vis the council with regard to control of the project, although there was still some residual tension with the Cat 'n' Fiddle Partnership. They had never been entirely happy that the money for which they had applied had been awarded to the council, and they were not at all sure about the idea of outsiders from London being brought in and being given what seemed like a free hand. The BTCV worker, who had by this time set up a Friends of Fiddlewood Committee, also had her doubts to whether this London arts organization would give the proper priority to conservation concerns or would genuinely involve local people in their arts projects. Such locally influential individuals and groups are always an important part of any 'community', and gaining their trust is a crucial part of any such Brief.

Free Form put together a team for the Catton project with Goodrich as overall director. The project manager was Andy Newman. Newman, who trained as a TV and theatre set designer, began working for Free Form's commercial enterprise, Art Works, in the late 1980s, moving over to Free Form itself when that work dried up. All the structural environmental work was overseen by Max Brewer, a fully trained architect who had worked full time for Free Form since 1987. Goldman was given overall responsibility for community involvement, while Rossiter was in charge of the commissioning of artworks by non-Free Form artists. The final two members of the team, both of whom had begun working for Free Form a couple of years earlier, were Shahed Ahmed, who did much of the technical drawing and preparation of the various display boards, and Joanne Milmoe, who helped administer the project. Ahmed grew up in Hackney. From an early age, he showed artistic promise, winning a national art competition when he was about eleven. Interestingly, in the early 1980s, a year or two before winning this prize, he had worked on one of the D&TAS projects which involved the creation of a large play sculpture in the form of a snake in a local park (see Fig. 33 and cover image). This snake has become so popular with local children that the park is now commonly referred to as Snake Park, rather than by its official name, Stonebridge Gardens. Ahmed has vivid memories of helping decorate the snake with mosaics. After leaving school, he went on to study industrial design. Eventually, after a period spent working in his family's Hackney restaurant, he took one of Free Form's training courses for artists interested in working in the public realm, after which he was taken on full time. It was Ahmed who ran the GBU recycling workshops for

schools. Milmoe studied art history at university and began working at Free Form as an administrator in 2002.

While each member of the team had a clearly defined role, in practice Free Form always operated on the principle that everyone pitched in as necessary. This became harder as the audit culture became ever more of a presence. By 2004, time had to be strictly accounted for, with everyone required to fill out forms noting the precise amount of time spent on each task. On one of the journeys back from Norwich I made with Rossiter, he talked rather wistfully about the old, more carefree days, 'when there were no Form Bs, and you just did what needed to be done.' The Catton project certainly represented a different time-management culture from that of Free Form's early days.

The formal brief that Free Form was given by Norwich Council was very general. It boiled down to: 'The development of arts projects [in Catton Grove] involving the local community that will improve the environment and help generate an increased sense of community identity' (Free Form 2004a: 5). Part of Free Form's task was to translate this general brief into a more specific Brief. They began by trying to get a sense of the area's physical and social geography, carrying out 'a scoping exercise', as they termed it in their first report to the council. The form this took was members of the Free Form team, accompanied by Bacon, taking long walks round the area, during which they talked

Figure 33 Snake play sculpture, Stonebridge Park, London, 1984 (photograph and copyright: Free Form Arts Trust).

to local residents and took many photographs. What they learnt on their walks was then combined with basic socioeconomic data to provide a general sense of the place they had been asked to improve. This scoping exercise might be seen as the kind of 'ethnographic mapping' to which Foster claims progressive artists have increasingly turned, but it is a long way from the intense, empathetic project at the heart of the anthropological notion of ethnography. As Bronislaw Malinowski so famously put it in 1922 in his Introduction to *Argonauts of the Western Pacific*, '[T]he final goal, of which the Ethnographer [Malinowski had a fondness for capitalizing the ethnographer] should never lose sight . . . is, briefly, to grasp the native's point of view, *his* relation to life, to realise *his* vision of his world' (1984 [1922]: 25, Malinowski's emphasis). The *final* goal of the artist ethnographer is necessarily somewhat different. His or her final goal is the creation, whatever form this may take, of artworks.

The Free Form artists in Norwich, operating as they were by this point outside the gallery world, were not subject to the inescapable pressure gallery artists are under to produce artworks that embody a personal vision, but their scoping exercise was still very far from an anthropological understanding of ethnography. Their final goal was to translate the broad brief they had been given by the council into their own more specific Brief. What they were looking for were local problems, identified by local people, for which their kind of visual arts–based environmental work could provide solutions. The team's walks with Bacon were intended to identify appropriate opportunities. The art solutions then devised by the Free Form team would be responses to this particular local Brief; they would not be a response to an art world Brief or to one that defined 'art' in any simple, commonsense way.

THE CATTON GROVE BRIEF

In 2000, Catton Grove was listed in the Department for Transport, Local Government and the Regions' Index of Deprivation as the third most deprived ward in the city of Norwich. Unemployment was high, and 46 per cent of the population lived in social housing (Norwich City Council 2002: 7). But, while the housing stock was rather run down, it did not seem to the Free Form team to be in terrible shape. And one resource Catton did have was a relatively abundant supply of green spaces. These included two small patches of old woodland, Night Plantation and Fiddlewood (from which the Fiddlewood Estate took its name). It was on these woodlands that the BTCV's conservation efforts were focussed. After their walks around the ward, the Free Form team concluded that, while these green spaces had considerable potential, they were underused; paths were poorly maintained and overgrown, and in both the woods and elsewhere there was a serious problem of fly tipping. These

green spaces seemed to offer a number of opportunities for environmental improvement.

On the basis of the data they had collected from council documents, their walks and their chats with local people (Figs. 34 and 35 show two Fiddlewood residents), the Free Form team wrote a report for the council identifying sixteen different projects on which the ODPM money could be spent. Each project and project site was described, with a photograph, a map showing its location and rough costings. The descriptions explained the issues connected with each site and how the proposed projects would address them. The report was intended to provide a range of options from which people could choose. The report also stressed that even £350,000 was a very small amount set against the long-term regeneration needs of the area and argued that this project should be treated as a first step towards future major investment:

Figure 34 Chloe Green, participant in Fiddlewood Standing Stone workshops, Fiddlewood Estate, 2009 (photograph and copyright: Kate Goodrich).

Figure 35 Janet Green, participant in Fiddlewood Standing Stone workshops, Fiddlewood Estate, 2009 (photograph and copyright: Kate Goodrich).

some exemplary projects to show what could be done, which would generate enthusiasm to work towards a multimillion-pound regeneration plan.

Prior to the council meeting at which the final decision was to be made, the report was circulated to the Cat 'n' Fiddle Partnership and to local council officials. Some of those who read the report were rather taken aback and began to express doubts as to whether Free Form could deliver what was required. What worried them, Goodrich was told, was that, rather than being a proposal for a clearly recognisable 'art' project, this report seemed concerned simply with the problems of the area's public housing, particularly its underutilized green spaces. 'But where's the art?' one slightly bewildered councillor wanted to know—a question that nicely captures the commonsense assumption that, while we may disagree on the merits of a particular piece of 'art', we all know what counts as art and what does not. At the meeting, Goodrich answered the doubters by explaining how all artists start with a blank canvas; in this case,

Catton was the canvas, and research was necessary to identify what 'art' was appropriate and feasible, given the area and the budget. This explanation was accepted—Free Form, after all, represented accredited art expertise, and Goodrich's metaphor, with its invocation of the familiar image of the artist at his easel, was presumably reassuring. The meeting approved the report comfortably. Perhaps predictably, however, the hoped-for multimillion-pound regeneration plan never materialized.

It was decided at this meeting that a steering committee should be set up to oversee the project. The hope was that, since this was supposed to be a community-based project with a high level of participation, the steering committee would include a wider range of local voices than just those of the Cat 'n' Fiddle Partnership or the council. Bacon worked hard to recruit other people, but, although larger than the Partnership, the steering committee was still a fairly small group. At the meetings I attended, there were never more than twenty people present, and, of this twenty, around a quarter would be Bacon, the BTCV organizer, and members of the Free Form team. Nonetheless, in the name of the 'community', this steering group was given the task of deciding how many and which of the projects suggested in the Report should be undertaken. In an attempt to keep the 'community' informed, throughout the project Free Form produced regular newsletters, which were circulated throughout the ward, explaining what was happening and giving updates on the various projects.

At its first meeting, which happened shortly before I began my participant observation, the steering committee made its choice among the sixteen proposed projects. Bacon gave me this account:

> The first [meeting] was interesting. We split them into different groups. They looked at the different projects. We gave them Post-it notes: what's important to you? What really don't you want us to do? And from that the outcome was really, really clear. They were all saying, actually this area ticks a lot of boxes, really high unemployment, low education standards, poor housing stock, a circle of deprivation. Because the boxes were ticked, money comes in every now and then, and they felt very much they were victims of money comes in—quick job—done—move out again. And they were saying they don't want that. What they were saying was: have a few projects out of the sixteen and to do them well, to a really high quality, something to be proud of, which was a key part of what the money was there for; to raise participation and aspirations and to improve the environment, so it was fantastic that they did choose that.

The meeting also decided that the selected projects should be done in two phases. The first phase would consist of two environmental improvement projects involving permanent work and an event. The environmental projects would be the work on the Fiddlewood and Night Plantation woods and the renovation of a small, rundown garden area, Bullard Road Garden. In the event,

the woods project ended up focussing almost exclusively on Fiddlewood. Night Plantation was more of a wild habitat, and BTCV (the renewal of whose contract was included in the plans for the woods) in particular were anxious that it not be disturbed. The event would be the Catton Clear Day Carnival, a carnival convoy of service providers that would travel through the streets collecting rubbish, tidying up gardens and providing a general clear-up service. A final decision about the second wave of projects would then be taken once it was clear how much money was left. The council accepted all the recommendations, and work on the first three projects started in spring 2004, a couple of months before I began my participant observation. Two more projects of the original sixteen proposed, both quite small, were carried out in the second wave: a road signage initiative involving local children designing road signs to help slow traffic near a dangerous crossing close to their school and the landscaping of an awkward corner.

The two projects I followed most closely were the Catton Clear Day Carnival and Fiddlewood. In the next chapter, I use these two projects to examine what the Free Form Project had become by this point with regard to its aesthetic practices and artist expert/nonexpert relationships, and how far it had travelled from its D&TAS incarnation.

–9–

A Carnival and a Standing Stone

> Audits do as much to construct definitions of quality and performance as to monitor them.
>
> —Michael Power, 'The Audit Explosion'

Over the years, the Free Form artists continually had to adapt to shifting economic and political realities. Nonetheless, it is possible to trace an essential continuity as the initial Charge the founders had given themselves—'Make art that speaks to working-class people!'—developed into 'Use art to help people solve problems stemming from their built environment!' The D&TAS can be seen as a high point in the fulfilment of that Charge. As I followed the Norwich projects, I was particularly interested in looking at how the aesthetic practices developed in the D&TAS years had changed in the new, neoliberal Britain.

By the time I began my participant observation, in 2004, the iron cage of the audit culture was closing in ever more tightly. Funders were now imposing conditions that made it increasingly difficult to find money to pay for the kind of intensive, long-term collaboration between artists and local people on which the D&TAS was based. Grants had always required the filling-in of forms, but these had now become not only ever longer and more time consuming but increasingly focussed on precisely specified targets and quantifiable evaluation. It is hard to find appropriate spaces on such forms in which to explain the importance of spending long hours chatting with people, getting to know them and building up relationships of trust. And if the idea is to explore ideas and possibilities in a genuinely open-ended way, initial proposals will almost inevitably be somewhat vague. There is, in fact, an inherent contradiction between predetermined targets and forms of evaluation and ways of working based on the use of processes that, while they structure interactions between experts and nonexperts, do not have predetermined outcomes.

To some extent, the two projects I discuss in this chapter, the Catton Clear Day Carnival and Fiddlewood, represent two major strands of the Free Form Project: the Carnival harkening back to Free Form's early performance days, Fiddlewood its later environmental focus. Together they provide an opportunity to reflect on what the Free Form Project had become by the first decade of the

twenty-first century. Can we still see it as representing a mechanism by which those living in a place like Catton Grove can play a genuine, if small role in the shaping of their built environment? What kind of 'art' did it involve? Could this 'art' be considered in any sense 'politically progressive'—always remembering Benjamin's insistence that what matters is how art works and artists are positioned within the process of creative production. How were the artists in the Norwich project positioned? What role did the people of Catton play? I begin with the Carnival.

THE CATTON CLEAR DAY CARNIVAL

The Catton Clear Day Carnival was an event that drew on various forms of popular culture. A recurrent concern for the Free Form artists, as we have seen, was how to give form to the desires of those with whom they worked while not lapsing into what to them seemed sentimental or banal aesthetic language. This fear of kitsch, however, was largely absent when it came to Free Form's performance work; in part, this was probably because the performance events did not involve permanent art works but also, as I noted in Chapter 3, because the divide between high and low culture in the performing arts in Britain is far less rigid than the divide in the visual arts.

The original idea for a Carnival came from Newman, and it is perhaps not coincidental that his training was in TV and theatre set design. Newman saw the Carnival as providing a solution to one of the problems that together made up the Catton Brief, namely what to do about Catton's middle section. This middle section, to the south of Fiddlewood, which housed a more transient population than most of the rest of the ward, had perhaps the worst reputation of any area of Catton. On the walks with Bacon, Newman had noticed how neglected and uncared for many of the middle section's streets looked, with accumulations of rubbish, overgrown gardens, and pavements cluttered with residents' giant wheelie garbage bins, left on the street instead of being returned to people's gardens. Those living there complained to the team how this part of the estate was always overlooked: when things were done, it was always for Fiddlewood or other parts of the ward, never for them. It was agreed, therefore, that the Catton project must include something for this seemingly overlooked middle. As a way of cleaning things up and combating some of the negative associations, Newman proposed a parade, to be called the Catton Clear Day Carnival. The parade would consist of all the local services, such as dustmen, community police and dog wardens, and it would be organized around the theme of clearing up the streets and promoting environmental awareness. At the same time, as indicated by the term 'carnival', there would be a strong emphasis on 'fun'. Newman had helped organize just

such a Carnival in his own London neighbourhood—like many of the Free Form artists, Newman has a history as a community activist. That Carnival had been very successful, and he thought it would work well in Catton. The rest of the Free Form team and Bacon agreed, and the event was included as one of the sixteen projects proposed to the council. The steering group then selected it, along with Fiddlewood and Bullard Road Garden, as one of the three projects to be carried out in the first implementation phase.

Once the Free Form team began turning the proposal for a Catton Clear Day Carnival into an actual event, it was decided that there should be two carnivals on successive Saturdays in October, each focussed on a different section of the neglected middle area. One of Newman's first tasks as project manager was to secure the support of the managers of the various services they planned to involve. Not surprisingly perhaps, participating in a Carnival was not initially a high priority for any of the managers, and Newman found it quite a challenge even to get them all to a meeting to discuss the idea. Eventually, however, a meeting, which I attended, was held at the council offices and the practicalities hammered out (the enthusiasm of the council's chief executive for the Carnival idea undoubtedly made Newman's task easier).

If the Carnival was to work, it needed above all to be fun. Since the dispute in the 1980s, when the visual artists and the performers parted ways, Free Form has not included performers among its core full-time members; to supply the fun performance element, Free Form therefore commissioned Theatre of Adventure, an East Anglia–based theatre group well known to Newman. Theatre of Adventure specializes in street theatre and site-specific performance and seemed well qualified to deliver this element of the Carnival. They also fulfilled Free Form's general preference to use local artists wherever possible. It was agreed that Theatre of Adventure would run workshops with the different service-provider teams in the weeks leading up to the Carnival, during which the teams would be taught a special Catton Clear Day Carnival song, composed by Theatre of Adventure, and a little dance to accompany it.

It was also decided that, since the actual parade routes were relatively short, those living in the surrounding streets would be offered similar cleanup services in the subsequent weeks; they would just not have the Carnival itself. To facilitate the cleanup, all those living on the Carnival routes were asked to move items for collection to their front gardens. Details of the upcoming Carnivals and how people could get help with moving heavy items were included in one of the regular Catton Pride newsletters. Then, on each of the Fridays prior to the Carnivals, Newman went round the route with five of the bin men, who helped people, especially the elderly, bring out large items, such as fridges and washing machines, while Newman told them about the upcoming Carnival and handed out explanatory leaflets. Over the period of the two Carnivals, 2,000 households were contacted.

160 COMMUNITY ART

I attended the first Carnival. The weather was exceptionally mild for October, and there was a good crowd of a few hundred. In addition to the newsletters and leaflets put out by Free Form and the Cat 'n' Fiddle Partnership, there had been articles in local newspapers describing the upcoming event, and these had attracted people from outside the area. The cavalcade of service vehicles, decorated with Catton Clear Day Carnival banners, slowly made its way along the half-mile parade route: first, the dustmen, picking up the bulky items that had been left out for them (see Fig. 36); following the dustmen, a white-goods team picking up fridges, washing machines and the like; next a recycling team taking furniture and other recyclable goods; then a hazardous waste team picking up old batteries and other dangerous waste; after them the community police, handing out personal alarms, antiburglary leaflets and other information; then dog wardens giving out information about dealing with dog mess and various other services. Bringing up the rear was a garden team, who trimmed hedges, cut lawns and generally provided a tidy-up for people's

Figure 36 Collecting discarded TVs, Catton Clear Day Carnival 2004 (photograph and copyright: Free Form Arts Trust).

front gardens. Accompanying the parade were four members of Theatre of Adventure, dressed in fanciful costumes, who led the service providers in the singing of the song and the dancing of the dance and generally encouraged everyone to enter into the carnival spirit. The service teams wore colourful disposable boiler suits and hard hats, with each team having its own colour. The hats were decorated by Spectrum Crafts (another local arts group and long-term collaborators with Theatre of Adventure) with appropriate motifs: little black rubbish sacks for the bin men, floppy ears for the dog wardens and the like. Additional music was provided by Norwich Samba, an amateur samba band made up of percussion players, who followed behind the service vehicles.

Local children were also given a role. After the parade had passed, an aftercare team of children visited all the homes on the route with clipboards and questionnaires. They too were dressed in boiler suits, in their case red, and wore gold hard hats trimmed with little wings. Helped by some similarly dressed council officials and Free Form artists (including Goodrich and Rossiter), the children asked people what they thought of the Carnival and whether they had been 'cleaned up'. This exercise also provided the Free Form team with useful quantifiable evaluations they could later use to demonstrate 'outcomes'—to use the language of the audit culture. At the suggestion of Rossiter, the aftercare team also borrowed an idea from the old 'Bob a Job' week. In this once-popular British tradition, which Rossiter remembered from his childhood, one week every year Boy Scouts would go round performing helpful tasks for people for which they were paid a shilling (a bob, 5p in today's money); money that went to charity. So that the same people would not be continually bombarded with small boys demanding work, once a house had been visited and a task satisfactorily completed, a sign with a large tick on it was put in the window. For the aftercare team, this took the form of a giant tick on a sign attached to a long pole planted in people's gardens once they confirmed that they had indeed been 'cleaned up'.

Free Form, Theatre of Adventure, Bacon, the service providers, as well as the council officials involved all judged the two Carnivals to have been a great success. The council were particularly happy with the favourable write-ups they were given in the press. As might be expected, the individual service workers themselves varied considerably in their degree of enthusiasm. On the day of the Carnival I attended, some of them clearly enjoyed the whole performance aspect enormously, singing the song with gusto and doing the dance moves they had been taught along with the Theatre of Adventure performers, while others, anxious perhaps to maintain their cool demeanour, were a little more halfhearted, and a few simply glowered at the back.

The responses to the aftercare team's questionnaire were overwhelmingly positive, perhaps not surprising given that it was being administered

by local children. The opportunity to off-load unwanted, difficult-to-dispose-of stuff that seemed to be much appreciated, as was the free garden cleanup. On the day of the first Carnival, fifteen tonnes of rubbish were collected; on the second, eighteen tonnes; during the two-week period of the associated cleanup of the surrounding area almost a hundred tonnes were picked up. The City Care manager (City Care is the private company to which Norwich City Council had contracted out the city's waste disposal) was so pleased that he determined to make the dustcart team a part of Norwich's next Lord Mayor's Procession.

'IT'S PERSONALIZED THE RUBBISH COLLECTION A BIT MORE'

In terms of the Catton Project as a whole, the Carnival was not just about picking up rubbish and giving the area a temporary makeover; it was also aimed at creating a more positive relationship between residents and service providers. Often, those living in social housing come into contact with the council only when there is a problem: they are behind on their rent, are trying to get the council to carry out some repair or have some other complaint about their services. The Carnival offered an opportunity for council officers to meet those whom they serve not only in the context of the council doing something positive—clearing rubbish—but at an event focussed on fun and celebration. Some of the Housing Department workers, for instance, who normally rarely visit any of the estates, were part of the aftercare team. One of these, a senior housing manager, later told Bacon: 'You've converted me to community development.' For him, apparently, meeting people in his red boiler suit and winged hard hat in this friendly, informal context had been a revelation, and he felt had gathered a lot of useful information from those he chatted with along the parade route. He was now eager to build on the work done by the Catton Project and was planning more visits to the estate.

As for the dustmen and the residents, normally dustmen receive little respect, ignored by those whose rubbish they collect except when they cause a problem by failing to take stuff away, drop unsavoury rubbish as they empty the bin or idle their motor in the dawn hours outside a bedroom window. The Carnival gave both dustmen and residents a rare chance to meet each other in a quite different and positive context. One woman, who had been very negative about the whole Catton project, told Bacon after the Carnival that now, when she sees the dustmen, she often stops and chats with them. On one occasion she was with a friend who asked in surprise how she knew the bin man with whom she was apparently so friendly. She explained to her friend that she got to know some of the dustmen through the Carnival: 'It's really

nice because I've now made friends with these guys and it's personalized the rubbish collection a bit more.' For the dustmen (who demanded a photo of the Carnival to put in their canteen), it was an opportunity to show those they serve, who normally hardly even seem to see them, that they are fellow human beings doing a necessary and important job, and to do this not in a defensive or aggressive way but in an atmosphere of celebration and fun. For a moment at least, the Carnival seemed to have conjured up a sense of community that included both Catton's residents and its service providers.

By no stretch of the imagination could the Catton Clear Day Carnival be seen as *critical art,* and indeed it seems very far from anything that would be recognized as 'art' within the gallery world. As a performance event, it could be seen as something of a throwback to Free Form's early days of neighbourhood Fun Festivals, but those, as I described, were more closely linked to ideas circulating in the art world. Since those early days, not only had Free Form moved further away from the gallery world, the art world itself has moved away from the anarchic, rebellious ethos of the 1960s and 1970s reflected in the fun festivals.

The culture on which the Carnival drew was very much popular culture—the long tradition of town parades, for instance. Such local parades have always been an integral part of the Catholic Church. Goodrich, who grew up in a Catholic family on a new housing estate on the outskirts of London, remembers church parades as one of the few memorable public cultural events of his childhood, and they remain for him a powerful image of collective community celebration. The notorious marches through Catholic areas of Northern Ireland by the Protestant Orange Order represent another parade tradition—one that illustrates how such popular expressions of 'community' identity are not necessarily benign or apolitical. Such parades tend to represent, whether explicitly, as with the Orange Marches, or more subtly and implicitly, a claim of ownership of an area on the part of a particular 'community'. One of the threads of meaning bound up with the notion of 'community' is indeed a sense of belonging, entangled with notions of ownership.

Another important, although more recent, parade tradition in Britain, on which the Catton Carnival drew and which also figured in the Provost mural, is that of Caribbean Carnival. Brought to Britain by the early Caribbean immigrants, Carnival, with its huge floats, elaborate costumes and multiple bands playing a wide of range of musical styles, can similarly be seen as an assertion of a particular identity and a right to the streets.[1] The annual

1. Both Ives and Goldman, independent of their work with Free Form, have long associations with various Caribbean Carnival Clubs.

Notting Hill Carnival in London, which began in the mid-1960s, has been hugely influential in spreading the Caribbean Carnival culture far beyond its immigrant roots. Take Norwich Samba, for instance. Norwich's population is more than 90 per cent white, and almost all the members of Norwich Samba seemed to be white, evidence of how this kind of Carnival culture has embedded itself in mainstream white British culture. The musical idiom of Theatre of Adventure's Catton Clear Day Carnival song and the accompanying dance, by contrast, was one familiar from older mainstream popular music, drawing on the songs of Cole Porter, George Gershwin and the like. While this is a tradition with roots in American popular music, it has now become an international musical language, which those in many countries, including Britain, think of as their own. The Boy Scouts, and their very British tradition of Bob a Job week, can be seen as another element of popular culture which is both international and local. The familiarity of the Catton Carnival's cultural references made it something to which local people could immediately respond. It was an event rooted in what Gramsci called 'the humus of popular culture', the aesthetic language of which is little spoken in the elite visual art world except ironically. As far as I could tell, the Catton Carnival was irony free.

It is also true that the Catton Carnival, while it provided a cultural event accessible to local people, was not created by those people. The form of the event was suggested by the Free Form team, and even if the service teams (or some members of them) enthusiastically joined in the performance of the song and the dance, these, like the costumes and the decorated vehicles, were devised by Theatre of Adventure and Spectrum Crafts. Theatre of Adventure may have run workshops with the service providers, but the purpose of these was simply to teach the bin men and the others a dance and song written by Theatre of Adventure. These workshops were quite different from the Chats Palace workshops, in which whole shows were devised (see Chapter 3). But, while the local participants in the Catton Carnival may not have played a central role in its devising, a point made by Gramsci in one of his Notes on folklore is also relevant here. Gramsci takes issue with one Ermolao Rubieri, who proposed a three-fold classification of popular songs into '(1) songs composed by the people and for the people; (2) songs composed for the people but not by the people; (3) songs written neither by the people nor for the people but that the people have nevertheless adopted because they conform to their way of thinking and feeling.' Such a classification, Gramsci argues, is misguided: 'all popular songs could and should be reduced to the third category, since what distinguishes popular song, within the framework of a nation and its culture, is not its artistic element or its historical origin, but its way of conceiving the world and life' (Gramsci 1996: 399–400).

THE FIDDLEWOOD PROJECT

The Fiddlewood project had more obvious links with the aesthetic language and practice of the art world than did the Catton Carnival. On their walks around the Fiddlewood section of Catton Grove, the Free Form team were told by many residents, particularly the elderly and young children, that they found the wood itself (Fiddlewood), with its overgrown entrances and paths and piles of fly-tipped rubbish, intimidating. To make it more inviting, the team proposed clearing the fly-tipped material, improving the existing paths and opening up the entrances from the street. The more superficial clearing up would be done by local volunteers working with BTCV, with local contractors brought in for the heavier work. The idea was not to change the basic character of this little patch of wildness but to emphasize it and increase accessibility. BTCV, as a conservation rather than an arts organization, was particularly concerned that any work done not disturb the wood's natural habitats. The Free Form artists accepted this but wanted also to strengthen local people's sense of the woods, Night Plantation and Fiddlewood, both as special places and as *their* places. One way they proposed to do this was by commissioning artworks for Fiddlewood. The idea was that the artist selected, working with local people, would produce specially designed elements such as benches or entrance markers. Over the course of my fieldwork, I was able to observe the creation of this artwork, from the initial selection of an artist to the work's completion, almost nine months later. I was particularly interested in the role played by local people in the creation of this 'community' artwork.

SELECTING AN ARTIST

After its turn towards more permanent environmental work in the 1980s, Free Form began to bring in more artists from outside the organization to work on specific projects on a contract basis. Some of these artists, such as Simon Read, Maggi Hambling, Maggy Howarth, Laurence Broderick and Peter Fink, were already well established in the art world; a number, such as Maureen Black and Angus Watt, would go on to become so. To find an artist for a given project, the organization would write a brief, to which artists were invited to respond. A short list of finalists would then be drawn up, and those artists would be invited to come and present their ideas, at which point a final selection would be made. Given the small budgets with which the artists had to work and the demand that the artist work with local people, such opportunities rarely attracted big-name artists. Standing within the art world, however, was never an important criterion for Free Form: quality was important to them—and the criteria they used to judge quality were the kind of art world

criteria we might expect a trained artist to use—but they paid little attention to the judgements of the art market. In this, they differed from many organizations that commission art.

For the curatoriat institutionally locked into the art world, it is hard to ignore that world's evaluations and hierarchies. One of those I interviewed was Piers Masterson, who trained as a public art curator at the Royal College of Art and later worked as a public art officer in the North-East of England. Masterson, who was volunteering at Free Form when I interviewed him, stressed that for those, such as the Arts Council, who are given the responsibility of spending public money on art, accountability is an inescapable reality. Casting its shadow over any decision is the fear of an outraged response from those less tuned into current art world criteria: how can you justify spending tax payers' money on *that*? And in the visual arts, once you leave the calm harbour where established and safely dead artists are moored, you can easily find yourself sailing in dangerous waters. One form of protection is to use, as Masterson put it, 'artists off the approved list'. Should a curator's choice run into trouble, the authoritative judgements of the art world provide some defence, or at least comfort, against the complaints of the uninitiated.

Free Form, by contrast, confronted different demands with regard to accountability. A central demand of those who employed the organization was evidence of participation by the 'community'. Aesthetic competence was required, but an artist was also expected to commit to working with the 'community' and to have the skills necessary to make this a reality. But who exactly constituted this 'community'? In practice, this was something that had to be discovered and negotiated in the context of each project. As with the Goldsmiths and Provost projects, the 'community' was to some extent a web of relations that emerged in the course of the work, not some preexisting entity. What was crucial, however, was that any artist employed be willing and able to work with local people. Artists could go about this in various ways, but they were expected to take community engagement seriously and to have strategies to achieve it. They were required, as it were, to give local people some role in shaping the Brief.

The formal brief that Free Form wrote for the Fiddlewood artist defined the opportunities for artworks as follows:

> Fiddlewood lacks identifiable landmark entrances and seating areas within the woodland. A detailed survey . . . has identified a number of possible opportunities for artworks:
> Entrance features and seating . . .
> Sculptural art forms
> Creating a gathering/focal point for the woods

It continued:

> The proposal is for an Artist to create high quality, imaginative, permanent art work(s) for Fiddlewood. They will be required to work with the local community to explore the possible opportunities, ideas and location of artwork(s). It is important that the Artist develops opportunities for the creative participation of the community in the development and implementation of these features. This will ensure the artwork(s) longevity and increase the sense of community ownership of the work. (Free Form 2004b)

The materials used could include 'wood, stone, metal work or other suitable natural products that are robust'. The main artwork(s) would be expected to have a minimum five-year lifespan. The total budget, to include 'the Artist's fee, meetings, community participation, materials, fabrication and installation', was £20,000. Those interested were asked to submit a written proposal, a CV and six examples of previous work. Although the brief did not specifically mention this, Free Form hoped to appoint an artist from the Norwich area, in part because they lacked the funding to pay for an artist in residence and in part because it would be difficult for anyone from too far away to work with local people in any substantive way.

More than twenty submissions were received. Rossiter and Newman drew up a short list of three East Anglia–based artists who were invited to present themselves and their ideas at an interview at the community centre on Fiddlewood Estate. The discussions about who should be short listed that I observed focussed, first, on standard fine-art aesthetic criteria: was this artist's previous work of sufficiently high quality? A second criterion was whether this artist was suitable for this kind of public art commission. Precisely because they were artists themselves, part of the expertise the Free Form artists saw themselves as having as commissioning agents for public art works was an ability to read other artists' partially articulated ideas, visualize what they would translate into, and assess whether the ideas were feasible. Their years of working on so many diverse Briefs and having to operate on very tight fixed budgets had given them a keen nose for feasibility. The question of exactly how the artist selected would involve 'the community' was by and large left to the interview. At this point, the idea was that it would probably be Free Form that would set up workshops for local residents, although the artist chosen would have to demonstrate a genuine commitment to local participation. Given their considerable experience of work in this field, the artists commissioned might well have been ones known to the organization from other projects, but, as it turned out, neither Rossiter nor Newman had any prior knowledge of the three short-listed artists.

The final selection committee was made up of Rossiter, Newman, Bacon, the BTCV organizer and two local residents who were members of the Friends of Fiddlewood, the organization set up by BTCV. The interview with the short-listed artists at the Fiddlewood Community Centre was the first opportunity for members of the local community to have direct input into the selection of the artist. Since they would be choosing from a carefully preselected group of artists, the Free Form team were happy to let the local members of the committee have the final say. Everyone was agreed that they wanted an artist seriously committed to involving local people in both the conception and the realization of the artwork; they did not want someone who had already decided what artwork he or she was going to produce. At the actual interview, which I attended, the outcome was never in doubt. One of the three finalists decided that he was really not interested in the level of community involvement demanded and withdrew. Of the other short-listed candidates, one was a team of two women, Carole Reich and Charlotte Howarth, the stone mason we have already met in Chapter 5 (see Figs. 37 and 38). Both

Figure 37 Carole Reich, 2009 (photograph and copyright: Kate Goodrich).

the presentation boards showing their previous work and their verbal presentation explaining how they planned to involve the local residents were impressive. They rapidly convinced all the members of the selection committee that they would genuinely involve local people in the creative process and be responsive to them and also that they would also produce artwork of high aesthetic quality. The decision to appoint them was immediate and unanimous.

Interestingly, neither Reich nor Howarth comes from a fine-art background. Reich graduated in 1980 from Manchester Polytechnic (now part of Manchester Metropolitan University) with a degree in arts education and then went on to work with various art and education projects, all with a strong 'community' dimension. She stressed to me several times how she sees herself not as an artist but as a *community* artist: 'I would never say I am an artist . . . I do see myself as a community artist, because I actually believe everybody has the ability to produce.' Her experience includes a number of years working in San Francisco, mainly as an artist in residence at various schools working with

Figure 38 Charlotte Howarth, 2009 (photograph and copyright: Kate Goodrich).

children on art projects. On her return to Britain, in 2001, she and her family moved to East Anglia, and she continued her work with schools. She had not been back in Britain very long when the head teacher of her son's school, knowing of her skills, asked her to meet with Howarth, whom the school had recently employed to work with the children on an arts project. Howarth at this point, while a very experienced carver, had little experience of this kind of collaborative working and was rather nervous at the prospect. As it turned out, Reich and Howarth's different skills and personalities meshed together very productively, and, having discovered how comfortable they felt working together and how well they seemed to complement each other, they began to think about working together on a more permanent basis. This had become a reality shortly before they applied for the Fiddlewood commission. After trying out various names for themselves, they settled on Making Marks.

Reich's great strength is her ability to work with any kind of group:

> Give me a group a people and I'm really happy . . . what do we want from them? We want designs, we want text. Fine. As long as I know what we want and what ideas, broad, strategic ideas we've got, then I'm comfortable and confident about actually getting those and getting enough breadth of image or text that we can use for a final piece, whatever that might be.

While Reich may be committed to the idea that 'everybody has the ability to produce', implicit here is the assumption that people need help in realizing their ideas. Essentially, she is situating herself within the creative process as someone whose expertise can turn raw ideas into high-quality art works.

Howarth's particular strength is the high quality of her design work and her carving. The deep-cut Assyrian reliefs in the British Museum were a strong influence on her style. Her formation as an artist, however, was in a craft, rather than a fine-art, tradition—an artistic socialization reflected in her definition of herself as a *maker,* rather than as an artist. Her specific craft world is that of lettering, a particularly interesting form of visual art in the context of this study. Lettering can certainly be defined as art in the sense of 'the skilful production of the beautiful in visible forms' (according to the *Oxford English Dictionary* 'the most usual modern sense of *art*') and can, as in some Islamic calligraphy, reach extraordinary levels of artistic achievement. But, while it may be possible to appreciate particular letter forms or examples of calligraphy on purely aesthetic grounds without regard to their actual written meaning, the central purpose of lettering remains nonetheless the conveying of a predefined meaning: letter forms are expected to be legible to those literate in that language. Lettering is not simply about the lettering artist's personal expression, and, because it has this functional dimension, the Romantic understanding of Art with a capital A consigned it to the generally less-valued domain of craft.

Howarth has spent many years learning and perfecting her skills. Having discovered and fallen in love with calligraphy at school, she went on to do a three-year City and Guilds course in lettering at the London School of Art. After college, she did a two-year apprenticeship with the letter carver Richard Kindersley, after which she spent six years in Ireland working with another letter carver, Ken Thompson, before returning to her home base of East Anglia and setting up her own stone-carving business in 2000. A number of the leading British letter carvers, such as Eric Gill, have also been sculptors and painters who produced gallery art; nonetheless, there is a world of stone carvers, to which Howarth belongs, who represent an older tradition of commissioned work where the individual carver is not primarily concerned with self-expression. As I discussed in Chapter 5, much of Howarth's work, such as the memorial headstones that constitute a significant part of her livelihood, represents a mediated expressiveness. Howarth is certainly seeking to express something in her memorial work, but that something is not the Romantic self-expression of the individual artist; her concern is to give visual form to what her clients 'want', something that often involves helping them articulate their wishes in a visual form. Once she started working with Reich, she realized that her relationship with her clients was in many ways similar to the one called for by the new work with children in schools or other 'communities'; she might now be working more with groups than individuals, but there was the same need to draw visual ideas out of people who may well not realize that they have this kind of visual awareness. Like Reich, she situates her expertise as providing a bridge between raw ideas and professional realization.

THE STANDING STONE

At their presentation to the selection committee, Reich and Howarth had put forward some preliminary ideas for a series of small artworks in the two woods. What they heard repeatedly when they walked around the area and talked with local residents, however, was a plea for something 'substantial'. And what they took that to mean in this context was, first, that it should be vandal proof—many, including a number of the members of the Cat 'n' Fiddle Partnership, were sceptical that any public artwork could survive in their area. But Reich and Howarth also heard 'substantial' as a desire for something that would be a genuine marker or focal point for the area—a desire linked, perhaps, to the commonsense notion that an art object is something that makes a statement and proclaims itself 'Art'. 'Substantial' also echoes the sentiment of the first steering committee meeting, which opted for selecting a few proposals from the sixteen put forward by Free Form and doing them, in Bacon's words, 'well, to a really high quality, something to be proud of' (quoted

in Chapter 8). Hearing this clear preference, Reich and Howarth decided to rethink their original ideas, proposing instead a single large standing stone to be sited in the middle of the wood at the point where the various paths intersect. The stone (approximately 2 metres high) would be carved with images and texts to be devised in a series of workshops with local residents. Free Form organized a meeting, which I attended, to present this idea and the plans for the workshops to the Catton steering committee and the Friends of Fiddlewood. The artists' presentation was again impressive. Reich and Howarth brought a carved sample of the stone they proposed using, Kilkenny limestone, a very hard limestone that polishes to an almost black surface and that weathers well and is resistant to graffiti. They also provided a small model to demonstrate what the stone would look like and Photoshop images of where it would be sited and how it would look, together with some illustrations of carvings on this kind of stone and of the rubbings that can be made of them. Rubbings of low-relief carving provide a very direct and tactile way of interacting with a sculpture. Reich and Howarth explained that they planned to hold six workshops, at which the images and text for the stone would be generated. The response at the meeting was generally enthusiastic. Reich and Howarth's professionalism, their down-to-earth manner and their obvious readiness to work with local people seemed to reassure even the doubters; seeing the model, the carved stone and the Photoshop images of the stone in situ made it easy to get a sense of just what was being proposed.

Their proposal having been accepted, Reich and Howarth set about recruiting people for their workshops. This was not easy. The Fiddlewood Estate is not a tight-knit 'community'. The Cat 'n' Fiddle Community Plan, which the Partnership had commissioned from a commercial firm in 2002, 'highlighted the difficulty in engaging local people and its findings were based on consultation with a very small number of people' (Norwich City Council 2002: 3). More important, perhaps, unlike at Goldsmiths or Provost, where the D&TAS team built up relationships of trust over a period of time, Reich and Howarth were having to organize their workshops within a tight time frame. Nonetheless, Reich and Howarth distributed flyers throughout Fiddlewood inviting people to 'Come and Create: be a party to creating beautiful lasting pieces of art for the ancient woodlands', and, with Bacon's help, they managed to round up what everyone considered a respectable number of workshop participants. The workshops were held over a period of about three weeks, and, except for one at an old peoples' home, took place at the local community centre. In the event, there were five workshops rather than six, of which I attended four. Each of those I attended had ten to twelve participants and lasted between two and three hours. The participants were a mix of children and adults, with a solid core of about seven, mainly adults, who attended all the Community Centre workshops. These workshops, carried out in the context of a culture

of stringent accounting of time, were far more limited in scope than the extended collaborative process of the Goldsmiths and Provost projects. Unlike the D&TAS, subsidized by a revenue grant, Reich and Howarth had to find the money to pay for their time out of an already quite modest budget for the Fiddlewood artworks.

As planned, the workshops were used to generate images and text for the stone. At the first one, Reich began by asking people what Fiddlewood meant to them and what had they seen there. Everyone shared personal experiences of the wood, and the long lists of words it conjured up was written on sheets of paper and pinned up. Reich and Howarth then handed out sheets of newsprint and told people to fold them into four squares; people were then asked to draw on each of the squares anything at all they associated with the wood. They could use as many sheets as they liked, and they were encouraged not to be precious but draw as freely and quickly as possible. After about a half-hour of this, Howarth went round looking at all the drawings; as might be expected, most of the images produced were plant forms, woodland wildlife and the like. From each person's drawings she selected one that the person should work further on to turn it into a design that could be printed. Reich and Howarth had hoped to get on to printing at this first workshop, but time ran out. They told me how what they actually do in any given workshop always depends to a large extent on who turns up: they have a general plan but then adapt it according to what seems appropriate. All the work produced was carefully collected and saved for the next workshop; it would also be part of the raw material Howarth would use to create the final images and text for the stone.

At the next workshop, the drawings were brought out again, and attendees from the first workshop began the process of printing their designs (Fig. 39 shows an example of a print), while the newcomers were started off on creating designs. The printing process was very simple: using a sharp pencil, each person drew his or her worked-up design onto a 25 cm^2 polystyrene tile. This was then inked with water-soluble ink and press-printed onto cotton. Everyone was given a long strip of white cotton, approximately 1.2 m by 50 cm, and shown how to create a repeating pattern using the tile. Six or seven colours of ink were provided, and people could choose which colour to use and decide whether to use more than one colour, although Reich and Howarth recommended keeping it simple. Once finished, the banners were taken away by Reich to be hemmed and threaded onto bamboo poles so that they could be easily hung for display. Helped by Howarth to produce a strong, simple design, the workshop participants produced designs whose repetitions of motifs created attractive and quite professional-looking banners. These would be permanently available to decorate the community centre whenever needed. Their first use was at the unveiling ceremony for the standing stone, when they

174 COMMUNITY ART

Figure 39 Fiddlewood Standing Stone poem, final design for Standing Stone, and one of the workshop prints included in the design (photograph and copyright: Making Marks).

were hung from the trees to make something like a ceremonial approach to the stone itself.

At the second workshop, Reich and Howarth also began working with people on the text for the stone. Again, people were asked to come up with words they associated with Fiddlewood and, this time, to write them in a circle to create a poem. Although Reich and Howarth did not use the term, I immediately thought of the concrete poetry movement.[2] After the workshop, I asked them about this, and it turned out that Howarth was very familiar with concrete

2. The concrete poetry movement was an international poetry movement, at its height in the 1950s and 1960s, in which the words and other symbols making up a poem are printed in such a way that the visual pattern on the page corresponds in some way to the sense of the poem or comments upon it.

poetry and that it had been a significant influence on the use of text in their work. This is a good example of how 'art' that might seem at first sight essentially populist and quite removed from high art may in fact be linked in interesting ways with distinctly nonpopulist, apparently elite art. In subsequent workshops, Howarth brought in special calligraphic pens and showed people how to write their word streams about the woods onto long ribbons. The ribbons, like the banners, would be hung in the trees on the day of the stone's unveiling.

For Reich and Howarth, as for Free Form generally, it was important that workshops both give participants a sense of involvement in the creation of the permanent artwork and allow them to produce some kind of finished 'artworks', albeit temporary rather than permanent. The central purpose of the workshops, however, was the generation of images and texts that Howarth could work up and use on the stone (see Fig. 39). Both Reich and Howarth stressed to me that they thought it important that the imagery come from local people and not from them. The workshops provided them with a large stock of visual ideas and words with which Howarth could then work. Beginning with her initial selections from people's rough sketches, she was on the lookout for designs that she could see working well as carved images. This indeed was one of the reasons that she and Reich structured the workshops around printing. Getting people to create designs for printing, they have found, is a good way of getting them to simplify their ideas into more abstract forms that lend themselves to carving. In choosing images, Howarth was also looking for images that evoked the woodlands but that were not, according to her and Reich's aesthetic criteria, too obvious or trite. Similarly, in selecting text from the workshop participants' word streams, they wanted to capture local people's own feelings about this little green space in their lives in language that did not, to their ears, lapse into the clichéd or the sugary sentimental. Another important consideration for Howarth was how the words and letters would look as carved designs.

The final poem is shown in Fig. 39. After experimenting with various formats for the text, Howarth and Reich decided to opt for a continuous spiral encircling the stone and interrupted by seven variously sized rectangles in which the selected images would be carved (see Fig. 39). In the finished sculpture, text and images blend into a single, unbroken entity. This overall unity was enhanced by the finish Howarth selected for the stone: the poem and the rectangles containing the images are the only polished areas where the Kilkenny limestone's natural dark colour is revealed. The rest of the stone was given a textured finish, which brings out what Howarth, with her love for stone, sees as the material's inherent soft, organic quality. The carved text, which can be read in its entirety only by walking round the stone, almost buries itself in this rough texture (see Fig. 40).

Figure 40 Unveiling of the Fiddlewood Standing Stone, 2005 (photograph and copyright: Making Marks).

Initially it had been hoped that the Fiddlewood artist would work on the artwork in Fiddlewood, but, once the standing stone had been decided on, this was no longer practical. Howarth needed all the resources of her studio to carve the extremely large and heavy stone. The organizing of the workshops, the working up of the imagery they generated, the long wait for the piece of stone to be delivered from the Irish stone quarry and its carving by Howarth and her apprentice[3] stretched over several months. During this time, as a way of building interest and to help create a sense of local investment in the restoration of the wood—of which the Fiddlewood stone was a central element—Free Form organized a Halloween celebration in, and of, the wood, with Theatre of Adventure providing the performance element. Lantern- and costume-making workshops for local children were held prior to the celebration. On the night itself, once it got dark, the children, in their costumes and accompanied by their families and other local residents led by Theatre of Adventure, processed through the wood carrying their lanterns. Fortunately, it

3. Just as Howarth was about to begin work on the stone, she had employed a young novice stone carver through an apprenticeship scheme funded by the Arts Council.

was a mild October night. At various points along the route, there were performances by Theatre of Adventure, with an overall narrative involving ghosts and an environmental theme. The event, which was attended by several hundred people, ended with a hog roast laid on by a local butcher.

Finally in spring 2005, the standing stone was completed, transported to the middle of Fiddlewood and installed. On 28 May, there was a ceremonial unveiling by the Mayor of Norwich (see Fig. 40). Leading up to this event, there were again workshops for the local children in which they made costumes, masks and fiddlesticks and learnt the Fiddlewood song (the words of the poem engraved on the stone set to music by the Theatre of Adventure and sung as a round). On the day itself, Theatre of Adventure provided entertainment. The wood was decorated with the banners and the ribbon poems from Reich and Howarth's workshops, and there was a parade to the stone featuring the children in their masks and costumes, led by two Theatre of Adventure performers dressed as wood nymphs. Before the parade set off and when it arrived, the 'wood nymphs' led people in the singing of the Fiddlewood song. Once again, food was provided.

In part, as with the celebrations at Goldsmiths Estate, the Free Form artists saw the Halloween and unveiling celebrations as a means by which large numbers of people—far larger, for instance, than those who attended Reich and Howarth's workshops—could become actively involved in the restoration of the wood. But, even more than this, in the eyes of the artists, such celebrations were a way of conjuring into being, even if only for a moment, that desired entity 'the community'. Celebrations provide an opportunity to lay down memories, and shared memories are often at the heart of a sense of community. The Free Form team explicitly talked about events as ways of creating memories. In the planning for the various Catton celebrations and events, Goodrich, for instance, continually came back to the importance of structuring in time at the end of an event, often over food and a drink, during which people could relive what had happened, remember the near disasters, the funny bits and so on, a time, in other words, for people to begin to fix their memories and their collective experience.

'IT'S MUCH BETTER THAN THAT *ANGEL OF THE NORTH*'

For the Free Form team, the Catton project was not simply about improving the physical environment, important as that was; it was centrally about the relationship of the people of Catton Ward to where they live and the implications of this relationship for their relations with one another. The Fiddlewood project, for instance, was intended to strengthen the relationship between local people and their woods and to create more positive associations for these

little pieces of wildness. The standing stone was envisioned not as a piece of Art demanding the viewer's intense and focussed attention but rather as a tangible and comfortable embodiment of a particular place, something—to use the words of Benjamin quoted in Chapter 5—'consummated by a collectivity in a state of distraction'. The stress that Reich and Howarth put on the tactile qualities of the stone is interesting in this context: as Benjamin notes, 'Tactile appropriation is accomplished not so much by attention as by habit' (1973: 241–2). One man I talked with at the stone's unveiling gave me a nice indication of the stone's tactile appeal. He told me how his children now insist on passing the stone on their way to school and how the younger one always gives it a hug. Two women I spoke to also told me how much they liked the stone, one remarking, with evident local pride, 'It's much better than that *Angel of the North*'.[4]

Reich and Howarth's approach to the creation of art work for Fiddlewood could hardly be further from Keynes's characterization of the artist (quoted in Chapter 1) as 'individual and free, undisciplined, unregimented, uncontrolled' and as someone who 'cannot be told his direction'. Reich and Howarth were extremely disciplined—not least by their need to work to a strict and not particularly lavish budget—and they explicitly committed themselves to being, to some degree, 'told their direction'. But in what sense and to what degree were they being told their direction, and who was doing the telling?

Reich and Howarth's formal brief required that the artist appointed 'work with the local community to explore the possible opportunities, ideas and location of artwork(s)'. Once the work(s) were decided on, the artist was expected to develop 'opportunities for the creative participation of the community in the development and implementation of these features' (see earlier discussion in this chapter). The specific Brief into which Reich and Howarth translated this general brief can be seen as reflecting a serious commitment to the idea that the artworks they create are not primarily about their individual expression or even about their individual response to a particular context. They put it like this on their Making Marks Web site: 'Making Marks responds to and, as appropriate, integrates the interests, ideas and desires of the local community and our clients into long lasting, beautifully designed and skilfully produced pieces of art'.[5] We should note here, however, the *as appropriate* and the insistence on *beautifully* designed and *skilfully* produced. Like the Free Form founders, Reich and Howarth position themselves as experts with a range of skills that can help those without such skills translate their 'interests, ideas

4. *The Angel of the North,* one of the most popular British public art works of recent times, is Antony Gormley's huge public sculpture in Gateshead.

5. From http://www.making-marks.com/, accessed 19 August 2008.

and desires' into art works. We can see Reich and Howarth as implicitly laying claim to an expertise that gives them not only the ability to produce such art but also the authority to decide what *is* appropriate, beautiful and skilful. And the particular 'discourse of reasons', to use Danto's phrase (see Chapter 1), informing these judgements is that of the art world. Reich and Howarth may not be 'artists' in the Keynesian mould, but their visual expertise is very much rooted in that world.

To help them discover what local people 'wanted', Reich and Howarth spent time walking around Fiddlewood talking to as many people as they could. It was in response to the request that they kept hearing for something 'substantial' that they abandoned their original idea for a series of small artworks. At the same time, neither the basic idea of a standing stone nor the idea that this stone should have carved images and text came from local people. We can see the finished stone as Reich and Howarth's solution to the problem defined by the Fiddlewood brief as they had interpreted this to constitute their own Brief. A standing stone provided a solution to the problem of creating something substantial that involved local people in the actual design if not its execution. As with the Provost mural, where the separate panels provided a basic frame within which local people's own narratives could be incorporated, in the eyes of the Fiddlewood artists the standing stone functioned as a frame within which local people's individual contributions, as both images and text, could be pulled together to make a coherent whole. To Reich and Howarth, this was a solution that genuinely included local people in the stone's design, while ensuring that the finished stone would meet their own aesthetic criteria and be the 'high quality, imaginative, permanent art work' demanded by the original brief. Nonetheless, while local people were involved in generating the imagery and text for the standing stone, they were not, as were the Provost residents, actively involved in the making of the art work. The carving of the stone demanded the expertise of a trained stone cutter. Even had it been possible for Howarth to work on the stone in situ rather than in her studio, it is difficult to imagine how local people could have played any very active role. Watching the stone gradually take shape might well have helped local people build up a relationship with it, but they would still have been spectators at its making, not participants in that making. Unlike the Provost mural, the form of the standing stone did not lend itself to participation in its physical making.

Overall, local participation in the various elements of the Norwich project, while real, was more limited than in the earlier D&TAS projects, such as Goldsmiths and Provost. One important reason for this is that Reich and Howarth and the Free Form team as a whole simply did not have the same latitude to spend the many hours working with local groups on planning, design and implementation that had been possible during the D&TAS years. Nonetheless,

I would argue, even the creation of the Fiddlewood Standing Stone, with its more limited opportunities for creative collaboration, is based on a set of aesthetic practices and a relationship between artist experts and nonexperts that situates the artists' expertise in a significantly different place from that of the traditional, gallery-based fine artist. And, even if the nonexperts' contribution is relatively minor, any approach to creative production that involves 'all sorts of people', as the Rector of the RCA complained in the context of the D&TAS art works (see Chapter 1), can be seen as challenging the conventional understanding of where the artist—or, more precisely, artistic expertise—is located within the creative process. Following Benjamin here, I think we can conclude that, while the Fiddlewood Standing Stone and the D&TAS projects may not constitute a critique of capitalism, they do provide a glimpse of a creative process, which is in some respects at least 'progressive'.

THE END OF THE JOURNEY

Five years after I completed my fieldwork, the Free Form story finally came to an end. Free Form had for a number of years operated with an overdraft facility it had negotiated with Barclays Bank. With the onset of the Great Recession in 2008, banks began to come under increasing pressure, and in 2010 Barclays insisted on the full repayment of the overdraft within a very strict time frame. This proved impossible, and the Bank withdrew its facility, giving Free Form's trustees little option but to accept administration on 30 September 2010. The recession certainly played an important part in Free Form's demise, but perhaps equally important was the retirement of the two people, Goodrich and Wheeler-Early, who for so long had provided its creative leadership. Wheeler-Early retired in 2008, although, after her retirement, she became a Free Form Trustee and continued to work on the organization's behalf. Goodrich retired from Free Form in 2009 and concentrated on preparing the recycled-glass operation GBU for sale to a commercial enterprise with the kind of funds necessary to develop it as a commercially viable product. Free Form's demise and its precise cause is less significant, however, than what we can learn from the Free Form Project's attempt over many years to 'make art' in a more 'democratic' and inclusive way. The final chapter provides some reflections, in the light of the Free Form story, on the questions with which I began this study.

Conclusion: Of Art and Community

> [P]olitics has its aesthetics, and aesthetics has its politics. But there is no formula for an appropriate correlation. It is the state of politics that decides that Dix's paintings in the 1920's, 'populist' films by Renoir, Duvivier, or Carné in the 1930s, or films by Cimino or Scorsese in the 1980s appear to harbour a political critique or appear, on the contrary, to be suited to an apolitical outlook on the irreducible chaos of human affairs or the picturesque poetry of social differences.
>
> —Jacques Rancière 2004: 62

I began this study with two sets of questions. One set had to do with the exclusion of ordinary 'nonexpert' inhabitants of cities like London, especially those living in poorer neighbourhoods, from the design of their built environment: How might it be possible to include 'nonexperts' in that design process? What would genuinely collaborative relationships between 'experts' and 'nonexperts' look like? Are there specific techniques that could achieve this kind of participation? A second set of questions was concerned with issues of 'art': how might expertise in the visual arts be of use to those living in neighbourhoods beset by unemployment, poverty, and all the associated social problems? What happens to visual artists, such as the Free Form founders, who reject the gallery world and attempt to make art with those living in working-class neighbourhoods? How does this affect their aesthetic practice? What can the history of the Free Form artists' relationships with working-class people and the art world tell us about the category 'art' (with or without a capital A), and the hegemonies of the art world? These two sets of questions run through the project of 'community art'. In this conclusion, I reflect on both 'community art' and 'community' in the context of the Free Form story.

ARTISTS IN THE 'COMMUNITY'

As I discussed in Chapter 4, just what community art (or arts)[1] is has been much disputed by its practitioners. For some, such as the radical activist and

1. As explained in Chapter 4, I use 'community art' to refer to work grounded in the visual arts, 'community arts' when I am talking about the movement as a whole.

community artist Owen Kelly, whom we met in Chapter 4, community arts should be about the use of art 'to effect social change and affect social policies' (Kelly 1983: 2). The Free Form Project, however, always represented a more pragmatic, essentially reformist version of community art. The D&TAS, for instance, was set up to give those living in impoverished neighbourhoods access to the expertise of skilled professionals; its projects brought experts and locals together to improve bleak and neglected built environments, not to overthrow capitalism. But does this mean that the Free Form Project was by definition not 'progressive'? The answer here depends on how we want to define 'progressive'. One of the reasons I devoted so much space to the D&TAS in telling the Free Form story is that I see it as a serious attempt to find a place for artists committed to using their expertise in progressive ways that is not simply, as Benjamin so dismissively put it, 'beside the proletariat' (quoted in Chapter 7).

By the time they established the D&TAS, the Free Form artists had moved a long way from seeing art as, in Christo's words, 'a scream of freedom', and the artist as someone who 'can do anything he wants to' (quoted in Gablik 1995: 78; see Chapter 1). They had developed, as Benjamin stresses progressive artists must, specific techniques, in particular the workshop, that shifted the traditional location of the artist as *the* creator within the process of creative production. It is when Goodrich and Ives start running workshops with local children in their Jutland Road studio that the Free Form Project, which up to that point had been essentially an aspiration, begins to assume a reality as aesthetic practice.

Free Form was by no means alone in making workshops a central part of their practice; workshops were characteristic of many community arts groups, and they could take many forms. A workshop format in itself, does not define either the nature of the nonexperts' contribution or the power relationship between expert and nonexpert; within the community arts movement, both of these varied widely. Nonetheless, workshops can be seen as having at least the potential to provide spaces in which experts and nonexperts can work collaboratively on identifying problems and coming up with solutions, and nonexperts can learn specific skills. The mosaic technique used in many D&TAS projects, for instance, allowed nonartists who had received some minimal instruction to participate in the physical creation of professional-looking, finished artworks. In general, the Free Form workshops were intended to bring experts and nonexperts together in ways that allowed the artists to share their expertise and the nonexperts to explore their creativity. Working together in the context of the D&TAS, the artists and local groups sought solutions to the problems posed by specific Briefs, such as how to make a desolate council estate a little more liveable or how to devise imagery that told local people's stories in an aesthetic language that spoke to both artists and locals in ways acceptable to both.

A significant aspect of the D&TAS projects was their funding structure: it was not the D&TAS or Free Form that applied for or were awarded grants to carry out the projects but a tenants association or some other 'community group', who then employed Free Form. In the eyes of the artists, they were being employed much as a wealthy client might employ an architect or other skilled professional. This model, however, is dependent on some form of subsidy, such as the revenue grant the D&TAS received from Hackney Council. It was this subsidy that enabled Free Form to provide its initial free advice service, which included help in devising feasible plans and writing up these plans as fundable applications with full technical specifications.

Once the D&TAS's revenue grant ended, in the early 1990s, it became increasingly difficult for Free Form to maintain the labour-intensive D&TAS way of working, particularly as the Thatcherite revolution and the audit culture worked their way ever deeper into the world of funding. The reality is that, perhaps counterintuitively, the greater the role given to nonexperts in formulating problems, coming up with solutions, and devising and making artwork, the more time the artists/experts need to contribute. The process of identifying appropriate problems to tackle and working through possible solutions in a serious, substantive way requires time, as does teaching nonexperts the skills that will allow them to participate in the execution of projects. And creating the all-important relationships of trust between the outsider experts and locals cannot be rushed. All this time is difficult to justify in the strict, clearly itemized terms insisted on by the audit culture. How do you find the right box to tick for the hours spent getting to know different social housing residents and exploring their concerns and priorities or for the often similarly long hours needed to gain the trust of local bureaucrats?

Inevitably, by the time of the Norwich project, the contribution of local people had shrunk considerably. Even though the grant from the Office of the Deputy Prime Minister had been awarded to the Cat 'n' Fiddle Partnership, Norwich City Council was given the responsibility of administering it: Free Form was employed not by local people but by the City Council. The relationship between the Fiddlewood project artists, Reich and Howarth, and the people of Fiddlewood was bound to be less intense than that characteristic of D&TAS projects like Goldsmiths or Provost. Nonetheless, Reich and Howarth did use workshops to generate imagery for the Fiddlewood Standing Stone, and it was local people's responses that led to their abandoning their original idea of a number of small pieces in favour of one substantial art work. We should also remember Reich's insistence that she is not an artist but a community artist and Howarth's definition of herself as a maker (see Chapter 9). This can be contrasted with the earlier insistence of the Free Form founders' and the Association of Community Artists that community arts and its embrace of collaborative work represented an important new direction in the arts; for its

pioneers, community arts was a new form of art and, as such, entitled to Arts Council funding. Reich and Howarth can be seen here as part of a younger generation of visual artists interested in community art and in working beyond the world of the gallery who either have no interest in being part of that world or—explicitly or implicitly—accept that an aesthetic practice that displaces the artist as lone creator will not be taken seriously as Art.

It should be stressed that what is important here is how the place of the individual artist as creator is perceived. Artists such as Damien Hirst, Jeff Koons or Takasi Murakami employ armies of people to manufacture their art works, but the role of these assistants is defined within the art world as simply giving form to the creative vision of the artist. Similarly, Christo and Jeanne-Claude's vast environment works required the involvement of thousands of people, but, as Christo insisted: 'The work is a huge individualistic gesture that is entirely decided by me' (quoted in Gablik 1995: 78; see Chapter 1). The workshop-based techniques so characteristic of community arts explicitly rejected the primacy of the single creator, a rejection that begins at least to shift the location of the artist within the process of creative production. The creation of the Fiddlewood Standing Stone may not have given local people as prominent a role as did the D&TAS projects, but, nonetheless, as aesthetic practice, it still challenges the traditional model of creation within the fine arts.

The adoption of a workshop technique did not mean, however, that the Free Form artists had abandoned their role as experts. They still saw themselves as possessing specific skills, such as the ability to devise and structure workshops that enabled participants to discover their own creativity. What changed was how they defined their expertise and how they saw its place within the process of creative production; above all, they saw themselves as able to recognize, evaluate and develop nonartists' creative ideas. As Goodrich explained in answer to my question about the role of visual expertise in community work (quoted in Chapter 6), artists have 'the means, the skills whereby people's contributions can actually achieve a high standard. You simplify [what the local people have produced] so that artists can take that and transform it into something else.' At the same time, for the community artist, as Goodrich stressed, it is crucial that this appropriation be done in such a way that it allows local people to recognize their contribution and claim ownership. There are many ways through which people can develop a sense of ownership: simply being a part of the process of creation, for instance, whether this involves taking part in a workshop, working on a mosaic, watching one's children do so or simply making cups of tea for those involved. Even just being around a project as it gradually takes shape and watching the completion of the different stages can give people a sense that this is their project, as with the Fiddlewood resident who told me how superior the Fiddlewood Standing Stone was

to Gormley's *Angel of the North* (see Chapter 9). Stressing the importance of having those with whom they work in the 'community' develop a sense of ownership does not mean, however, that the artists must relinquish their ownership. After all, even if individual artists did not receive credit for specific works, Free Form as an organization did. It may have been competing for work in a very particular kind of marketplace, but, like any such organization, it depended for future work on its reputation and previous projects.

I have noted the interesting difference between the aesthetic language used in the environmental and performance work. While the Fiddlewood Standing Stone and the D&TAS projects may have involved genuine dialogue, ultimately the permanent works created reflected the artists' aesthetic language more than the language of those with whom they worked. In the case of the D&TAS projects, this art world language may have been pulled towards more populist aesthetics, but, in practice, what this tended to mean was the incorporation of more populist elements within an aesthetic language deriving from the art world. To some members of the curatoriat, this may well have looked like too much of a surrender to popular taste, but, in reality, when it came to the more permanent environmental work, a certain fundamental art world aesthetic remained hegemonic. It was in its performance events that the Free Form Project used popular cultural forms in more unmediated ways. It is notable that in neither the early neighbourhood Fun Festivals, Mobile Roadshow and Chats Palace nor the later Catton Carnival did the artists seem to fear a descent into kitsch. Here, too, however, as in the case of the environmental work, there was a shift over the years from a creative process that, as in the case of the Mobile Roadshow and Chats Palace, used workshops to devise the shape of the performance to one in which, as with the Catton Carnival, this shape and its details—the Catton Carnival dance and its accompanying song—were devised by the experts. The role of experts like the Theatre of Adventure performers had become that of creating enthusiasm among local nonexperts and equipping them with the skills they needed to play a predetermined role in an event scripted by others.

In addition to shifting the location of the artist within the process of creative production, the aesthetic practices and social relations developed within the context of the Free Form Project also redefined the nature of the artists' expertise in the eyes of potential funders. To be an 'expert', it is not enough to possess a particular kind of knowledge or certain skills; an expert needs to be acknowledged as such. The Free Form artists' status as experts in visual art derived from their art school qualifications. Maintaining standing within the established art world, however, depends upon the recognition of the curatoriat, and this requires regular participation in the gallery or academic art world. The Free Form founders' final turn away from the gallery world after *Artism Lifeism,* in 1971, meant that their work tended not to be seen as serious

art by the curatoriat, even if their art school credentials continued to have currency in less rarefied circles. Over time, however, their work with poor communities in deprived neighbourhoods established them among urban regeneration funders as possessors of another kind of expertise, namely an ability, in the language favoured by such funders, to 'deliver community participation'. And, nowadays, politicians, planners and the like seem to agree on the importance of community participation. Indeed, as Norwich City Council discovered, delivering it in the quantifiable forms demanded by the audit culture has often come to be a requirement for funding (see Chapter. 8). But those same politicians and planners tend to be less clear as to what 'participation' actually means, which makes recognized expertise in the mysteries of the 'community' a saleable commodity in the urban regeneration marketplace. And this was an expertise Free Form as an organization established itself as possessing, even if the collaborative community art they championed had by the twenty-first century lost its lustre within the art world.

NEW GENRE PUBLIC ART

Despite its discrediting by the curatoriat, the aspirations that gave rise to community art in 1970s and 1980s Britain have not disappeared; there are still many artists in Europe, the United States and elsewhere eager to reach beyond the confines of the gallery world. One manifestation of this is what Nicholas Bourriaud has called 'relational art', which I discussed briefly in Chapter 1. Another, in certain respects more explicitly political form is what the US-based artist and theorist Suzanne Lacy terms 'new genre public art'. She defines this as 'visual art that uses both traditional and nontraditional media to communicate and interact with a broad and diversified audience about issues directly relevant to their lives [that] is based on engagement' (1995: 19).[2] There is now a significant body of critical writing on new forms of public art. I do not have the space here to engage in any substantive way with this literature, but I do want to touch on a few points directly relevant to the Free Form case in the writings of Claire Bishop (2006a, 2006b), Miwon Kwon (2004), Grant Kester (2004), and Pamela Lee (2001).

Bishop distinguishes between two traditions in participatory art: 'an authored tradition that seeks to provoke participants, and a de-authored lineage that aims to embrace collective creativity; one is disruptive and interventionist, the other constructive and ameliorative' (2006a: 11). According to this dichotomy, the Free Form Project would be part of the 'de-authored lineage' which is 'constructive and ameliorative'. It would be a mistake, however, to

2. See Lacy 1995: 19 for a fuller definition of new genre public art.

see the 'de-authored lineage' as apolitical. As Bishop stresses, in both participatory traditions, 'the issue of participation becomes increasingly inextricable from the question of political commitment' (2006a: 11). The Free Form story, as I have tried to show, provides an illuminating vantage point from which to explore the complex issue of art and political commitment. From its first beginnings in the aspirations of a small group of art students, the Free Form Project was rooted in a determination to make the expertise of the visual artist accessible to working-class people—an explicitly *class*-based vision more common in Britain than in the United States. And, as we have seen, within a few years of attempting to translate the Free Form Project into aesthetic practice, the Free Form founders had come to the conclusion that genuine engagement with the working-class people they wanted to reach was incompatible with a location within the world of the gallery. The D&TAS provides an interesting example of artists attempting to find a more progressive location.

Both Kwon and Kester stress the importance of questioning, as Kester puts it, 'the rhetoric of community artists who position themselves as the vehicle for an unmediated expressivity on the part of a given community' (quoted in Kwon 2004: 139). Free Form's D&TAS offers an example of community artists positioning themselves not as 'the vehicle for an unmediated expressivity' but rather precisely as mediators. First, as aesthetic mediators, they attempted to mediate between the art world and the visual worlds of those living in impoverished neighbourhoods. Second, as mediators operating in the sphere of officialdom, they sought to provide a link between 'the community' and the various government and other bureaucracies local people had to navigate if projects were to be realized. The D&TAS team's mapping of possibilities in the context of any given project, for instance, always involved an assessment of local political realities. There is, of course, the question of how representative the 'community' groups with whom they worked were of the larger, heterogeneous 'community' as whole. The D&TAS, as we have seen, was generally approached for help by an established community group, and this group tended to continue as their primary local partners. In relation to Kwon's and Kester's point, however, I simply want to note that neither the D&TAS nor the Free Form Project more widely ever made claims to 'unmediated expressivity'.

The relationship of the Free Form artists to the 'community' was very different from the artist/community relationship described by Pamela Lee in her study (2001) of the site-specific artist Gordon Matta-Clark (1943–78), an artist with a considerable and growing reputation within the art world. Matta-Clark intended his work to be 'disruptive and interventionist'; he is very much part of Bishop's 'authored tradition that seeks to provoke participants', and his work was concerned, as Rancière insists critical art must be, with creating 'awareness of the mechanisms of domination' (2009:

45, quoted in Chapter 2). Lee stresses that 'community was fundamental to Matta-Clark's larger project: his commitment to the reclamation of social space, held against its alienation as property' (2001: 162). But what community exactly was Matta-Clark addressing with his most famous works, his 'building cuts'—huge sculptural cuts in buildings scheduled for demolition? Drawing on the work of the philosophers Georges Bataille and Jean-Luc Nancy—Bataille's community 'of those who do not have a community' (Bataille, quoted in Lee 2001: 162–3) and Nancy's workless community (1991)—Lee sees Matta-Clark's interventions, unsanctioned and usually illegal, as overturning 'the conventional relationship between art and its viewing public' (2001: 209). Matta-Clark's work, in Lee's view, produced a quintessentially modern community: 'Challenging any claims to an essentialized community of spectators, his work produces a viewership founded on loss, not the fullness of productive or performative experience. And it is the commonality of this loss, endlessly played out in the space of the city, that is the heart of the modern itself' (2001: 209).

The community here would seem to exist essentially as an imagined community of spectators capable of reading the building cuts in this way. When it came to actual relationships with actual communities, there could be problems. Lee recounts, for instance, how, during a trip to Milan in 1975, Matta-Clark encountered a group of young members of the local Communist Party who were occupying a disused factory in an attempt to prevent its being taken over by private developers. As an act of solidarity, Matta-Clark 'proposed to cut an arch in the building to monumentalize their plight'. Unfortunately, as one of Matta-Clark's collaborators recalled, 'the authorities got wind of what he was going to do, and a day before the cutting, they went in on a trumped up drug bust and chased everybody out.' Lee notes, 'Well-intentioned as his gesture may have been, Matta-Clark's political aspirations for the group inadvertently contributed to the dispersal of the squatters' (2001: 168). This contrasts with the D&TAS team's stress on local political realities as an inescapable element of any Brief.

What is unusual about the Free Form founders in the context of the art world is the degree to which they were prepared not only to cut themselves off from traditional art world spaces but to forgo legitimation by the curatoriat. Matta-Clark and new genre public art in general may have been committed to engaging with audiences beyond those of the traditional gallery world, but this has not involved a rejection of that world. The audience for Matta-Clark's work, for instance, continued to be an art world one, and his aesthetic language a language spoken in art world circles.

A good example of how the work of such artists tends to remain firmly within the art world is provided by Thomas Hirschhorn, an innovative and much lauded contemporary public artist. Hirschhorn is very articulate about his work,

which he has explained in many interviews. He insists that he makes art—often room-size installations of everyday materials—not for art world insiders but for a 'nonexclusive' audience. It is worth examining his claim here in some detail, since it raises interesting questions about the kind of artist/community relationship possible within the 'authored tradition'—a tradition which puts so much stress on the individual creator.

THE FREE ARTIST AND THE 'NONEXCLUSIVE AUDIENCE'

In an interview with the artist Ross Birrell, Hirschhorn explains how he addresses his work to what he terms 'the nonexclusive audience', contrasting this audience with the 'spectre of evaluation (the Institution director, Art critic, Curator, Gallerist, Collector, Art historian and Art professor)' (Birrell 2009/10: 7). We can see Hirschhorn's 'spectre of evaluation' here as essentially Danto's curatoriat. Nonetheless, Hirschhorn's work fits comfortably into the official gallery world, as his many exhibitions, prestigious art prizes and residencies attest. For Hirschhorn there is no contradiction here since, for him, Art (which he always capitalizes) is nothing if it is not universal:

> Universality is constitutive to Art . . . One can say that Art is universal because it's Art. If it is not universal it is not an Artwork . . . I believe—yes, believe—in Equality. And I believe that Art has the Power of transformation. The power to transform each human being, each one and equally without distinction. I agree that equality is the foundation and the condition of Art. (Birrell 2009: 6, capitalizations in original)

As he stresses, Hirschhorn is convinced of the transformative power of Art. He would clearly reject Bourdieu's sceptical questioning of 'the miracle of unequal class distribution of the capacity for inspired encounters with works of art and high culture in general' (1984: 29, quoted in Chapter 1). Hirschhorn is also convinced that nonart world audiences are able to respond to work like his in a more open way than the 'spectre of evaluation'. He claims, for instance, that 'the "non-exclusive audience" is able to judge the work of the artist directly from the heart whereas the "spectre of evaluation" only evaluates the work.' (Birrell 2009/10: 7) This seems to me a problematic claim. I would agree that those unsocialized into the accepted evaluations might respond to an artwork with a freshness that the curatoriat, burdened by their knowledge of centuries of art history, may lack, but, as I have argued in earlier chapters, while the 'nonexclusive audience' may not judge art works by the same criteria as the curatoriat, this does not mean they do not have their own different criteria—criteria which are themselves, as I discussed in Chapter 1, linked in complex, mediated ways to various 'commonsense' notions of art.

In his commitment to reaching 'nonexclusive audiences', Hirschhorn often creates artwork in nongallery spaces, constructing, for instance, monuments in the form of temporary installations to four philosophers whom he sees as having 'something to say today': Baruch Spinoza, Gilles Deleuze, Antonio Gramsci and Georges Bataille (Hirschhorn 2004: 251). These monuments are not intended to explain these thinkers or their ideas but rather simply to confront the viewer with them. As the artist Craig Garrett puts it in an interview with Hirschhorn:

> In his [Hirschhorn's] ardor for the writing of Spinoza and Bataille, he reproduces their words in staggering quantity, stacking them in towers of photocopied sheets or using them to wallpaper entire sections of the gallery. Moreover, he mixes them with the debris of everyday modern life: discarded beverage containers, fake washing machines, shop window mannequins. He has, in other words, dragged these writings out from their 'gold standard' vault and mixed them with the dross of material reality in the most irreverent manner imaginable. (Garrett 2004)

The monuments are all located in nonart world spaces: the Spinoza Monument in a street in the red light district in Amsterdam, the Deleuze in a public housing complex in Avignon.[3] The aesthetic of these seemingly random collection of documents, images and detritus is deliberately antimonumental. Hirschhorn sees the very ordinariness of the material used to construct them as making the monuments more accessible: 'I really try to use materials that everybody knows and uses in their everyday life, not for doing art . . . tape, cardboard, paper, photocopies, mailing tubes, silver paper: it's very important to me to have materials that are in everyday use' (Schmelzer 2006). Hirschhorn explains his inclusive vision in the following terms:

> I am interested in energy, not quality. This is why my work looks as it looks! Energy yes! Quality no! I do not want to intimidate nor to exclude by working with precious, selected, valued, specific art materials. I want to include the public with and through my work, and the materials I am working with are tools to include and not to exclude. This is what makes me choose the type of materials I use. It is a political choice. I want to work for a non-exclusive audience. (Garrett 2004)

Hirschhorn may want to 'include the public', but, like Christo, he sees himself as the sole creator of his artwork and the condition of artist that of total

3. The first stage of The Gramsci Project (funded by the NEA) involved a lecture by Hirschhorn on art and philosophy as part of a day-long public culture program at the City University of New York's LaGuardia Community College in 2010 organized by Charity Scribner. This event also included a Gramsci Roundtable of scholars in which I participated and a presentation by the artist Hong-An Truong on the public artwork *Rehearsal for Education,* produced collaboratively with students from LaGuardia.

freedom. In *Thomas Hirschhorn,* a monograph on his work published by Phaidon, a leading visual arts press, Hirschhorn explains in an interview with the curator and critic Alison Gingeras: 'I realised that I had to make the choice to be an artist because only as an artist could I be totally responsible for what I did. The decision to be an artist is the decision to be free' (Gingeras 2004: 11). This is an artist who has no doubts that *he* is the author of his works. Hirschhorn describes his Bataille Monument (located in an immigrant neighbourhood in a suburb of Kassel) as 'a precarious art project of limited duration, built and maintained by the young people and other residents of a neighbourhood . . . the *Bataille Monument* seeks to raise questions and to create the space and time for discussion and ideas' (Basualdo 2004: 98). But, while Hirschhorn may have employed local residents to help him with the work of construction, he stresses that he retained total creative control, departing here from Lacy's definition of new genre public art in that he explicitly denies that his artworks are interactive. For him, the Monument was a fully autonomous artwork that confronted its spectators:

> I'm not an animator and I'm not a social worker. Rather than triggering the participation of the audience, I want to implicate them. I want to force the audience to be confronted with my work. This is the exchange I propose. The artworks don't need participation; it's not an interactive work. It doesn't need to be completed by the audience. (Gingeras 2004: 25–6)

Hirschhorn, like Matta-Clark, is an artist who belongs to Bishop's 'authored tradition that seeks to provoke participants', which is 'disruptive and interventionist'. Within the art world, Hirschhorn's apparently chaotic assemblages are perfectly intelligible as critical artworks. To Benjamin Buchloh, the Harvard-based scholar of post-1945 art, 'Hirschhorn's most haunting structures are instances of material mimesis, juxtaposing grotesque commodity objects with the travesty of failed utopian aspirations that now spark only negative epiphanies' (Buchloh 2004: 73). To those less familiar with the language of contemporary art, however, Hirschhorn's installations might well provoke reactions closer to those of the tabloid commentators on the 2004 Momart fire that destroyed so much contemporary British art (discussed in Chapter 1), for whom the art destroyed, far from being seen as 'haunting structures', was simply 'overpriced, over-discussed trash' (*Daily Mirror* columnist quoted in Meek 2004). Hirschhorn has admitted that the local 'community' does not always seem to find his artworks accessible. The Deleuze monument, for instance, had to be dismantled prematurely because of vandalism and theft.

The larger point here is that Hirschhorn and other new genre public artists may make unconventional art works and display or perform them in

nongallery spaces, but their meaning tends to remain rooted in the art world, while the creators themselves continue to depend on their links with that world. Both their standing as artists and their access to the funding they need to produce their work depend on their maintaining credibility with the curatoriat. Hirschhorn is a good example. The interview with Gingeras ends with Hirschhorn's passionate commitment to generating his own projects: 'The only demand I have to make on myself is to go on producing non-commissioned artwork. And to stay alert, stay attentive and to keep conquering' (2004: 39). Hirschhorn's access to the art world funding he needs if he is to create his 'noncommissioned artwork' is inescapably bound up with his stature in the eyes of the curatoriat.

Acknowledgement as a serious artist requires a certain kind of presence in the art world, such as gallery exhibitions (this might include photographs, videos and other documentation of their work outside the gallery), teaching in art schools, or being an artist in residence. Maintaining the necessary links requires that an artist continue to locate his or her work within that 'discourse of reasons . . . construed institutionally' which is ultimately what defines the art world (Danto 1992: 40; see Chapter 1). Making art works that pass muster with the curatoriat or the 'spectre of evaluation' and that also speak in an intelligible way to those unsocialized into the art world's discourse of reasons is extraordinarily hard. It becomes even harder if those art works are to speak to such an unsocialized public about what Lacy referred to in her definition of new genre public art as 'issues directly relevant to their lives' (quoted earlier). In practice, it seems, artists usually have to decide who their primary audience is: those unfamiliar with art world discourse *or* the curatoriat.

I have discussed Hirshhorn's work at some length because I think it helps clarify the difference between the Free Form Project and this kind of 'public art'. My intention is certainly not to disparage Hirschhorn's work; his innovations, like those of a number of the new genre public artists, open up new and exciting possibilities for visual artists. This is a legitimate, indeed important endeavour; it is just different from that at the heart of the Free Form Project. And a fundamental difference is the role assigned to the 'community'. The Free Form founders made the decision both to turn their backs on the gallery world and its legitimating institutions and to step aside from the claim of sole creator. Over time, as we have seen, this not only led them to developing collaborative mechanisms, such as the workshop, which enabled the 'community' to participate in the creation of art works but also resulted in the 'community' shaping the artists' aesthetic practice and language. Having reflected on the relationship between community art and the art world, I want now, therefore, to shift to considering that between community art and the 'community'.

COMMUNITY ART AND THE 'COMMUNITY'

As I discussed in Chapter 2, the term 'community' is a slippery animal. Part of its appeal to politicians of both Left and Right is the way it fuses together an enormously powerful and positive emotional charge with a useful vagueness as to precisely *what* social relations constitute 'community'. The seductive combination of authenticity and vagueness also helps explain its appeal to artists dissatisfied with the elitism of high culture and seeking to reach beyond the narrow confines of the gallery world. It is not surprising that many artists in the 1970s and 1980s chose to call themselves community artists. We need to be careful, however, not to confuse commonsense understandings of community, with their comforting fantasies of authentic belonging, with empirical social realities. The specific tangle of social relations to be found in what we might call 'actually existing communities' can never be assumed. The precise nature of this tangle is always an empirical question, answerable only for a given context. And, even then, the answer depends on how the question has been framed, from where the 'community' is being seen, and who is doing the looking. Ocean Estate, for example, chosen by Tony Blair for his speech promoting community empowerment, might look like a 'community' viewed from the vantage point of Whitehall politicians and planners, but those living there may have been just as aware of their differences with many of their neighbours as they were of belonging to the Ocean Estate 'community'. In the case of community art and artists who claim to work with or in the 'community', we need to ask: exactly what social relations were involved in any given project? How was the term 'community' invoked and by whom?

For instance, as the Free Form Project moved from general aspiration to making art in working-class neighbourhoods with working-class people, the artists' aesthetic practice came to be based on interactive techniques that created webs of relationships both between the artists and those with whom they worked and amongst the local people themselves. From Goodrich and Ives's earliest attempts to tame the hordes of intrusive children besieging their flimsy prefab by inviting them into their studio to the later, more organized workshops, the artists' concern was to establish strong relationships in the neighbourhoods in which they worked. They called themselves community artists because the term seemed to them to capture the spirit of what they were doing, but this does not mean they saw their task as connecting with an already existing 'community'. Working as artists in a range of neighbourhoods, they were continually made aware that they were dealing with individuals with different interests and different aesthetic beliefs, amongst whom there might be serious tensions. They had to think beyond the clichés of 'community'.

The Briefs they adopted forced them to think about how a group of people who happen to share a common living space might be brought together around a specific project. For the Provost project, for instance, they devised the window box initiative with a view to including as many of those living on the estate as possible and created a permanent art work, the mural, as a focal point embodying the residents' sense of themselves as Londoners. For Goldsmiths, the refurbishment of the games pitch—a specific need defined by the tenants association prior to their involvement with Free Form—both brought the estate's residents together and served as a marker of the estate's identity. This is not to say that everyone living on Provost or Goldsmiths identified with these projects or that they had somehow been welded into a community. Nonetheless, I think we can say that the projects created, at least for a little while, a certain shared sense of community. The D&TAS projects may have been relatively small in scale, but they allow us to see in concrete terms what bringing together the skills of a visually trained expert with the nonexpert's knowledge of living in a given place might look like and the kind of 'artworks' such collaboration might produce. The process of finding solutions to the problems defined by specific Briefs often resulted, as we have seen, in 'artworks' that challenged both art world and commonsense understandings of 'art'.

Debates about aesthetics were a normal part of the projects. The story of the Provost mural, for instance, shows artists working with local people to find an aesthetic solution that both spoke to the Provost tenants' sense of themselves as Londoners and met the artists' aesthetic standards. The products of such aesthetic dialogue would be seen by some as tipping over into kitsch. In reality, once artists who are committed to working in the 'community' or other forms of interactive art genuinely begin listening to that 'community', aesthetic clashes of this kind are to be expected. In an interview, Kester described just such a clash of tastes in the context of work by the Hamburg-based group Park Fiction:

> I [i.e. Kester] was discussing Park Fiction's work recently with a landscape designer who was dismayed by what she saw as the ugliness of the park they [Park Fiction] developed in conjunction with their Hafenstrasse neighbors. She described it as kitsch, which struck me as exactly right. Park Fiction doesn't really care if their fake palm trees and flying carpet lawns are seen as kitsch by a design professional: they are more concerned with the modes of interaction that the creation of the park set in motion. (Wilson 2007: 112–14)

This was essentially the Free Form artists' response to the criticisms of the Arts Council evaluators.

It is important, however, to distinguish between a willingness to accept what might be seen as kitsch by some and a relinquishing of the role of expertise. A distinction made by the stone carver Howarth (quoted in Chapter 5)

is pertinent here. Howarth stressed that, while she might find some of the imagery chosen by her clients to be sentimental, she saw her role as using her expertise to realize this imagery: 'it has to be well designed and well executed, beautifully designed and beautifully executed.' One reason community art in Britain became unpopular not only with the curatoriat but also many of those living in the deprived communities it was designed to serve was that a good deal of it was poorly designed and executed. A number of the Provost residents, as Goodrich recalled, shared what had become a common belief: murals meant 'childish daubs' (see Chapter 6). This was not an issue of kitsch versus 'good taste'. The association of murals with 'childish daubs' arose in part because there was a faction among the community artists working in Britain in the 1970s and 1980s who believed in simply handing over aesthetic control to the 'community' and letting them execute the art work even if they lacked the skills to do so. To such practitioners, essentially the only thing that mattered was the 'modes of interaction' with the 'community'. This was never Free Form's position. Once the organization's focus had shifted from performance events to environmental work, the artists committed themselves to high standards of execution, reasoning that, in contemporary industrial societies, any permanent intervention in the built environment needs to meet certain commonly accepted standards of professional competence. Otherwise, except possibly to those directly involved, it is likely to look like unwelcome vandalism.

The issue of 'professionalism' is linked to modern society's ever-proliferating division of labour. Those who live somewhere like Britain are embedded in a complex division of labour, which makes it impossible for them to have the direct, unmediated control over the construction of their built environment enjoyed by the rural Zambians with whom I began this book. In contemporary industrial societies, for instance, even the richest and most powerful individuals—and a fortiori the less privileged—depend for their housing on a complex, cooperative effort in which accredited experts (planners, architects, builders, accountants) play a crucial role. The social distribution of skills in the cities of the global North necessarily gives power to 'experts' at the expense of 'nonexperts'. This is a reality that cannot be wished away. If we want ordinary 'nonexperts' to play a genuine role in the shaping of their environment, we cannot simply dismiss the importance of expertise. Rather, we need to devise mechanisms that bring experts and nonexperts together in ways that make expertise accessible and that create spaces for experts to learn from nonexperts. The workshop provides an example of such a mechanism.

To the degree that the workshop as a technique displaces the artist as lone creator and incorporates in an acknowledged way the creative labour of the nonartist, it can be seen as the kind of shift within the relations of artistic production that Benjamin saw as crucial in defining the political progressiveness of both art works and artists (see Chapter 7). It is important, however, also to recall

Rancière's caution about artworks' shifting political character: the political significance of a given art work depends on the wider political context. And we can extend this to the aesthetic practice that produced that artwork. The early years of Free Form and community arts more generally were a time in Britain when radical change of various kinds still seemed possible. Challenging the romantic individualism of the visual arts and the elitism of the gallery world seemed to be part of a great experiment in a new kind of democracy. By the time of my fieldwork, more than twenty years later, the political and economic climate was very different. There had indeed been a revolution, but it was a neoliberal one. In this new neoliberal context, the aesthetic practice of the Free Form Project might well seem, as Kelly dismissively puts it in a passage I quoted in Chapter 4, no more than, 'one more worthy branch of whatever this government [that is the Conservative Government of Margaret Thatcher] chooses to leave of the welfare state. Meals on wheels, homemade scones, inflatables and face painting: the kindly folk who do good without ever causing trouble' (Kelly 1983: 1). Such wholesale dismissal, however, misses the real possibilities of a different kind of aesthetic collaboration between artist experts and nonexperts opened up by the Free Form Project. In the current climate, these may only be possibilities, but that does not make the endeavour pointless.

These possibilities bring us back to my original question: are the ordinary, 'nonexpert' inhabitants of a city like London, especially those living in its more deprived neighbourhoods, doomed to be ever more excluded from the shaping of their built environment? The aesthetic collaborations that resulted from the Free Form Project, I suggest, offer concrete examples of ways in which 'experts' and 'nonexperts' might be brought together. Their value, however, is not that they provide some simple template for others to adopt but that they can help us think through key political and aesthetic questions. What, for instance, are the possibilities and the limitations of such ' artwork'? How and by whom should such collaborative projects be funded? Who should have control over projects, and how should that control be exercised? When, as is likely, there are aesthetic disagreements, how should these aesthetic disputes be resolved? How can, or should, experts trained in the visual arts use their expertise? What constitutes 'visual expertise'? Must would-be 'progressive' artists dedicate themselves to the production of 'critical art' as defined by Rancière: 'art that sets out to build awareness of the mechanisms of domination to turn the spectator into a conscious agent of world transformation' (Rancière 2009: 45)? Can aesthetic projects like those of the D&TAS, concerned with making the often bleak spaces in which so many of the less privileged are condemned to live a little more liveable, never be considered politically 'progressive'? These are not questions that can be answered in the abstract. Rather, they point us in the direction of certain important issues that need to be explored in particular times and places. An anthropological approach is well suited to provide this kind of careful ethnographic mapping.

References

Arts Council (1985a), 'Internal Memo on visit to Free Form Arts Trust, 12/12/85', ACGB/29/24 Free Form Arts Trust, 1984–94.

Arts Council (1985b), 'Internal Memo on visit to Free Form Arts Trust, 13/12/85', ACGB/29/24 Free Form Arts Trust, 1984–94.

Arts Council (1986), 'Paper for the Advisory Panel on Art by the Assistant Art Director', ACGB/29/24 Free Form Arts Trust, 1984–94.

Asthana, Anushka, and Vanessa Thorpe (2007), 'Arts Chief Warns of Cultural Apartheid', *Observer,* December 2.

Baldry, Harold (1981), *The Case for the Arts,* London: Secker and Warburg.

Basualdo, Carlos (2004), 'Focus', in Benjamin H. D. Buchloh, Alison M. Gingeras and Carlos Basualdo, *Thomas Hirschhorn,* London and New York: Phaidon: 94–109.

Baxandall, Michael (1972), *Painting and Experience in Fifteenth-Century Italy*, Oxford: Oxford University Press.

Baxandall, Michael (1985), *Patterns of Intention: On the Historical Explanation of Pictures,* New Haven and London: Yale University Press.

Benjamin, Walter (1973), 'The Work of Art in the Age of Mechanical Reproduction', in Hannah Arendt (ed.), *Illuminations,* London: Fontana: 219–53.

Benjamin, Walter (1986), 'The Author as Producer', in Peter Demetz (ed.), *Reflections,* New York: Schocken Books: 220–38.

Berger, John (1972), *Ways of Seeing,* London: Penguin Books.

Birrell, Ross (2009/10), 'The Headless Artist: An Interview with Thomas Hirschhorn on the Friendship between Art and Philosophy, Precarious Theatre and the Bijlmer Spinoza-festival', *Art and Research*, 3/1 (Winter): 1–10.

Bishop, Claire (ed.) (2006a), *Participation,* Cambridge: MIT Press.

Bishop, Claire (2006b), 'The Social Turn: Collaboration and Its Discontents', *Artforum International*, 44/6: 178–83.

Blair, Tony (2001), 'Opportunity for All, Responsibility from All: A New Commitment to Neighbourhood Renewal', http://www.socialexclusionunit.gov.uk/media/speeches/PM_speech.doc, accessed 10 January 2003.

Bourdieu, Pierre (1984), *Distinction: A Social Critique of the Judgement of Taste,* Cambridge, MA: Harvard University Press.

Bourriaud, Nicolas (2002), *Relational Aesthetics,* Dijon: Les presses du réel.

Braden, Su (1978), *Artists and People,* London: Routledge and Kegan Paul.

Buchloh, Benjamin H. D. (2004), 'Survey', in Benjamin H. D. Buchloh, Alison M. Gingeras and Carlos Basualdo, *Thomas Hirschhorn,* 40–93, London and New York: Phaidon.

Buchloh, Benjamin H. D., Alison M. Gingeras and Carlos Basualdo (2004), *Thomas Hirschhorn,* London and New York: Phaidon.
Campbell, Peter (2009), 'At the National Gallery: Picasso's Borrowings', *London Review of Books,* 31/6: 36.
Caroll, Noël (ed.) (2000), *Theories of Art Today,* Madison, WI: University of Wisconsin Press.
Chapman, Robin (2006), Letter to the editor, *London Review of Books,* 28/16: 4.
Charity Commission (2008), *CC9 Speaking Out: Speaking Out Guidance on Campaigning and Political Activity by Charities.*
Clark, Kenneth (1977), *The Other Half: A Self-Portrait,* London: John Murray.
Coote, Jeremy, and Shelton Anthony (eds) (1992), *Anthropology, Art and Aesthetics,* Oxford: Clarendon Press.
Creed, Gerald (ed.) (2006), *The Seductions of Community: Emancipations, Oppressions, Quandaries,* Santa Fe, NM: School of American Research Press.
Crehan, Kate (1997), *The Fractured Community: Landscapes of Power and Gender in Rural Zambia,* Berkeley: University of California Press.
Crehan, Kate (2002), *Gramsci, Culture and Anthropology,* London: Pluto Press, and Berkeley: University of California Press.
Crehan, Kate (2006), 'Hunting the Unicorn: Art and Community in East London', in Gerald Creed (ed.), *The Seductions of Community: Emancipations, Oppressions, Quandaries,* 49–76, Santa Fe, NM: School of American Research Press.
Crehan, Kate (2009), 'Sinking Roots: Using Gramsci in Contemporary Britain', in Joseph Francese (ed.), *Perspectives of Gramsci: Politics, Culture and Social Theory,* 33–49, London and New York: Routledge.
Danto, Arthur C. (1964), 'The Artworld', *Journal of Philosophy* 61: 571–84.
Danto, Arthur C. (1992), 'The Art World Revisited: Comedies of Similarity', in Arthur Danto, *Beyond the Brillo Box: The Visual Arts in Post-Historical Perspective,* 33–53, Berkeley: University of California Press.
Danto, Arthur C. (1994), *Embodied Meanings: Critical Essays and Aesthetic Meditations,* New York: Farrar, Straus and Giroux.
Danto, Arthur C. (1997), *After the End of Art: Contemporary Art and the Pale of History,* Princeton: Princeton University Press.
Dickie, George (2001), *Art and Value,* Oxford: Blackwell.
Dickson, Malcolm (ed.) (1995), *Art with People,* Sunderland: AN Publications, Artic Producers.
Dutton, Denis (2000), '"But They Don't Have Our Concept of Art"', in Noël Carroll (ed.), *Theories of Art Today,* 217–38, Madison: University of Wisconsin Press.

Edgar, David (2006), Review of *John Osborne* by John Heilpern in *London Review of Books,* 28/14: 8–10.
Fisher, Ernst (1963), *The Necessity of Art: A Marxist Approach,* London: Penguin Books.
Foster, Hal (1996), 'The Artist as Ethnographer', in Hal Foster, *The Return of the Real,* 171–203, Cambridge, MA: MIT Press.
Francese, Joseph (ed.) (2009), *Perspectives of Gramsci: Politics, Culture and Social Theory,* London and New York: Routledge.
Fox, John (2002), *Eyes on Stalks,* London: Methuen.
Free Form (1973), *The Growth of Public Art.*
Free Form (1985), *Extending Participation: A report by Free Form Arts Trust for UNESCO on the Goldsmith's Square Estate.*
Free Form (2004a), *Catton: Pride of Place: 2004 Study Report.*
Free Form (2004b), *Fiddlewood Artist Brief.*
Free Form (n.d.), *Free Form Design and Technical Aid Service.*
Gablik, Suzi (1995), 'Connective Aesthetics: Art after Individualism', in Suzanne Lacy (ed.), *Mapping the Terrain: New Genre Public Art,* 74–87, Seattle: Bay Press.
Garrett, Craig (2004), 'Thomas Hirschhorn: Philosophical Battery (interview)', *Flash Art,* 238, http://www.papercoffin.com/writing/articles/hirschhorn.html, accessed 7 July 2010.
Gell, Alfred (1992), 'The Technology of Enchantment and the Enchantment of Technology', in Jeremy Coote and Anthony Shelton (eds), *Anthropology, Art and Aesthetics,* 4–67, Oxford: Clarendon Press.
Gell, Alfred (1995), 'On Coote's "Marvels of Everyday Vision"', *Social Analysis,* 38: 18–31.
Gell, Alfred (1998), *Art and Agency: An Anthropological Theory,* Oxford: Clarendon Press.
Gingeras, Alison M. (2004), 'Interview' in Benjamin H.D. Buchloh, Alison M. Gingeras and Carlos Basualdo, *Thomas Hirschhorn,* London and New York: Phaidon: 6–39.
Girling, Richard (2004), 'Save our streets', *The Sunday Times,* September 19, http://www.epicview.net/commondemo/pdf/botchjob.pdf
Gramsci, Antonio (1971), *Selections from the Prison Notebooks,* edited by Quintin Hoare and Geoffrey Newell Smith, London: Lawrence and Wishart.
Gramsci, Antonio (1985), *Selections from Cultural Writings,* edited by David Forgacs and Geoffrey Nowell Smith, London: Lawrence and Wishart.
Gramsci, Antonio (1996), *Antonio Gramsci: Prison Notebooks,* Vol. II, edited by Joseph Buttigieg, New York: Columbia University Press.
Harvey, David (2005), *A Brief History of Neoliberalism,* Oxford: Oxford University Press.

Hewison, Robert (1995), *Culture and Consensus: England, Art and Politics since 1940,* London: Methuen.

Hirschhorn, Thomas (2004), 'Four Statements, February 2000', in Florian Matzner (ed.), *Public Art: A Reader,* 246–53, Ostfilden-Ruit: Hatje Cantz Verlag.

Kelly, Owen (1984), *Community, Art and the State: Storming the Citadels,* London: Comedia.

Kester, Grant H. (2004), *Conversation Pieces: Community and Communication in Modern Art,* Berkeley: University of California Press.

Kristeller, Paul Oskar (1990a), 'The Modern System of the Arts', in Paul Oskar Kristeller, *Renaissance Thought and the Arts: Collected Essays,* 163–227, Princeton: Princeton University Press [originally published in *Journal of the History of Ideas* 12/4 (1951): 496–527, and 13/1 (1952): 17–46].

Kristeller, Paul Oskar (1990b) 'Afterword: "Creativity" and "Tradition"', in Paul Oskar Kristeller, *Renaissance Thought and the Arts: Collected Essays,* 247–58, Princeton: Princeton University Press [originally published in *Journal of the History of Ideas,* 44 (1983): 105–13].

Kwon, Miwon (2004), *One Place after Another: Site Specific Art and Locational Identity,* Cambridge, MA: MIT Press.

Lacy, Suzanne (1995), *Mapping the Terrain: New Genre Public Art,* Seattle: Bay Press.

Lee, Pamela M. (2001), *Object to Be Destroyed: The Work of Gordon Matta-Clark,* Cambridge, MA: MIT Press.

Malinowski, Bronislaw (1984 [1922]), *Argonauts of the Western Pacific,* Prospect Heights, IL: Waveland Press.

Marcus, George E., and Myers, Fred R. (eds) (1995), *The Traffic in Culture: Refiguring Art and Anthropology,* Berkeley: University of California Press.

Marx, Karl (1976), *Capital,* vol. I, Harmondsworth: Penguin.

Matzner, Florian (ed.) (2004), *Public Art: A Reader,* Ostfilden-Ruit: Hatje Cantz Verlag.

Meek, James (2004), 'Art into Ashes', *Guardian,* September 23.

Morgan, Sally (1995), 'Looking Back over 25 Years', in Malcolm Dickson (ed.), *Art with People,* 16–27, Sunderland: AN Publications, Artic Producers.

Morphy, Howard, and Morgan Perkins (eds) (2006), *The Anthropology of Art: A Reader,* Oxford: Blackwell.

Musil, Robert (2006), *Posthumous Papers of a Living Author,* Brooklyn, NY: Archipelago Books.

Myers, Fred R. (2003), *Painting Culture: The Making of an Aboriginal High Art,* Durham, NC: Duke University Press.

Nancy, Jean-Luc (1991), *The Inoperative Community,* Minneapolis: University of Minnesota Press.

Norman, Nils (2004), *An Architecture of Play: A Survey of London's Adventure Playgrounds,* London: Four Corners Books.

Norwich City Council (2002), *Catton and Fiddlewood Area Community Plan.*
O'Neill, Gilda (2000), *My East End: Memories of Life in Cockney London,* London: Penguin.
Ortega y Gasset, José (1957), *The Revolt of the Masses,* New York: W. W. Norton.
Ortega y Gasset, José (1968), *The Dehumanization of Art and Other Essays on Art, Culture and Literature,* Princeton: Princeton University Press.
Phillips, Ruth B., and Christopher B. Steiner (eds) (1999), *Unpacking Culture: Art and Commodity in Colonial and Postcolonial Worlds,* Berkeley: University of California Press.
Plattner, Stuart (1998), *High Art Down Home: An Economic Ethnography of a Local Art Market,* Chicago: Chicago University Press.
Power, Michael (1994), *The Audit Explosion,* London: Demos.
Rancière, Jacques (2004), *The Politics of Aesthetics,* London and New York: Continuum.
Rancière, Jacques (2009), *Aesthetics and Its Discontents,* Cambridge: Polity Press.
Richardson, John (1991–7), *A Life of Picasso,* 3 vols, New York: Random House.
Sassoon, Donald (2001), *Becoming Mona Lisa: The Making of a Global Icon,* Orlando, FL: Harcourt.
Savšek, Maruška (2007), *Anthropology, Art and Cultural Production,* London: Pluto Press.
Schmelzer, Paul (2006), 'Interview with Thomas Hirschhorn', http://www.mnartists.org/work.do?rid=126081, accessed 7 July 2010.
Shiner, Larry (2001), *The Invention of Art: A Cultural History,* Chicago: University of Chicago Press.
Skidelsky, Robert (2001), *John Maynard Keynes,* vol. 3, *Fighting for Freedom,* New York: Viking Penguin.
Steiner, Christopher B. (1994), *African Art in Transit,* Cambridge: Cambridge University Press.
Strathern, Marilyn (ed.) (2000), *Audit Cultures: Anthropological Studies in Accountability, Ethics and the Academy,* London and New York: Routledge.
Thornton, Sarah (2009), *Seven Days in the Art World,* New York: W. W. Norton.
Towers, Graham (1995), *Building Democracy: Community Architecture in the Inner Cities,* London: UCL Press.
Walker, John A. (2002), *Left Shift: Radical Art in 1970s,* London and New York: I. B. Taurus.
Warburton, Nigel (2003), *The Art Question,* London and New York: Routledge.
Wates, Nick, and Charles Knevitt (1987), *Community Architecture: How People Are Creating Their Own Environment,* London: Penguin Books.

Williams, Raymond (1983), *Keywords: A Vocabulary of Culture and Society,* London: Fontana Paperbacks.

Wilson, Mick (2007), 'Autonomy, Agonism, and Activist Art: An Interview with Grant Kessler', *Art Journal,* 66/3: 106–18.

Woodmansee, Martha (1994), *The Author, Art, and the Market: Rereading the History of Aesthetics,* New York: Columbia University Press.

Young, M., and P. Willmott (1962), *Family and Kinship in East London,* London: Pelican.

Index

Note: Page numbers for figures are shown in italics.

accessibility of art, 5
accountability, 138, 151, 166
Acting Up, 76
adventure playgrounds, 48–9, 59, 69
Advisory, Conciliation and Arbitration Service (ACAS), 76
aesthetic language of art world, 10–11, 185, 194, 196
Agis, Maurice, 43–4, 45–6, 53–4
Ahmed, Shahed, 150–1
Albany Empire, 66
anthropology and art, 12–13
Anthropology of Art, The (Morphy and Perkins), 12
antiracist movement, 52, 135
'Architectonic Paint Rags' (Wheeler-Early), *53*
architectural service, 77, 79–80, 86–7
see also D&TAS
architecture, 104–5
Argonauts of the Western Pacific (Malinowski), 152
art/Art, definition, 11–12, 13–14, 103, 154–5
art establishment, 81–2
see also curatoriat
Art for Offices Award, 146
Arti del designo, 14
Artism Lifeism, 53, 54, 131
artist ethnographers, 130–1, 152
artists
 commissioned for environmental work, 165–9
 community relationship, 187–8
 as creator, 184
 and genius, 14–15, 16
 spectator relationship, 30
art market, 21, 132, 133, 137
arts centre, 69–70
Art Scope, 143

Arts Council, 14, 30–1, 58–9, 61, 83–5, 126–7, 143
 Gowing visit, 54–5
 on hoardings, 147
 and NAC, 45
Arts Generate, 143
arts, the, 13, 14
Art Works, 147
'The Artworld' (Danto), 5–7
Ash Sakuler, 144
Association of Community Artists (ACA), 82–3
Association of Community Technical Aid Centres (ACTAC), 86–7
audit culture, 138, 151
authentic identity fallacy, 131, 136
'Author as Producer, The' (Benjamin), 129–30, 136
awards, 144, 146, 147

Bacon, Emma, 149, 150, 155
Baldry, Harold, 85
Barker, Godfrey, 11
Bataille, Georges, 188
Bataille Monument, 191
Baxandall, Michael, 22–3, 33
Baynes, Cilla, 67–8, 142
beliefs and ideas, institutions, 31
Benjamin, Walter, 104, 105, 108, 129–30, 136, 178, 195
Berger, John, 32
Berman, Ed, 44
Bertelsen, John, 49
Birchall, Bruce, 82
Birrell, Ross, 189
Bishop, Claire, 186–7
Blair, Tony, 40–1
Bob a Job week, 161
Bourdieu, Pierre, 16–17
Bourriaud, Nicolas, 7–9, 20, 186

– *203* –

Boy Scouts, 161, 164
Brewer, Max, 150
Briefs/briefs, 24, 35–8, 52, 54, 60, 71, 194
 and built environment, 77
 Combination community theatre group, 66
 definition, 23
 for Fiddlewood artist, 166–7, 178, 179
 Fun Festivals in deprived inner-city areas, 67
 and Goldsmiths, 108–9
 and Norwich project, 152
 and Operation Clean-up, 88
 for Provost Estate, 116–17
Brillo Box (Warhol), 6, 7
British Trust for Conservation Volunteers (BTCV), 149, 150, 156, 165
Buchloh, Benjamin, 191
building cuts, 188
built environment, 48, 76–7, 147
Bullard Road Garden, 155
butcher's shop, Hackney, 60

calligraphy, 170–1
Canning Town Free Form Fun Festival, 57, 58
Caribbean Carnival, 163–4
carnivals, 158–64
Case for the Arts, The (Baldry), 85
Cat 'n' Fiddle Community Plan, 172
Cat 'n' Fiddle Partnership, 149, 150, 154, 155, 172
Catton Clear Day Carnival, 156, 158–64
Catton Grove, 149, 152–6
Catton Pride newsletters, 159
Catton project, 150, 177–8
celebrations, 102, 177
 see also carnivals; Fun Festivals
Charge, 24, 30, 35, 50–1, 52, 54, 60
 and aesthetic language, 136
 and built environment, 77, 95, 126, 157
 definition, 23
charitable status, 61, 83
Chats Palace, 69–70

children
 art courses for, 145
 and Daubeny Road project, 88–9
 in Liverpool, 72
 near Jutland Road, 44–5, 46
 and Norwich project, 161, 177
 on Provost Estate, 115, 123
 and Roadshows, 67–8
 and school, 17–18
 and workshops, 51
Christie, Ian, 100
Christo, 15, 43, 184
circus, 66
City Garden, 89–90
Clark, Kenneth, 20
class, 134–5
 see also working classes
cleanup of streets, 158, 159
Combination community theatre group, 66, 67
comedy, 71
commedia dell'arte, 71
common sense, 19–20, 21
communal spaces, 112–14
community
 and community art, 193–6
 as concept, 40–1
 funding, 91–2
 lack of involvement, 146, 147–8
 sense of, 101–2, 115, 125, 162–3, 177–8, 194
community architecture, 79–81, 86–94
Community Areas Programme, 91
Community Art and the State: Storming the Citadels (Kelly), 80–1, 134
community/artist relationship, 187–8
community arts, history, 79–86
Community Arts North West, 67, 142
Community Arts Panel, 84
Community Arts Workshop, 142
community participation, as commodity, 134
community police, 160
concentration, 104
concrete poetry movement, 174–5
conservation, 149
consumption of art, 16–17
Cooper, Virginia, 114, 120

INDEX

Cornford, Christopher, 15
Costa Packet, 58
council estates, 69, 95–103, 108–9, 111–25
Council for the Encouragement of Music and the Arts (CEMA), 14
 see also Arts Council
Covent Garden, 145–6
craft versus fine art, 106, 170
critical art, 30, 81, 129
Cruickshank, Lenny, 74–5
Cultural Partnerships, 76
culture, popular, 163, 164
curatoriat, 19, 20, 29, 55, 136, 189
 and the art market, 21
 definition, 18
 and Free Form's house style, 126
 recognition of some community artists, 82
 rejection of gallery world, 185–6, 188
 and Thomas Hirschhorn, 192

D&TAS (Design and Technical Aid Service), 77, 79–80, 87, 92–102, 103, 136–7, 194
 funding, 134, 182–3
 as mediators, 187
 Provost Estate, 111, 112–24
Daily Mail, 11, 20–1
Daily Mirror, 11
dancing, 161
Danto, Arthur, 5–7, 9–10, 18
Daubeny Road project, 87–9
de-authored lineage, 186–7
'Dehuminization of Art, The' (Ortega), 32–3
Deleuze Monument, 191
democracy and artistic practice, 8–9
deprivation, 80–1, 152
derelict sites, 87–90
design awards, 144, 146, 147
Dickie, George, 7
Diggers, 74–5
distraction, 104
Döblin, Alfred, 129
dog wardens, 160
Downside, 143
dustmen, 162–3

Dutton, Denis, 9
Dyke Coombes, Martin, 146

East End of London, 39–40, 51–2
 environmental work, 87–93
 Goldsmiths Estate, 95–103, 108–9, 194
 Provost Estate, 111–25, 194
Edgar, David, 58
Elfreda Rathbone Society, 72
Elphick, Chris, 72, 73
Emerick, Dee, 97–8, 99, 100, 109
employment, 99–100
empowerment, 41, 93
England, Diana, 63, 65, 67, 68, 71
environment, improving, 48, 73–5, 76–7, 79, 87–94, 147, 158
essentialist, 9
Essex Education Department, 38–9
ethnography, 130, 152
European Social Fund, 144–5
evaluations, 161
Evering Road, 90
expertise of artist, 29–30, 180, 183, 185, 186, 194–5, 196
 and Provost mural, 117–20, 122–3

Fairchild, Thomas, 90
Fairlop School, 36–8
Family and Kinship (Young and Willmott), 40
female professionals, 18
festivals
 in Liverpool, 72–3
 in North East England, 142–3
Fiddlewood, 152–3, 155–6, 165–80
Fiddlewood Standing Stone, 172, *174*, *176*, 178, 179, 180
Fiddlewood Standing Stone Poem, *174*, *176*
fine art, 13–14, 34, 119, 127
fire, Momart, 11
fire shows, 51, *52*
Fisher, Ernst, 32
fish mosaic, 142
Fish Quay Festival, Tyneside, 142–3
floodlighting, 109
focussed attention, 103, 104
football, 18, 115

football pitch, 99–100
Forth Bridge, 23
Foster, Hal, 129–31
freedom and structure, 47–8
Free Form Arts Trust, 61, 85, 192
 and D&TAS, 92–4
 demise, 180
 funding, 30
 and Norwich project, 149–52
 and Operation Clean-up, 87–90
 opinion of Arts Council, 126–7
 organization, 141–8
 poster, *84*
Free Form Fun Event, 47–9, 50
Free Form Mobile Visual Workshops, 67
Free Form Project, 4–5
 and aesthetic tension, 10–11
 Charge, 24, 30
 founders, 22
Free Form Project Centre, 60–1, 75
Freire, Paulo, 32
funding, 51, 81, 83, 91, 102–3, 133–4, 143–5
 Arts Council, 30–1, 84
 Chats Palace, 69–70
 for D&TAS, 92, 183
 imposing conditions, 157
 Norwich project, 149
 for Stratford Fair, 58–9
Fun Festivals, 47–9, 50, 51–2, 57, 59, 67, 68–9

Gablik, Suzi, 15
gallery world, 4–5, 29, 30–1, 54, 132, 185–6, 188, 190
games pitch, 98–100, 194
gardeners, 160–1
Garrett, Craig, 190
Gell, Alfred, 12, 22, 31, 103–4
gemeinschaft, 40
geniuses and art, 14–15, 16
Gill, Eric, 171
Gingeras, Alison, 191, 192
glass recycling, 148, 150–1, 180
global North, 12, 21, 22
Goldman, Hazel, 63, *64*, 68, 99
 and Norwich project, 150
 and Provost Estate, 114, 116, 123–4
Goldsmiths Estate, 95–103, 108–9, 194

good art, definition, 18, 19, 20, 21
Goodrich, Martin, 3–4, 22, 29, 31, 57, 99, 184
 and ACA, 82
 and Chats Palace, 70
 and the Combination, 66, 67
 and Fairlop project, 36–8
 on Free Form Fun Event, 47–8
 and funding, 58–9
 and Hackney, 60
 influences, 32–4
 and *Its a Knockout*, 72
 and *Market 70*, 46
 and memories, 177
 and North West Arts, 142
 and Norwich project, 149–50, 154–5
 and Operation Clean-up, 87–8
 prefab studio, 39
 and Provost Estate, 114, 115, 116–17, 119–21, 122–3, 124, 195
 retirement, 180
 use of colour in the environment, 41–3
 and working classes, 136
 and workshops, 45
Gowing, Sir Lawrence, 54–5, 82
Gramsci, Antonio, 17–18, 19–20, 21, 64–5, 116, 164
Granby, 72–5
grants, 69–70, 157, 183
 see also funding
Gray, Michael, 69, 70
Greater London Arts Association (GLAA), 58, 69, 80–1
Greater London Council (GLC), 49, 91, 97
Green Bottle Unit (GBU), 148, 150–1, 180
Green, Chloe, *153*
Green, Janet, *154*
The Growth of Public Art (exhibition), 60, 61
Guardian, 11
Gulbenkian Foundation, 67

Hackney, 60, 87–90, 91, 92–3, 95–103
Hackney Council, 69, 87, 92

Hackney Grove Gardens, 131, *132*
Hackney Marsh Adventure Playground, 69
Hackney Marsh Fun Festival (HMFF), *62*, 69
Hackney, Rod, 86
The Hackney Show, 70
Halloween celebration, 176–7
Harrogate Festival, 53
Hecht, Michael, 59, 60
Hedge (Klassnik), 59
hegemony, 18, 21
Hewison, Robert, 83–4
high art, 20, 21, 65
high culture, encounter, 17
Hill, Stuart, 114, 126
Hirschhorn, Thomas, 188–92
historicist, 9
hoardings, 145–7
Hothouse, 144
Housing Department, 162
Howarth, Charlotte, 107, 168–9, 170–6, 178–9, 183, 184, 194–5
Hutchinson, Max, 86

ideas and beliefs, institutions, 31
Illich, Ivan, 32
individualism, 34–5
Inner City Partnership Programme, 91
Institutional Theory of Art, 7
institutions, art, 29–30, 31
 see also Arts Council
Inter-Action, 44, 86
Its a Knockout, 72
Ives, Jim, 3–4, 5, 22, 29, 31–2, 57, 60
 and Artism Lifeism, 54
 background, 34
 and Fairlop project, 36, 37, 38
 and *Market 70*, 45, 46
 and performance, 48
 use of colour in the environment, 41–3
 and working classes, 136
 workshops, 59

Jeanne-Claude, 43, 184
job-creation scheme, 73–5, 99
Jones, Peter, 43–4, 45–6, 53–4
jumble sales, 51
junk playgrounds, 49
Jutland Road, 38–9, 41–2, 44–5, 46–7

Kelly, Owen, 80–1, 82–3, 134, 182, 196
Kent, Sarah, 81–2
Kester, Grant, 187, 194
Keynes, John Maynard, 14, 178
Kilkenny limestone, 172
Kindersley, Richard, 171
Kingsmead Estate, 69
Klassnik, Robin, 53, 59, 66
Kristeller, Paul, 13, 14, 15–16
Kwon, Miwon, 187

Lacy, Suzanne, 186
land purchase, 144
landscaping, 73–5
Lee, Pamela, 187, 188
Le Grand Magic Circus, 66
lettering, 170–1
lighting, 109
limestone, Kilkenny, 172
Littlewood, Joan, 57–9
Liverpool, 72–5
Liverpool City Corporation, 73
Lives of the Artists (Vasari), 14
Livingstone, Georgina, 99
Lodge Lane Regeneration Group, 75
London see East End of London

Making Marks, 178
Malinowski, Bronislaw, 152
Marcus, George, 12–13
Market 70, 45–6, 49–50
market, art, 132, 133, 137
Masterson, Piers, 166
Matchbox, 76
Matta-Clark, Gordon, 187–8
mediators, 187
Meek, James, 11, 21, 35
memorials, 105–8
memories, importance, 177
middle classes, 18
Milmoe, Joanne, 150, 151
Mobile Roadshows, 67–8
Mobile Visual Workshop, 67, 68
modernism, 33
'Modern System of the Arts, The' (Kristeller), 13
Momart fire, 11
Mona Lisa, 20
Morgan, Sally, 83

INDEX

mosaic murals, 74, 88, 89, 90, 101, 120, *137*, 142
murals, 59, 74, 115, 116–17, 118–25, 126, *137*, 194
 childish daubs, 195
music, 161, 164
Musil, Robert, 105–6
Myers, Fred, 12–13

Nancy, Jon Luc, 188
National Strategy for Neighbourhood Renewal, 40–1
National Vocational Qualification (NVQ), 145
Necessity of Art, The (Fisher), 32
neighbourhood festival, 57
neoliberalism, 138, 196
New Activities Committee (NAC), 45
new genre public art, 186–9
Newham Council, 51
Newman, Andy, 150, 158–9
Newnham, Eva, 72
newsletters, 159
Night Plantation, 152–3, 155–6, 165
Noble, Joe, 69
'nonexclusive audience', 189–90
nonexperts, 55, 127, 148, 183, 196
 use of workshops, 44, 182, 195
nongallery spaces, 190
Norman Foster and Partners, 148
North East England, 142–3
Northern Free Form, 143
North, global, 12, 21, 22
North West Arts, 141–2
Norwich City Council, 149–50, 151
Norwich project, 148–56, 158–80
Norwich Samba, 161, 164
Notting Hill Carnival, 164
NUBS (Neighbourhood Use of Buildings and Spaces), 86

Ocean Estate, 41
Office of the Deputy Prime Minister (ODPM), 149
open spaces, 112–14
Operation Clean-up, 87–90, 91
oppositional otherness, 131
Orange Marches, 163
Ortega y Gasset, José, 32–3
otherness, 131

outcomes, 138, 161
ownership and community, 163, 184–5

paintings, 47, 48
 see *also* murals
parades, 158–61, 163–4
Pardo, Carlos, 89
Parkes, Derek, 145–6
Park Fiction, 194
participation, local, 73–4, 179–80, 182, 183, 186
 Catton Clear Day Carnival, 158–62
 Operation Clean-up, 87–90
 see *also* D&TAS (Design and Technical Aid Service)
patronage, 133–4
Patterns of Intention: On the Historical Explanation of Pictures (Baxandall), 22–3, 33
performance, 48, 57, 61–72, 76, 77, 158, 159
 Catton Clear Day Carnival, 163
 and Theatre of Adventure, 176–7
performers and visual artists, split, 76
Perry, Grayson, 17
Picasso, Pablo, 23
Pinhorn, Maggie, 82, 146
play, 51
playgrounds, 48–9, 59, 69
poems, *174*, 175, *176*
police, community, 160
political location, 136
politics, 61, 196
popular art, 20
 tension with high art, 65
popular culture, 163, 164
popular music, 164
Portrait of Kahnweiler (Picasso), 23, 24
poverty, 39, 40
power relations, 5, 13, 182
printing designs, 173, 175
private sector, 145–8
producers of art, 16
professionals, 17, 18
Prop Pieces (Serra), 43
Provost Estate, 111–25, 194

questioning, 187
questionnaires, 48, 161–2

racism, 52, 135
railings, 114, 126
Rancière, Jacques, 30, 129, 196
RCA (Royal College of Art), 35–6
Read, Herbert, 32
recession, 180
recycling, 148, 150–1, 180
Redbridge, 35–6
regeneration funds, 143–4
Reich, Carole, 168–70, 171–4, 175, 178–9, 183, 184
rejection of gallery world, 4–5, 29, 30–1, 54, 132, 185–6
Relational Aesthetics (Bourriaud), 7–9
relational art, 7–9, 186
Revolt of the Masses, The (Ortega), 32
Reynolds, Joshua, 106
Richardson, John, 23–4
Roadshows, 67–8
road signage, 156
Romanticism and art, 15, 16, 34
Rossiter, Alan, 63–4, 69, 146, 147, 148
 and Norwich project, 150, 151, 161
Royal Academy, 106
Royal Academy Schools, 34, 106
rubbings, 172
rubbish, 158, 160, 162

samba band, 161, 164
schools, 17–18
 working with artists, 36–8, 145, 148, 150–1
scoping exercise, 151–2
Scouts, 161, 164
sculptors, 32, 43, 132–3
secondary schools, 36–8
self-expression of the artist, 106
Serra, Richard, 43
Shakespeare, William, 17
Shanks, Christopher, 99
Shiner, Larry, 104
Simpson, Svar, 132–3
snake play sculpture, 150, *151*
Snowden, Joe, 36
social recognition, 29–30
songs, 161, 164, 177
South Bedfordshire District Council, 143
spaces, open, 112–14
spectator/artist relationship, 30

'spectre of evaluation', 189
Spectrum Crafts, 161
Spitalfields, 148
sponsorship, 51
standing stone, 172, *174*, *176*, 178, 179, 180
steering committee, Norwich, 155
Stewart, Carol, 114
Stonebridge Gardens, 150, *151*
stone carvers/masons, 107–8, 133, 171
Stratford Fair, 58, 59
Street Participatory Theatre, *62*
streets, clearing up, 158
structure and freedom, 47–8
studios, 60
surrealism, 32, 51

tactile qualities, 178
technical aid, 92–4
Technical Aid Centres, 86–7
teenagers, 17, 18
tenants associations, 95, 97–9, 108–9, 112–13, 114
Thatcher revolution, 85–6
theatre, 57–8, 70–1
Theatre of Adventure, 159, 161, 164, 176–7
Thomas Hirschhorn, 191
Thompson, Ken, 171
tiles, 148
Tower Hamlets Art Project, 81–2
Traffic in Culture, The: Refiguring Art and Anthropology (Marcus and Myers), 12–13
training courses, 142, 144–5
transformative power of art, 189
travelling arts workshop, 67, 68
Trikilis, June, *113*
Trikilis, Elsie, *113*
Trikilis, Robert, *113*
trust, 124
TVs, collecting, *160*
Tyne and Wear Development Corporation, 142

universality, 189
unmediated expressivity, 187
Urban Programme, 91, 92, 93
urban regeneration, 81, 91, 92–3

Valley Curtain, 43
value of work, 133, 137
Vasari, Giorgio, 14
visual art and performance, 67–8, 76
Visual Systems, 36–9, 58–9

Walker, Mary, 125
wall painting, 47, 48
Warburton, Nigel, 12
Warhol, Andy, 6, 7
Ways of Seeing (Berger), 32
Welfare State (performance troupe), 44
West, the *see* global North
Wheeler-Early, Barbara, 3–4, 6, 22, 29, 35, 57
 'Architectonic Paint Rags', 53
 background, 34
 and the Combination, 66, 67
 and environmental projects, 75, 91, 93
 and Fairlop project, 36
 fundraising, 144
 and Goldsmiths, 99, 103
 influences, 32
 and Jutland Road, 46
 and murals, 59
 retirement, 180
 teaching, 133
 and wall painting, 48
 and working classes, 136
 and workshops, 68
Williams, Raymond, 40
Willmott, P., 40

window boxes, 114–15, 194
women, professionals, 18
woodlands, 152–3, 155–6, 165, 176–8, 179
 brief for Fiddlewood, 166–7
 and standing stone, 172, 173–4, 175
Woodmansee, Martha, 14
working classes, 17, 22, 30, 135, 136
 and aesthetic language of art world, 10–11
 gulf with art students, 3–4, 34
 teenagers, 17, 18
'Work of Art in the Age of Mechanical Reproduction, The' (Benjamin), 104
workshops, 51, 81, 137, 182, 184
 and Catton Grove, 159
 at Chats Palace, 69, 70
 in Fiddlewood, 177
 in Granby, 72–3
 at Jutland Road, 44, 45
 learning from nonexperts, 195
 and Operation Clean-up, 88–9
 on Provost Estate, 116, 120
 for schools, 145, 148, 150–1
 on standing stone, 172–5
 at Stratford Fair, 59
 Theatre of Adventure, 164
 travelling, 67, 68

Young, M., 40
Young British Artists (YBA), 11
young people, courses, 145